Posters of Paris

Toulouse-Lautrec & His Contemporaries

Posters of Paris

Toulouse-Lautrec & His Contemporaries

Mary Weaver Chapin

MILWAUKEE ART MUSEUM

DELMONICO BOOKS • PRESTEL
MUNICH LONDON NEW YORK

CONTENTS

LENDERS TO THE EXHIBITION

The Art Institute of Chicago

Donald and Donna Baumgartner

William V. DeLind

The Richard H. Driehaus Collection, Chicago

Galerie Berès, Paris

Grand Rapids Art Museum

Indianapolis Museum of Art

Library of Congress, Washington, DC

Jeffrey H. Loria, New York, in honor of Sue Selig

Los Angeles County Museum of Art

Machinery Row Bicycles, Madison, WI

The Museum of Modern Art, New York

National Gallery of Art, Washington

National Gallery of Canada, Ottawa

Princeton University Art Museum

The Rennert Collection, New York City

Reva and Philip Shovers

Jim and Sue Wiechmann

Zimmerli Art Museum at Rutgers University

As well as those lenders who
prefer to remain anonymous

The Milwaukee Art Museum is proud to present *Posters of Paris: Toulouse-Lautrec and His Contemporaries*, a visual romp through the earliest days of the *affiche artistique* (artistic poster). The exhibition takes us from the first flowering of the *affiche* in the 1870s under Jules Chéret—the "father of the modern poster"—through the poster's many styles under a new generation of artists including Pierre Bonnard, Henri de Toulouse-Lautrec, and Alphonse Mucha in the 1890s. Bright, bold, and innovative, these posters sparked widespread *affichomanie*, or poster mania, and created a marvelous spectacle on the streets of Paris.

Mary Weaver Chapin, exhibition curator and author of this catalogue, has brought together the finest examples of French posters to transport us to fin-de-siècle Paris. In her essay "Posters of Paris: The Spectacle in the Street," Chapin recreates the boulevard culture, establishing the poster as a vital element in animating life along the streets of nineteenth-century Paris. The artists behind these iconic images each advanced the art of poster making with uniquely French élan and incited critics to lively debate concerning the relationship between art and commerce. The *affichomaniaque*, too, contributed to the culture of the poster—stirring innovation and providing niche interests that print dealers and publishers were quick to satisfy.

More than one hundred years later, we are grateful to these poster enthusiasts for preserving this ephemeral art form, and to the subsequent generations that placed these works in the Museum's care. Mrs. Harry Bradley donated rare posters by Henri de Toulouse-Lautrec to the Museum's Collection during the 1960s and 1970s, followed by gifts of French posters from Dr. and Mrs. Milton Gutglass in the 1980s and 1990s, among others in the years since. The city of Milwaukee is further blessed by the superlative collection of work by Jules Chéret in the collection of Jim and Sue Wiechmann, whose generous loans have greatly benefited the exhibition. Superb posters from other private Midwestern collections—Donald and Donna Baumgartner, Roger Charly of Machinery Row Bicycles, Richard H. Driehaus, Reva and Philip Shovers, and lenders who prefer to remain unnamed—have also enhanced the exhibition. We are indebted to Jack Rennert, who has kindly loaned works from his rich collection and has been unstinting in his vast knowledge of the *affiche artistique*. Both the Los Angeles County Museum of Art and the Zimmerli Art Museum generously granted our requests to feature a large number of posters from their fine holdings. We are grateful to all the donors, public and private, who have made this exhibition possible, as well as to our sponsors for their support. Finally, we are greatly pleased that *Posters of Paris* will travel to the Dallas Museum of Art, and we owe director Maxwell L. Anderson and his talented staff our thanks for partnering with us on this exciting project.

Daniel T. Keegan
Director, Milwaukee Art Museum

ACKNOWLEDGMENTS

Throughout the planning and execution of the exhibition and catalogue *Posters of Paris*, I have benefited from the assistance and advice of many colleagues and friends. At the Milwaukee Art Museum, my thanks go to Director Dan Keegan, Chief Curator Brady Roberts, and Director of Exhibitions Laurie Winters for their support of this project and for providing the resources needed to turn my idea into an exhibition and a catalogue under tight deadlines. Christa Story, research assistant, was an invaluable ally and contributor to the project; I am grateful for her organization, linguistic skills, and passion for the material. Librarian Heather Winter was diligent in her efforts to obtain rare material and facilitate my research. Christina Dittrich was a superb and sensitive editor, helping me shape the material to best tell the story at hand. Senior Conservator Jim DeYoung and his staff contributed countless hours to this project. Curatorial colleagues Lisa Hostetler and Brooke Mulvaney offered support at critical junctures of the exhibition and the catalogue. Registrars Dawn Gorman Frank and Melissa Hartley Omholt oversaw the complex shipping arrangements, and Stephanie Hansen advised me on image rights and database management. John Irion developed the stunning exhibition design, and the entire crew of art preparators installed and lit the works beautifully. Darryl Jensen took time to discuss the nuances of lithographic technique with me. In Communications, Vicki Scharfberg and Kristin Settle created a dynamic marketing program for the exhibition, and Mary Albrecht, Kathy Emery, and the Development staff were tireless in securing the funding to make this idea a reality.

Beyond the Milwaukee Art Museum, other professionals greatly enhanced this project. John Glembin provided much of the photography in this volume, and Béatrice Armstrong of the French Institute of Milwaukee helped refine my translations from the French; any infelicities remaining are mine alone. Hal Kugeler created the elegant design of the catalogue and shepherded the book through each deadline with grace and good humor. Mary DelMonico of DelMonico Books/Prestel proved to be the ideal publisher for this volume, and Karen Farquhar deftly handled the production of the book.

Several historians and art historians kindly shared their work with me, engaging in telephone and email conversations as I prepared this manuscript. I would like to thank Karen Carter, Phillip Dennis Cate, H. Hazel Hahn, Ruth E. Iskin, Vanessa R. Schwartz, and Nicholas Zmelty for their collegiality and fine scholarship. I owe Jack Rennert a special debt of thanks for his generosity with his time, loans, and many connections in the poster world.

Many colleagues facilitated my research trips and welcomed me to their print study

rooms or answered questions by telephone and email: Suzanne Folds McCullagh, Mark Pascale, Martha Tedeschi, and Emily Vokt Ziemba, The Art Institute of Chicago; Kristin Spangenberg, Cincinnati Art Museum; Joyce Lee, Driehaus Enterprise Management, Inc.; Marie-Christine Bonola, Galerie Berès, Paris; Richard Axsom, Cindy Buckner, and Julie Burgess, Grand Rapids Art Museum; Jan Grenci, Library of Congress; Leslie Jones and Taras Matla, Los Angeles County Museum of Art; Kit Basquin, George Goldner, Cora Michael, and Liz Zanis, The Metropolitan Museum of Art; Katherine D. Alcauskas and Paul Galloway, The Museum of Modern Art; Greg Jecman, National Gallery of Art, Washington; Calvin Brown, Princeton University Art Museum; Suzanne Boorsch and Lisa Hodermarsky, Yale University Art Gallery; and Christine Giviskos and Marilyn Symmes, Zimmerli Art Museum at Rutgers University.

I am very pleased that *Posters of Paris* will be seen by the patrons of the Dallas Museum of Art, and I am thankful for the support of Maxwell L. Anderson, Heather MacDonald, Olivier Meslay, Joni Wilson, and Tamara Wootton-Bonner and their colleagues for orchestrating its presentation. I am especially indebted to the lenders, listed on page 6, who agreed to share their works so we could tell the story of the *affiche française* in fin-de-siècle Paris.

Finally, a project of this scope extends beyond the workday. For their support, encouragement, and help keeping the home fires burning, I am happy to thank Steve, Oliver, and Sadie Chapin, Elizabeth Haws, Lisa Meyerowitz, S. Alan and Nancy Weaver, and Penne Zeigen.

Mary Weaver Chapin, PhD
Associate Curator of Prints and Drawings
Milwaukee Art Museum

Posters of Paris

The Spectacle in the Street

Mary Weaver Chapin

There are … degrees of surprise and not all astonishments
would have the same shock; but the *spectacle of posters*,
the walls completely covered with grimacing or licentious
colored pictures of clowns, puppets, and multicolored women
laughing and pirouetting in the limelight and aggression
of Gomorrah, would certainly cause [a time traveler from the
seventeenth century] the most profound amazement.

— Maurice Talmeyr, 1896[1]

W riting in 1896, author and social critic Maurice Talmeyr posited that if a man from the seventeenth century were to find himself in Paris in the 1890s, he would be surprised by many things, but nothing would be more shocking than the "spectacle of posters." As Talmeyr's words convey, by the end of the nineteenth century, Paris had been transformed into a city of

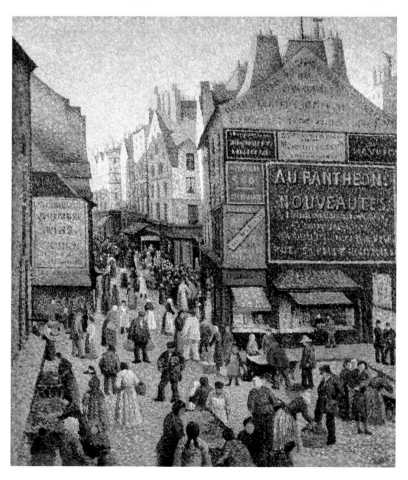

posters. Designs from the splendidly artistic to the utterly banal decorated the sides of buildings along the grand boulevards and camouflaged decrepit structures in cramped neighborhoods. Posters had "taken possession" of the city and covered Paris like "magical vegetation"; in 1902 an estimated one and a half million posters appeared annually in the capital alone.[2] Posters were part of daily life, as described by art critic Raoul Sertat: "From our windows we see advertisements spread across the neighboring house. If we go outside, advertisements are behind and ahead of us, they are all around us, to the left, to the right, everywhere" (fig. 1).[3] So ubiquitous (and beloved) was the poster that it came to stand as an embodiment of the city itself, especially as expressed in the work of the so-called father of the poster, Jules Chéret. Writer Joris-Karl Huysmans cited the posters of Chéret as the very "essence of Paris," while Symbolist poet and novelist Georges Rodenbach enthused that to own a poster by Chéret was to possess a bit of Paris at home.[4] Such was the level of intense fascination with the poster that art critic Octave Uzanne coined the term *affichomanie* (poster mania) in 1891.[5]

Talmeyr's writings point to the centrality of posters in fin-de-siècle Paris, as well as the fact that they had become a *spectacle*, a word connoting in French (as in English) a public display or performance, an exhibition on a grand scale. Posters did not merely advertise products or cultural diversions but were ipso facto entertainments themselves. Cultural historian Vanessa R. Schwartz has studied how "life in Paris became so powerfully identified with spectacle that reality seemed to be experienced as a show," transforming urban life into a series of "spectacular realities."[6]

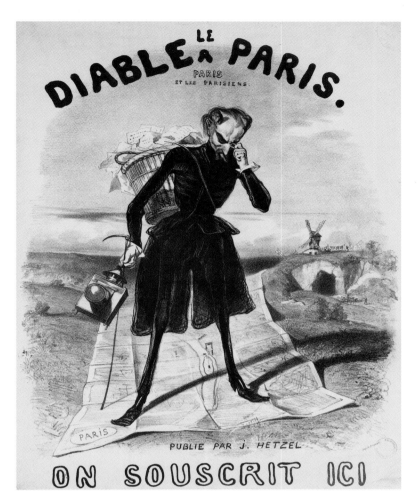

The poster, which held a highly visible place in the capital and was an object of great fascination, was part and parcel of this phenomenon. It became an element of the theater of the street, the decoration of the home, and the theme for social gatherings. As a recent arrival into the canon of fine art (or aspiring social climber, depending on the critic's point of view), a hybrid creation that merged art and advertising, the poster seemed to embody modernity in an entirely new way. *Posters of Paris: Toulouse-Lautrec and His Contemporaries* explores how the poster formed a new type of spectacle, both public and private. And just as Talmeyr conjectured that a person from the seventeenth century would find late nineteenth-century Paris unrecognizable, we in the twenty-first century would not understand the city in the same way as its fin-de-siècle inhabitants. By highlighting the voices of the critics and the collectors of the day, examining the rise of the poster and the artists who excelled in its production, and investigating the poster's conflicted status as a commercial agent, this exhibition illuminates the spectacle of posters in fin-de-siècle Paris.

SETTING THE STAGE OF PARIS AND THE RISE OF *AFFICHOMANIE*

The illustrated poster was not unique to late nineteenth-century Paris. In fact, the poster had been a prominent part of city life for centuries, dating back to handwritten proclamations and woodblock prints. In 1798 author and dramatist Louis-Sébastien Mercier wrote that the poster "covers, colors, dresses Paris one may say…. And Paris may be denominated *Poster-Paris*, and be distinguished by this costume from any other city of the world."[7] The posters referenced by Mercier were generally black-and-white woodblock prints, heavy on text and light on illustration. Around the same time Mercier wrote these words came the first of the major catalysts in the growth of the poster: the invention of lithography by Alois Senefelder in 1796–99. Lithography, a planographic printing technique based on the principle of the repulsion of water and grease, was an experimental medium at first, but by the 1830s, it had been adopted by Parisian publishers for illustrated novels and for small posters to advertise them. Illustrators such as Gustave Doré, Paul Gavarni, and J. J. Grandville all made posters to publicize the romantic novels of the day (fig. 2). Usually monochromatic and small in size, these posters give little hint of the colorful and striking *affiches artistiques* (artistic posters) that would proliferate at the end of the century.[8]

The invention of lithography was followed by a remarkable confluence of technological, economic, sociological, and artistic factors that were the midwives to the birth of the *affiche artistique* and the resulting *affichomanie*. One of the most decisive factors that fostered the flourishing of the *affiche* was the physical transformation of the city of Paris into an urban stage where the poster would thrive. This process was already in play in the eighteenth century along the *grands boulevards* that formed a semicircle from the Madeleine in the west to the Bastille in the east.[9] Cafés, shops, and theaters lined the boulevards and drew pedestrians who marveled at the constantly changing displays. This boulevard culture was accelerated in the second half of the nineteenth century under the aegis of Emperor Louis Napoléon III, who charged Georges-Eugène Haussmann, the prefect of the Seine, to modernize the city. Haussmann's plan called for more parks, better water supply and sewer systems, and new

Figure 1, opposite
Maximilien Luce
La Rue Mouffetard,
1889–90
Oil on canvas
31 ⅝ × 25 3/16 in.
Indianapolis
Museum of Art

Figure 2, above
Paul Gavarni
Poster for *Le Diable à Paris*,
1843
Lithograph
28 ¾ × 22 ¼ in.
Musée de la Publicité, Paris

public buildings, including the Opera House and the Central Markets (*Les Halles*). Perhaps the most visible change Haussmann undertook was the creation of an axis of boulevards cutting north-south and east-west through the medieval, labyrinthine heart of the city. These wide avenues improved traffic circulation (and troop movement, in times of war or insurrection) through the city by connecting major points of commerce, transportation, and government and intersected the older *grands boulevards* in key locations, thereby facilitating access to the heart of Parisian street culture and entertainment. Haussmann's new buildings, with their vast swaths of uniform walls, would become the stage for thousands of *affiches*. Even more important, new urban furniture including kiosks and urinals offered space for displaying posters. The Morris company, a printing business specializing in theater posters, invented structures for the express purpose of posting *affiches* to accommodate the increasing demand for advertising space; known as "Morris columns," the cylindrical columns debuted in Paris in 1863 and quickly became a defining feature of the capital. By 1868, one hundred

and fifty Morris columns punctuated the *grands boulevards*, and artists began to incorporate the columns and the posters they displayed into their paintings, drawings, and prints of Parisian life as a signifier of modernity (figs. 3, 4).[10]

One industry that saw a marked rise in its need for additional advertising was entertainment. All manner of diversions—circuses, cafés-concerts, cabarets, dance halls, museums, theaters, and operas, among others—were opening across Paris and needed to lure paying customers. At the same time, consumer goods proliferated in the new *grands magasins* (department stores), catering to the nascent society of consumption. Posters were a key means of both educating consumers and seducing them to purchase the new wares. These developments coincided with technological advances in lithographic printing that allowed steam-powered presses to produce large-scale color posters more rapidly; one source recorded that a press could print two thousand color posters daily, versus the previous rate of twelve per day.[11] The passage of the 1881 Press Law, which relaxed the regulation of printing and eased restrictions on the distribution and

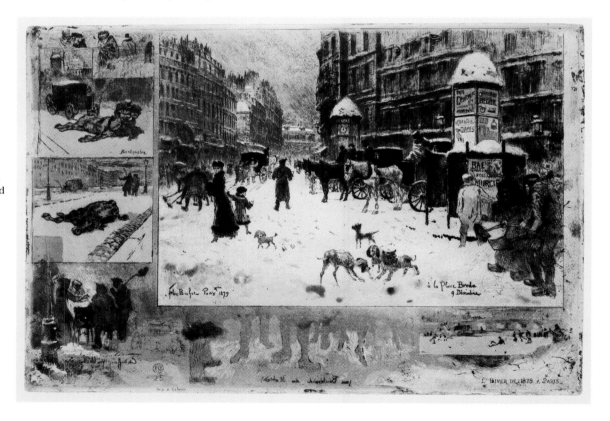

Figure 3
Félix-Hilaire Buhot
Winter in Paris or
Paris in the Snow,
1879
Etching, aquatint,
spit bite etching,
soft-ground
etching, drypoint,
and scraping
11 ⅞ × 16 ¹⁵⁄₁₆ in.
Milwaukee Art
Museum, Purchase,
Edna Lee Hass Fund

posting of *affiches*, further enriched the fecund environment for posters. Yet it is possible that the *affiche* would never have reached artistic heights without the presence of one man: Jules Chéret.

Chéret was born in Paris in 1836. He showed artistic talent from an early age and was apprenticed to a lithographic firm when he was thirteen.[12] After an eight-year sojourn in London, Chéret returned to Paris and opened his own printing shop on July 1, 1866. Although, as previously mentioned, posters were nothing new in the capital, Chéret brought three important aspects to bear on the *affiche*: color, size, and artistic design. These features, in concert with the favorable Haussmannian urban conditions for posters, the boom of consumer culture, and the recent technological advances in lithographic printing, created a sea change in the *affiche illustrée*. A master colorist, Chéret invented an economical method for introducing color into his designs: he printed the keystone (the outline of the main design) in black and a second stone in red, and then formed the background with a *fond gradué* (in contemporary terms, a rainbow roll) of color. Over the course of the 1870s and

early 1880s, Chéret developed his signature style, which quickly won admirers. The first trickle of what would become a flood of positive criticism came from novelist and critic Joris-Karl Huysmans in 1879. Railing against the banal academic nudes, history paintings, and grand allegories in the state-sponsored Salon that year, Huysmans declared that he would prefer "all the exhibition rooms hung with the colored lithographs of Chéret…than to see them blemished like this by a mass of sad works."[13] The following year, reviewing the Salon of 1880, he confirmed his admiration for Chéret (and not merely his disgust with contemporary painting):

I can only counsel people sickened…by this cheap and insulting display of prints and paintings to cleanse their eyes by directing them outdoors…where shine the astonishing fantasies of Chéret, these fantasies in colors so quickly drawn and so spiritedly painted. There is a thousand times more talent in the smallest of these posters than in the majority of the paintings that I have had the sad opportunity to review.[14]

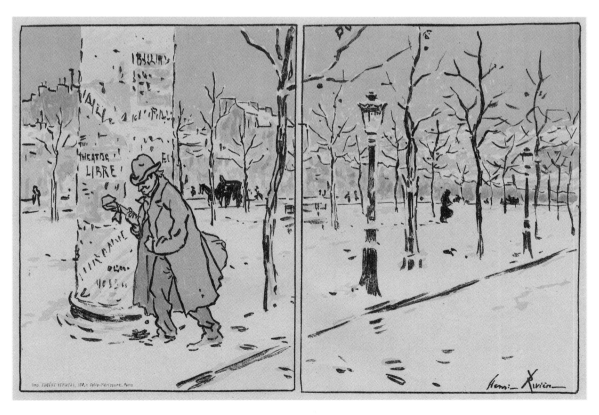

Figure 4
Henri Rivière
Paris in Winter,
program for the
1889–90 season of
Le Théâtre Libre,
1890
Color lithograph
8 9/16 × 12 1/4 in.
National Gallery
of Art, Washington,
Gift of The Atlas
Foundation, 1995

The outpouring of critical notice increased throughout the 1880s. In 1884 Ernest Maindron published a two-part article on illustrated posters in the *Gazette des Beaux-Arts*, a periodical supportive of the decorative arts; he expanded and illustrated his thesis in the book *Les Affiches illustrées*, published in 1886. That same year, Henri Béraldi included Chéret in the fourth volume of his series *Les Graveurs du XIXᵉ siècle* (Printmakers of the Nineteenth Century), thereby inscribing this poster artist into the official canon of art history. Chéret's artistic reputation (and that of the *affiche artistique*) was sealed shortly thereafter with three important exhibitions in 1889: a retrospective survey of French posters at the Exposition universelle, an exhibition of 300 contemporary *affiches* in Nantes, and a solo exhibition of 140 of Chéret's prints, drawings, pastels, and posters at the Théâtre d'Application.[15] The inclusion of Chéret's noncommercial work (pastels, drawings) signaled in the eyes of his contemporaries his elevation from craftsman to artist and further helped secure the place of Chéret and the poster in the realm of fine art.

The events of 1889 served as an apotheosis of Chéret, and the press soundly endorsed his reign as "roi de l'affiche" (king of the poster).[16] The following year, artists and writers representing an astonishing diversity of political and social positions petitioned the French government to recognize Chéret's contribution.[17] The officials concurred with their assessment, and on April 4, 1890, Chéret was awarded the Légion d'Honneur for creating a new branch of art "by applying art to commercial and industrial printing." At a banquet in Chéret's honor, the venerable writer, champion of the decorative arts, and aesthete Edmond de Goncourt toasted Chéret as "the first painter of the Parisian wall, the inventor of art in the poster," an opinion widely shared by artists and the public alike.[18]

As Goncourt's toast indicates, Chéret was credited with not only inventing a new art but also transforming the city. Raoul Sertat mused in *La Plume* that Paris was unimaginable without Chéret's posters, while poster aficionado Charles Hiatt declared that "Paris, without Chéret, would be Paris without one of its most pronounced

Figure 5
Eugène Atget
Paris, rue de l'Abbaye, 1898
Albumin silver print
6 ⅞ × 8 ¹¹⁄₁₆ in.
Musée Carnavalet, Paris

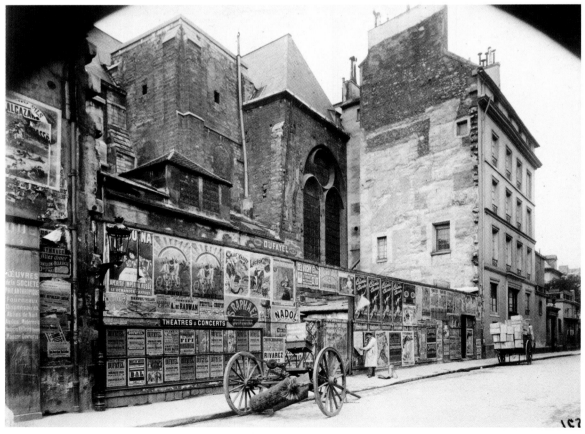

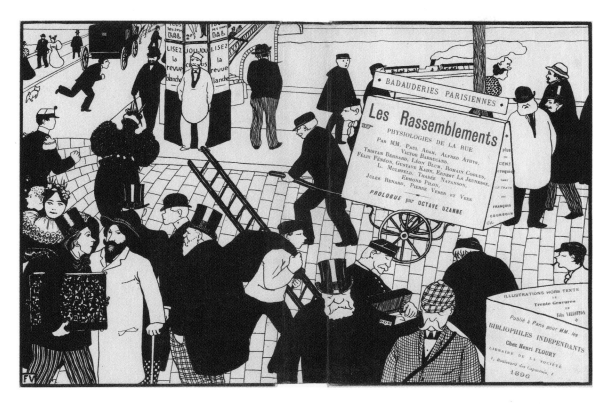

Figure 6
Félix Vallotton
Book jacket for
*Badauderies
parisiennes —
Les Rassemblements,
physiologies
de la rue*, 1896
Photo-relief
13 7/16 × 21 5/16 in.
National Gallery
of Art, Washington,
Virginia and Ira
Jackson Collection,
Gift in memory of
Virginia H. Jackson
2006

characteristics: Paris, moreover, with its gaiety of aspect materially diminished." Huysmans wrote a facetious quip praising Chéret for enlivening what was generally considered, for all its improvements, a deplorably drab Haussmannian Paris: "Were I the strict incarnation of the prevailing taste of the day…I would seek to prohibit the exhibition of M. Chéret's posters on the hoardings. In fact they ruin the uniform sadness and dullness of our streets, now that the engineers have demolished the few remaining houses and lanes that pleased us." Author and art critic Léon Maillard echoed his sentiments, decrying Haussmann's demolition of old, quaint Paris. Without the saving grace of "these clever artists of the mural posters," he wrote, "our poor Paris… would have soon acquired the scowling character of a Protestant church."[19]

The colored poster, critics agreed, had indeed brought gaiety to daily life, but, more significantly, posters had "given Paris a museum of pictures, an open-air exhibition."[20] "Here is the true Museum for the Masses, the free Museum of the Day, awakening the joy of an everlasting art," declared Émile Straus, in *La Critique*.[21] This *plein-air* museum, many critics theorized, would be an elevating agent on public taste. Jean Richepin went so far as to claim that just as Greek

sculpture and architecture had an ameliorative effect on citizens in ancient Athens, gradually acclimatizing the populace to great art, so, "in their fashion do the contemporary masters of the illustrated posters."[22] The critics' hyperbolic language, lush with superlatives and far-flung associations, points to their enthusiasm for the genre as well as their own discomfort with the poster as a parvenu in the realm of art; still unsure of its status, critics resorted to exaggerated language to assuage their misgivings and shore up its case. Much of the public, however, had already been won over by the *affiche artistique*, as demonstrated by the widespread *affichomanie*.

AFFICHOMANIE

Advertising and publicity were not merely backdrops to the street scene but also active, defining elements of it, part of the life of the boulevard. By the 1890s, posters were seen on *palissades* (scaffolding or billboards), Morris columns, kiosks, urinals, and in shop windows. They were distributed and posted by agencies such as Bonnard-Bidault, Dufayel, and Morris, the inventor of the poster column that bore its name. Each company specialized in a different niche and owned billboards throughout the city; the Dufayel name presides over the hoarding in Eugène

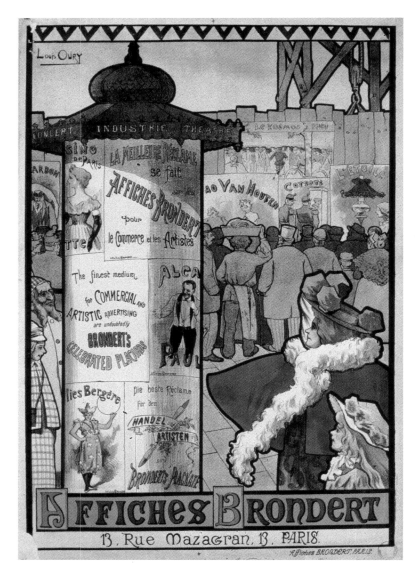

Figure 7
Léon Louis Oury
Affiches Brondert,
ca. 1900
Lithograph
32 7/8 × 22 3/8 in.
Musée de la
Publicité, Paris

Atget's photograph of the rue de l'Abbaye (fig. 5). These agencies were so efficient that they could effectively cover the walls of Paris in a matter of hours.[23] The daily routine of the French billposter (*afficheur*) required some cunning:

> At the present day, each Paris billposter is supplied daily with from 250 to 300 placards, on which is duly affixed the Government duty stamp, and his work is divided into two categories: first—posting on reserved places, and second—ordinary posting. In the first case he encounters no difficulties, but his task is more arduous in the second one, for the sites he chooses to place his bills being free of any charge, he has to keep a keen eye on his rivals, who will watch him, let him finish his work, and immediately after he has left cover up with their own bills the placards just affixed.[24]

Competitive billposting evolved into public theater. According to historian Aaron J. Segal, "Billposters dueling to cover one another's posters became a feature of the urban landscape, in one case attracting crowds estimated by police at about 200."[25] Novel advertising schemes created such a stir that at times the authorities were required to restore order; in 1888 police were called in when "a caravan of twenty carriages covered with advertisements of 'gigantic dimensions, escorted by a small army of sandwich men,' paralyzed traffic for several days."[26] While the *homme-sandwich* (sandwich man) was considered an object of pity, "sad to see and contributing nothing picturesque to our cities," *femmes-sandwiches* (invariably beautiful young women) were considered a stroke of genius.[27] In a poster of 1890, Chéret even depicted an *enfant-sandwich* (sandwich-board child) merrily advertising clothing at the Buttes Chaumont department store (pl. 32). While it is unlikely that *enfants-sandwiches* were actually employed in Paris during the 1890s, Chéret's poster is nonetheless indicative of how deeply the trope of the sandwich board and the posters they carried had pervaded Parisian consciousness and art.

As the advertising carriage traffic jam in 1888 demonstrates, mobile advertising activated the *affiche*. Men or horses pulled simple publicity carts—known as *voitures pousse-pousse* or *voitures à réclame*—through the streets, effectively catching pedestrians' attention (fig. 6).[28] Architect and painter Francis Jourdain recounted his initial encounter with Henri de Toulouse-Lautrec's first poster, writing, "I still recall the shock I had when I first saw the Moulin Rouge poster…. This remarkable and highly original poster was, I remember, carried along the Avenue de l'Opéra on a kind of small cart, and I was so enchanted that I walked alongside it on the pavement."[29] Enterprising businessmen constructed elaborate *voitures à réclame* endowed with posters and decorative elements such as gargantuan milk bottles, hats, or pots of mustard, illustrating the advertised items.[30] One promoter promised that his firm could provide carts "in the Moorish, Egyptian, Gothic, Renaissance, etc., styles, always sober and in good taste."[31] The daily parade of advertisements was a production of ever growing and

ever more outlandish proportions (sobriety and good taste, mentioned above, were surely meant facetiously), and the poster was at the heart of this theater of public life.

The arrival of an outstanding new poster was noted by passersby and could draw a crowd. Louis Oury's poster shows a row of Parisians three deep (from laborers to smartly dressed bourgeoisie) enthralled by the latest *affiches* plastered on construction scaffolding and displayed on a Morris column (fig. 7), while Félix Vallotton's woodblock print depicts top-hatted gentlemen on the run to see the latest posters and prints placed in the shop window of Edmond Sagot's gallery (fig. 8). Admittedly, both examples are for the *affiche* industry—Oury's image is an advertisement for the poster printer Affiches Brondert, and Vallotton's is an address card for Sagot, the leading poster and print dealer in the city—and thus have an incentive to show posters in an attractive light. Nonetheless, these images point to the role of the poster as a form of entertainment in the streets.[32]

It was a short step from admiring posters in the streets to coveting them for use at home. Poster collecting became popular in the 1880s and quickly escalated to a feverish pitch by 1891, when the term *affichomanie* came into parlance. To obtain their favorite specimens, collectors employed several strategies, the first among them, theft. Commentators from both the upper echelons of society as well as the proletarian ranks offered larceny advice for the aspiring collector. Esteemed art critic Arsène Alexandre wrote, "To peel them off the walls one's self, at night, seemed the simplest plan." It was also the most dangerous, he continued, because it involved the risk of being caught and fined by the police. Even more than arrest, Alexandre seemed concerned about "the risk of 'peeling' [the posters] badly and getting off the wall only a thing of tatters."[33] Anarchist, poet, and art critic Félix Fénéon, writing in street slang in the anarchist journal *Le Père peinard*, gave a step-by-step recipe for how to steal posters from billboards in good shape, so that every man of the street could have a bit of art at home:

> These posters are cool…why not take some from time to time? When they haven't been up too long, or when they start to fall down,

or even better when they're slapped up on layers of paper as thick as cardboard, it's possible to peel them off, good Lord…but watch out for the cops.… Once you're back to your pad, what the fuck do you do with them? Wash 'em down, dry them on a rack or on strings, repair the tears, and ah ha! Pin up your loot on the walls of your pad, where, obviously, your bastard of a landlord was letting the wallpaper rot.[34]

If theft proved too dangerous or inconvenient, another well-used method was to bribe the *afficheur*, who was generally happy to earn some extra income while also lightening his load.[35]

Print sellers on the quais began to sell copies of posters to their clients, but the printers and artists who objected to being cut out of the profits brought suit, and sentences were pronounced.[36]

Figure 8
Félix Vallotton
Print Lovers, 1892
Woodcut
10 × 12¾ in.
Milwaukee Art Museum, Gift of the Hockerman Charitable Trust

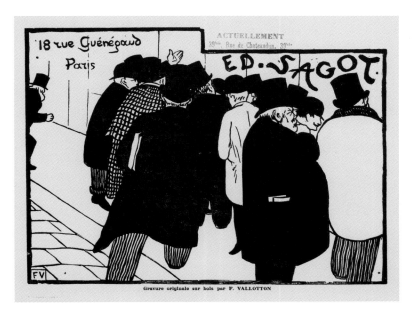

Merchants and entrepreneurs also fought against theft, paying insurance to guarantee that their posters were actually posted to the *palissades* (and not discarded or sold by billposters amenable to bribes), and that they stayed mounted until the adhesive had dried.[37] Some businesses went further by stamping warnings on their posters stating that the poster may not be either sold or purchased; the warning did little to stop theft, except, perhaps, by marring the design of the poster. *Affichiste* Jules-Alexandre Grün,

anticipating this disfiguring stamp, incorporated the warning right into his design (fig. 9).

Art galleries carried posters for collectors who preferred to purchase rather than steal *affiches* for their collections. In 1886 Edmond Sagot began selling posters in his art gallery, and in the 1890s other gallery owners followed, notably Édouard Kleinmann and Victor Prouté. Collectors and critics, eager to secure high art status for the *affiche illustrée*, promoted the discussion of the poster as a fine art print. Dealers also appropriated the language of fine art and were soon selling impressions without the text and posters on special papers. They also introduced limited runs of posters that were numbered and signed by the artist. Even a cursory glance at the 1891 catalogue of posters for sale in Sagot's gallery reveals the depth and breadth of *affichomanie* at the time; the catalogue lists more than two thousand posters ranging in price from one or two francs for ordinary impressions to sixty francs for a large, rare work by Chéret.[38] Most posters, however, were five francs or less, making them equivalent to an evening of entertainment at a café-concert, cabaret, or circus.[39]

Once a poster was obtained, by means legal or otherwise, the collector was admonished to store it properly: "If [posters] are worth collecting, they are worth treating well."[40] Alexandre instructed his readers to take their posters to a "*mounter* of posters; a workman (sometimes a binder, sometimes a framer) who pastes posters on a fine cloth back with a roller at each end, like the Japanese *kakemonos*."[41] Fittingly, Alexandre likened the mounted poster to *kakemonos*, vertical Japanese

scroll paintings, thereby elevating them into the realm of acceptable art. The poster as a fine art print reached its apogee in the *panneau décoratif*, or decorative panel. These were much like posters before the text was added (proofs before letters), designed specifically with the collector in mind. Chéret's four *panneaux décoratifs* of 1891 (pls. 35–38)—representing pantomime, music, dance, and comedy—were hung in bourgeois homes across the city, destined to "vanquish the drabness" of contemporary apartments.[42] Similar decorative panels designed by poster artists Eugène Grasset, Alphonse Mucha, and Paul Berthon targeted the same market. By purchasing a poster without lettering, the collector could evade the uncomfortable relationship with commerce; he or she could enjoy the poster "without abominable publicity," in the words of artist and historian Jules Adeline.[43] Collectors were highly creative with these panels and posters, pasting them onto folding screens for interior decorative use.[44]

The decorative panels came in sizes that were relatively easy for collectors to accommodate in their homes; each of Chéret's *panneaux*, for instance, measured approximately 49 × 34 ½ inches and could be hung on a wall. Very large *affiches*—some of which towered more than seven feet high—posed special display and storage problems for *affichomaniaques*.[45] For them, a special publication was born, *Les Maîtres de l'affiche* (Masters of the Poster), which reproduced the leading posters of the day in sheets measuring 11 ¼ × 15 ½ inches. *Les Maîtres* was distributed to subscribers, who would receive four reproductions each month. The venture lasted from December 1895 through November 1900, reproducing 256 plates from 97 artists. Monthly subscriptions cost two and a half francs; yearly subscriptions ran twenty-seven francs. Some annual subscribers opted to house the year's supply of *affiches* in luxurious bindings offered at eight francs (fig. 10). By comparison, a collector could purchase a poster by Pierre Bonnard, Chéret, Henri de Toulouse-Lautrec, or Théophile-Alexandre Steinlen for approximately two and a half to five francs, unless it was unusually large or rare. As poster expert and curator Alain Weill has written, this placed *Les Maîtres* well within reach of much of the Parisian population at a time when entrance to the Folies-Bergère music hall was two francs, dinner at the Taverne de l'Hermitage on the boulevard de Clichy was

Figure 9
Jules-Alexandre Grün
Revue à Poivre,
1904
(detail of pl. 58)

three francs, and an overcoat from the Belle Jardinière department store, twenty-two francs.[46] In addition to the plates issued by *Les Maîtres de l'affiche*, collectors could obtain reduced-sized reproductions of posters as premiums in journals such as *La Plume*, *La Revue indépendante*, and *Le Courrier français*.[47] Literature focused on describing, debating, and promoting posters also helped create and then fuel *affichomanie*. Readers turned to periodicals devoted to the *affiche* such as *The Poster* (which was published in London, but which devoted a great deal of coverage to French posters) and *L'Estampe et l'affiche*, as well as to a handful of other publications that frequently reviewed posters, including *La Plume*, *La Revue blanche*, *Le Livre et l'image*, *Art et décoration*, and even the august *Gazette des Beaux-Arts*.

POSTER PARTIES

Posters began as a public spectacle but soon penetrated private life. Poster parties, at which guests dressed as their favorite illustrated personages, were reported in the press. Collector Alexandre Henriot, for example, frequently held such parties, taking photographs of his costumed guests in front of backdrops replicating *affiches* in his collection.[48] Historian Aaron J. Segal noted that at a society gathering in the summer of 1907, "four women dressed as the subjects of posters for cigarettes, soap, medicinal wine and Chéret's *Saxoléine*."[49] Tableaux vivants based on French *affiches* were popular in Paris, the provinces, and even abroad. Articles from the *Washington Times* in Washington, DC, indicate that these entertainments were taken quite seriously; one article reported that "living posters" based on originals by Chéret, Grasset, and Lautrec would be created at a benefit for the Visiting Nurses Association. "The tableaux will be exact reproductions of the original posters, and will be shown in frames after the fashion of pictures. The background will be painted in and the figures will be done by a number of young women who are almost daily rehearsing in their decidedly difficult roles."[50] In New York, the poster party was a consuming social fad. In an unsigned article in *The Poster*, the author explained at length:

> In issuing the invitations the hostess requests each woman to come in the costume of the figure on the poster of a certain

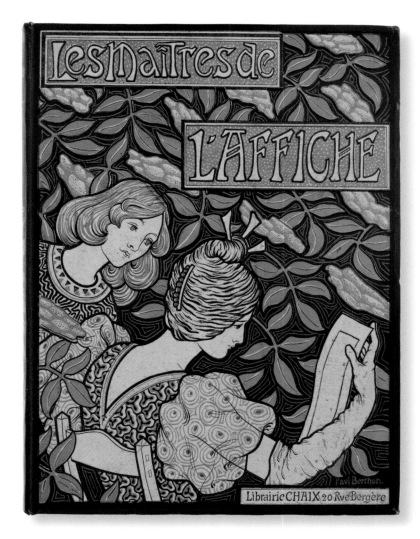

Figure 10
Paul Berthon
Cover for *Les Maîtres de l'affiche*, 1898
Embossed cloth binding
16 × 12 ½ × ½ in.
Collection of William V. DeLind

newspaper or magazine that she names, being careful to have no two alike. The men she requests to represent well-known literary men.…

> During a recent poster party each woman in turn was called on to pose in correct representation of the poster figure she portrayed, and guesses were made and written upon cards as to what newspaper or magazine she represented. The men were called upon to quote sayings of the men they represented. Guesses were made then, as in the cases of the women, and prizes were awarded.[51]

This text highlights two phenomena worth noting: First, men did not come dressed as characters from *affiches*, presumably because posters were dominated by images of women. Second, the commercial and the artistic aspects of the posters had been entirely expunged—the images were used for pure entertainment, without reference to their ostensible raison d'être.

A WEALTH OF ARTISTIC STYLES

héret was truly a foundational figure, single-handedly creating the genre of the *affiche artistique* and winning it artistic respect and legitimacy in the 1870s and 1880s. In the 1890s, his work reached its zenith just as a younger generation of artists was taking the poster to a new level. These artists worked in a mindboggling array of styles: Realist, academic, Rococo, caricatural, Moorish, Byzantine, *japonesque*, avant-garde, Art Nouveau, and strange hybrids of one or more of these. Some simply defy categorization. A study of each of the various styles and their practitioners is beyond the scope of this essay and exhibition, but it is useful to consider the handful of artists (and a few of their followers) who were considered superlative at the time: Chéret, Grasset, Toulouse-Lautrec, Mucha, and Steinlen. Leonetto Cappiello, whose work best bridges the nineteenth and twentieth centuries, is both a coda to the golden epoch of poster design and the first chapter to the new twentieth-century visual idiom.

CHÉRET: THE FRAGONARD OF THE STREET

The work of Jules Chéret (1836–1932) was rooted in the aesthetic of the Rococo, an artistic style that flourished in the late seventeenth and early eighteenth centuries and which was characterized by delicate colors, elaborate ornamentation, and natural forms.[52] Novelist Félicien Champsaur praised Chéret as the "Fragonard of the street, the Watteau of the intersection…the Tiepolo of the public square."[53] Painters Jean-Honoré Fragonard (fig. 11), Jean-Antoine Watteau, and Giovanni Battista Tiepolo depicted lighthearted romantic scenes, commedia dell'arte characters such as Harlequin and Pierrot, and *fêtes galantes* (genre scenes of figures in masquerade enjoying parties in pastoral settings). Chéret transposed these elements into a modern Parisian scene in his poster *Frascati* from 1874 (pl. 21), advertising a popular *bal* on the rue Vivienne. Elegant masked and costumed figures line the mezzanine looking down into the magnificent hall, where the party continues. Working with just black, red, and green, Chéret created a painterly atmosphere ranging from the darkest blacks of the

Figure 11
Jean-Honoré Fragonard
The Shepherdess, 1750/52
Oil on canvas
46¾ × 63 in.
Milwaukee Art Museum, Bequest of Leon and Marion Kaumheimer

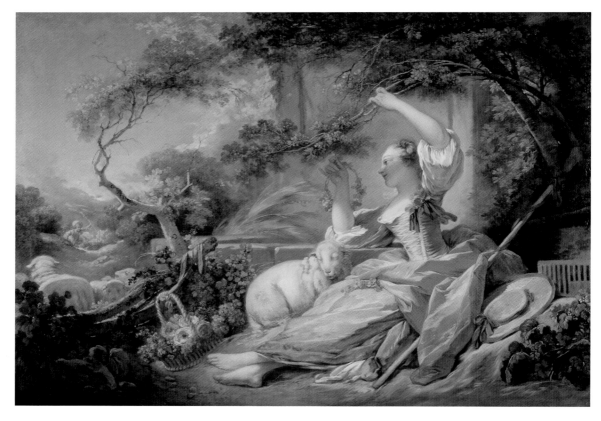

women's masks to the shadowy gray corners. The influence of Tiepolo is especially clear in Chéret's penchant for airborne characters, a motif that began early in his career and that became one of the hallmarks of his mature style. In *Folies-Bergère: Les Tziganes*, also of 1874 (pl. 20), figures and horses soar through the heavens above the heads of the musicians playing at the café-concert below. Again using his simple three-color formula, Chéret produced dramatic red shadows and reflections across the middle ground, thereby evoking the romance and excitement of the Gypsy music at the Folies-Bergère music hall.

Throughout the decade, Chéret adjusted and refined his style as the commission or his whim dictated, working in a highly painterly manner as well as a flatter, more simplified and graphic mode. Toward the end of the 1870s, he created a very lively, elastic style while also simplifying his backgrounds. The resulting posters possess a new energy that can be seen in *affiches* such as *Folies-Bergère*: *Les Hanlon-Lees* (pl. 26), *L'Horloge: Le Pékin de Pékin créé par Suiram* (pl. 27), and *L'Horloge*: *Les Girard* (pl. 29).[54] In all three examples, Chéret moved closer to caricature, endowing the performers with superhuman flexibility and elongating their limbs to impossible lengths. Fittingly, this caricatural aspect is most noticeable in *Les Hanlon-Lees*, an English troupe that specialized in pantomime.[55] *Les Hanlon-Lees* marked a striking new idiom in Chéret's style, which caught the eye of

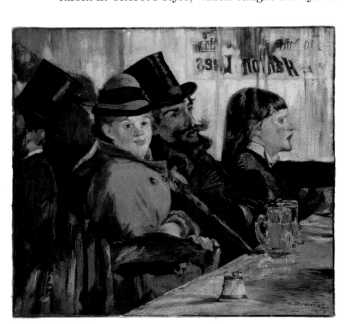

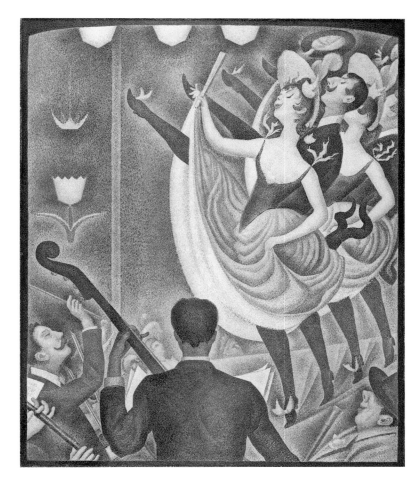

Édouard Manet, who included the poster in the background of his painting *At the Café* (fig. 12).[56] Manet's incorporation of Chéret's work not only shows how far the *affiche* had permeated public life but also points to the fact that avant-garde artists were accepting and incorporating posters into their artistic visions. Chéret's posters would also be a source of great inspiration for the Neo-Impressionist painter Georges Seurat, who collected Chéret's *affiches* and whose own figures exhibit an elastic vitality indebted to the older artist (fig. 13).[57]

Lettering plays an important role in Chéret's posters of this time. In *Les Hanlon-Lees* the conductor balances on his left toes, perched on the N of the text, while his right arm casts the baton high in the air, bisecting the O above. Chéret went even further in *Le Pékin* by curling the text around the performer's left calf and foot at the bottom of the composition and extending the stocking of his right leg into the text at the top, thereby tying the composition together, with Le Pékin's legs as the axis of the poster. Perhaps his finest achievement in this realm is found in *Les Girard*. Here the dancers not only tickle the letters at the top of the sheet, but a stylized

Figure 12, left
Édouard Manet
At the Café, 1878
Oil on canvas
30 ¾ × 33 in.
Oskar Reinhart
Collection
'Am Römerholz,'
Winterthur

Figure 13, above
Georges Seurat
The Chahut, 1889–90
Oil on canvas
66 ⅛ × 55 ½ in.
Kröller-Müller
Museum

dancer at the bottom weaves himself through the text. The rhythmic interplay between the three principal dancers creates visual excitement, and their interaction with the beautifully designed and drawn text makes this one of Chéret's most accomplished posters. This could in fact be the first example of the modern poster in which image and text are perfectly balanced to form a compelling whole.

Chéret's mature style dawned near the beginning of the 1890s, possibly in response to audacious posters by newcomers such as Pierre Bonnard and Henri de Toulouse-Lautrec. Chéret's posters of this decade are marked by superb lithographic skills. Working with a minimum of colors, he created intermediate hues by the careful overlapping of tints and the fine rain of *crachis* or spatter. Around 1891 he began using royal blue instead of black ink for the keystone of his compositions, effectively enlivening his bright color even more. His images are populated by commedia dell'arte characters such as Harlequins, Columbines, and Pierrots, but the most important feature of his mature style was the emergence of a vivacious and beautiful young woman whom critics dubbed the *chérette*. Blond, lightly clothed, and invariably smiling with parted lips, the *chérette* was the object of intense fascination for writers, who never seemed to tire of Chéret's formula, whether to entice visitors to the Moulin Rouge dance hall (pl. 31) or to purchase Saxoléine brand lamp oil (pl. 45). Chéret's *chérette* became a cultural phenomenon, the leading lady of the poster as discussed below.

AVANT-GARDE TRENDS AND *JAPONISME*: PIERRE BONNARD AND HENRI DE TOULOUSE-LAUTREC

If Chéret was a singular force throughout the 1870s and 1880s, his supremacy would be shaken abruptly in 1891 with the arrival of two startling new posters: Pierre Bonnard's *France-Champagne* and Henri de Toulouse-Lautrec's *Moulin Rouge—La Goulue*. Although dissimilar in their styles and in the effect they achieved, these two posters marked a new high point for design and ushered in the golden age of the artistic poster during the 1890s. Interviewed years later, artist Francis Jourdain and critic Thadée Natanson pointed to the appearance of *France-Champagne* and *Moulin Rouge—La Goulue* as key moments in the history of the

poster, recalling that Bonnard's poster "revealed a new universe." Jourdain continued, "Yes, a new universe, the existence of which was confirmed a few weeks later by another poster destined to make Parisians aware of the *Bal du Moulin-Rouge* and signed with a name equally unknown: Lautrec." There was little relationship between the images, the authors noted, but they shared a kinship in their audacity and novelty.[58]

Pierre Bonnard (1867–1947) received the poster commission for Debray's champagne in 1889, when he was just twenty-two years old and fresh out of law school. He began by making studies using his cousin Berthe Schaedlin as his model, working in pen and ink to block out the basic composition and the relationship of the letters to the image (pl. 6). Like Chéret, he based his advertisement on a comely young woman, but Bonnard's design goes beyond the elder artist's successful formula by radically flattening the pictorial space and relying on sensuous line to evoke the liveliness of the champagne. Bonnard, like a host of artists, was influenced by the art of Japan—the compressed space, areas of flat color, and flowing contour lines of *France-Champagne* made it the most *japonesque* poster design to hit the streets of Paris to date (pl. 7). Bonnard created volume, as seen in the study as well as the final design, by merely varying the thickness of his outlines, much in the style of a Japanese brush painting.[59] The cascade of bubbles flowing from the glass further animates the scene and creates a sense of superabundance, a surfeit of gaiety and champagne offered by this beautiful young woman posed in a suggestive manner, her head tipped to the side, eyes closed. Bonnard's curvilinear, irregular lettering mimics the tipsiness of the lovely model and forms an integral part of the overall design, an accomplishment only rarely achieved by Chéret.

Bonnard's poster appeared on the streets of Paris in March 1891 and immediately aroused the curiosity of critics who recorded their "astonishment" and the "emotion" evoked by this new poster by a totally unknown artist.[60] In fact, legend holds that it was Bonnard's poster that first captured the attention of the young painter Henri de Toulouse-Lautrec and inspired his highly successful poster career. Thadée Natanson, the co-founder and editor of the leading literary and artistic journal *La Revue blanche* (and close friend of both

Bonnard and Lautrec), recorded that Lautrec was stopped in his tracks by Bonnard's debut poster, *France-Champagne*: "The inventiveness of it overwhelmed Lautrec right away. Our connoisseur stood boldly in front of it on his crooked legs, and without a word, pointed at it with the tip of his cane. He was so taken with it that he stopped every passer-by to ask if anyone was familiar with Bonnard, but no one was, and almost everyone sniffed and left him standing there, and he would start up again. (…) He would stop at nothing until meeting its creator."[61] Natanson further recounts that it was Bonnard who took Lautrec to the Ancourt Imprimerie, where Lautrec was inducted into the world of color lithography and where, Natanson adds, Lautrec would spend some of the happiest hours of his life.

It is surprising that after his successful debut, Bonnard made just nine additional posters during his long artistic career. Bonnard scholar Antoine Terrasse hypothesized that the artist, "acknowledging [Lautrec's] genius, virtually abandoned the field to him."[62] Though he made a superb maquette for a poster for the Moulin Rouge (fig. 14), it remained unrealized, and Bonnard did not complete another poster until 1894, when he produced his masterful and somewhat enigmatic design for the periodical *La Revue blanche* (pl. 8). The poster depicts a smartly dressed woman on the streets of Paris, a copy of *La Revue blanche* in hand. She wears a fashionable hat and a tiered jacket, and holds an umbrella in her right hand. Bonnard playfully wove the umbrella through the A of *la* and represented its point with the V in *revue*, making the lettering an active and highly witty character in the composition itself.[63] Beside her, a brash newsboy points his thumb towards the magazine in her hand as he runs through the street, while behind them a gentleman in a top hat pauses to read the posters on the wall, also advertising *La Revue blanche*. The insistent flatness, complex relationship between the figures, restrained palette, and artful lettering make this a triumph of graphic design, but less legible as a commercial poster. Bonnard continued this trend in subsequent posters, employing rich patterning (pl. 9) and an elegant *japonesque* design, as seen especially in his poster for the Salon des Cent (Salon of 100), a series of monthly exhibitions launched by Léon Deschamps, editor of the artistic and literary journal *La Plume* (pl. 11).

Figure 14
Pierre Bonnard
Moulin Rouge, 1891
Pastel and charcoal
21 ½ × 19 ³⁄₁₆ in.
The J. Paul
Getty Museum,
Los Angeles

The first lithograph Henri de Toulouse-Lautrec (1864–1901) made, the groundbreaking poster *Moulin Rouge—La Goulue* of December 1891, even more than Bonnard's *France-Champagne*, broke significantly with existing poster design (pl. 87). Instead of the beautiful, carefree, and anonymous young women featured by Chéret and Bonnard, Lautrec focused his massive poster on a very real and notorious woman, the cancan sensation La Goulue (The Glutton), together with her dancing partner, Valentin le Désossé (Valentin the Boneless). Lautrec made this pair the center of his composition, which was so large that it required three sheets of joined paper.[64] It is not known how Lautrec won the commission for this poster, but he had been a regular patron of the Moulin Rouge dance hall since its opening night on October 5, 1889. He was certainly aware of Chéret's 1889 design for the establishment (pl. 31), which features *chérettes* astride donkeys en route to the pleasure palace that had captured the attention of *le tout Paris*. Eschewing Chéret's gaiety, Lautrec instead evoked the seamier side of the establishment: the Moulin Rouge where aristocrats, pimps, streetwalkers, bourgeois gentlemen, and proletarian workers (all depicted as a row of shadows in the background and identifiable by their hats) rubbed elbows and jostled for the best position near the dance floor.

Figure 15
Henri de
Toulouse-Lautrec
Study for
May Milton, 1895
Blue crayon
with black chalk
29 ⅛ × 23 ¼ in.
Yale University
Art Gallery

after the debut of *Moulin Rouge—La Goulue*, focused on its startling contrast to the posters of Chéret; his analysis is revealing and is worth quoting at length:

> Even today, we remember our emotion upon seeing for the first time, on a wall a poster by Lautrec. At that time, the color poster, which has become so trite since then, was not at all common. Only occasionally did we have the pleasure of seeing posters by Chéret, those delightful artistic treats! And, in fact, what a feast for the eyes, those Harlequins, those Columbines, those Pierrots, the masked balls and pretty girls and that dazzling flurry of multi-colored confetti with which Chéret would plaster the walls. It delighted the streets and filled them with sunshine. All of Paris was enthusiastic about Chéret. Then all of a sudden an unknown appeared who astounded us and who disturbed us with his strange determined drawings in flat, acidic tones! And they were signed Lautrec, and, strangely enough, the name quickly became popular, but as a name which implied anxiety and anguish. He made people uncomfortable but they also shivered with pleasure.[66]

Lautrec's poster makes plain the equation between sex, commerce, celebrity, and the Moulin Rouge.[65] Starting with the preparatory study, Lautrec focused on the raised petticoats and spread legs of the dancer, using white heightening (diluted lead white paint) to create an arrow-like shape pointing to her sex, thereby making La Goulue's whirling petticoats the focus of the composition and the locus of movement for the entire visual field. The figure of Valentin le Désossé adds to the sexual innuendo: his right thumb points towards La Goulue's spread legs while his left hand is positioned to suggest physical arousal. The radically flattened space adds a destabilizing element: the tilted floorboards and yellow globe lamps were drawn from different perspectives and create a reeling sensation that mimics the dizzying atmosphere of the Moulin Rouge in full swing.

Lautrec's poster—huge, thrilling, daring, crude—made a startling impact. Unlike Chéret's posters, which were generally greeted with encomiums for their beauty, lightness, and above all, *gaieté*, Lautrec's poster provoked stronger emotions. Gustave Coquiot, writing thirty years

This strange and determined poster in flat, acidic tones launched Lautrec's career as a poster artist and heralded a new, distinctive voice. Lautrec, who focused on the underbelly of Parisian entertainment, developed a style that combined his unique personal vision with elements drawn from Realism and *japonisme*, a style that generally provoked praise, undercut with revulsion or discomfort. Poster enthusiast Charles Hiatt perhaps best described this admixture, referring to the simultaneous "art-pleasure" and "art-pain" produced by Lautrec's posters.[67]

Lautrec followed his stunning debut poster with *affiches* for the charismatic cabaret performer Aristide Bruant. As with La Goulue in the Moulin Rouge poster, Lautrec immediately seized upon the most important features of the performer and distilled them into a highly legible visual code. Bruant gave life to songs of his own creation about the *bas-fonds* of Paris—the thieves, pimps, and streetwalkers who inhabited Montmartre and the outer boulevards of the city. Bruant's act became so popular in

Montmartre that he was invited to perform at the fashionable Ambassadeurs café-concert, and the *poète-chansonnier* commissioned Lautrec for a promotional poster. Lautrec's *affiche* (pl. 89) captures the rogue and dangerous aspects of Bruant that made him so titillating to the bourgeoisie. Bruant commands the visual field, standing in three-quarters view and wrapped in his signature costume of a black cape, red muffler, and wide-brimmed hat. To leverage Bruant's outsider status, Lautrec was careful to capture the performer's characteristic sneer and narrowed eyes. Not only did this ensure recognition, since, as poet Rodolphe Darzens claimed, Bruant was known to everyone in Paris by his "malicious eye and ironic lips,"[68] but it was also radical in its own way: in almost all other posters for the entertainments of the time, performers smiled and pandered to the audience, hoping to win them over with their charm. Lautrec, on the other hand, rendered his performers aloof, above the need for public approval, a trait that he carried into his audacious and unconventional designs. In *Aristide Bruant dans son cabaret* (pl. 90), the performer presents his back to the poster audience, implying impertinence on the part of Bruant, and graphic daring on the part of the artist. Lautrec's insouciance continued in posters such as *Divan Japonais* (pl. 92), in which Lautrec focused on the audience instead of the performer onstage, whose head is cut off by the top margin of the poster. Here, as in other works, Lautrec included erect canes, walking sticks, and other shapes rich with innuendo to charge the atmosphere with sexuality and humor.

Despite their seeming effortlessness, Lautrec's posters were carefully conceived and designed. The artist achieved his powerful images by working from highly finished studies before reducing them to their essential elements. In his crayon and chalk design for a poster for May Milton, Lautrec followed academic tradition by first drawing the performer's body beneath her dress, working out the details of her anatomy and pose, and carefully articulating the angle of her jaw (fig. 15). In the final poster, Lautrec discarded these details, rendering her dress as a flat field with no indication of the body beneath (pl. 94). In addition, he made her face more schematic and less beautiful. This same process, which allowed Lautrec to make pithy, iconic posters, is evident in surviving preparatory drawings:

Lautrec made carefully modeled and composed studies in graphite, charcoal, or paint to execute images that were flat, schematic, and synthetic (pls. 91, 95). Critic Arthur Huc understood this gift for reduction, writing that when Lautrec "created the magnificent poster for Bruant, which is and remains the masterpiece of the genre, he first painted him in detail as Bonnat might have done. Then…he deleted and deleted again, retaining only the essential lines. The basic idea remained sincere. Lautrec's capacity for synthesis had reduced it to an epigram."[69] Félix Fénéon made a similar observation, noting that rather than copying reality, Lautrec created "a set of signs which suggest it."[70]

Lautrec, the most gifted of the poster designers of the 1890s, had a very limited career as an *affichiste*, creating just thirty posters before his death at age thirty-six. Lautrec had no followers or disciples, but the spirit of Lautrec can be felt in the rhythmic lettering and striking composition of Jacques Villon's *Le Grillon* of 1899 (pl. 105).

Figure 16
Pablo Picasso
Jardin de Paris
(Design for a poster), 1901
Ink and watercolor on paper
25 ½ × 19 ½ in.
The Metropolitan Museum of Art, Gift of Raymonde Paul, in memory of her brother, C. Michael Paul, 1982

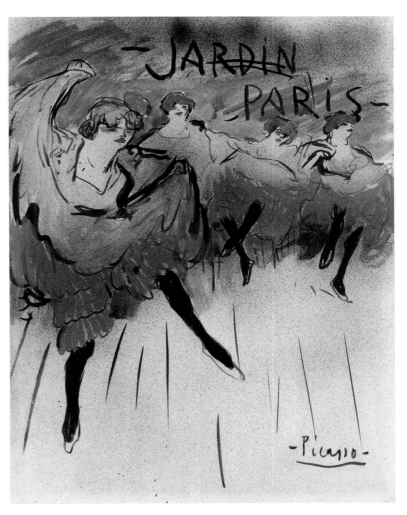

Likewise, René Georges Hermann-Paul's poster for the Salon des Cent (pl. 59) shares something of Lautrec's esprit and mastery of color and *crachis*. Henri-Gabriel Ibels' powerful poster portrait of the performer Mévisto (pl. 60) exhibits a kinship to Lautrec's posters of Bruant. The most ardent follower of Lautrec, at least for a brief moment, was the young Pablo Picasso. First visiting Paris in 1900, and returning again in 1901, the year of Lautrec's premature death, Picasso may have been positioning himself to replace the Frenchman as the new poster artist for the entertainments of the city. His unrealized design for a poster for the Jardin de Paris (fig. 16) owes much to Lautrec's *Troupe de Mademoiselle Églantine* (pl. 100). Furthermore, Picasso paid homage to Lautrec's poster of May Milton in his own painting *The Blue Studio*, which shows Lautrec's iconic *affiche* hanging on the walls of the atelier.[71]

ART NOUVEAU: GRASSET, MUCHA, AND ORAZI

Eugène Grasset (1845–1917) was widely hailed as a master *affichiste* during the late 1880s and throughout the 1890s. His work was avidly collected by *affichomaniaques* and he was considered Chéret's greatest competitor; the two artists were seen as the pillars of French poster design.[72] Grasset worked in all branches of the decorative arts, including furniture, jewelry, stained glass, and ceramics, and was influenced by a wide range of sources—most notably by writer and architect Viollet-le-Duc (1814–1879), the English Arts and Crafts movement, and the resurgent interest in medieval forms and designs.[73] Among Grasset's first major posters was *Jeanne d'Arc, Sarah Bernhardt*, 1889/90 (pl. 52). Compared to Chéret's airy and gay style, Grasset's monumental poster of the great stage actress represents a significant departure. Heavy ornament pervades the image in which, as poster enthusiast Charles Hiatt wrote, the actress stands "with splendid disdain amidst a forest of spears and a shower of arrows."[74] In this poster, the subject—Sarah Bernhardt's portrayal of the medieval heroine Joan of Arc—and the style are wedded perfectly; Grasset created a script evocative of medieval missals and, except where the actress's toe protrudes through the picture plane, he maintained a strict flatness and stiffness of form prevalent in medieval art.[75] In subsequent designs, Grasset translated this medieval style into a more general idiom, which Ernest Maindron aptly dubbed "archaïsme moderne,"[76] as

in his advertisement for Marquet ink (pl. 53). The woman, attired in a vaguely medieval dress, with stylized, flowing hair, symbolizes another era, far from the bustling metropolis of Paris.

Grasset never embraced the term, but he was one of the key artists who helped forge what would become known as *Art Nouveau*. Grasset had both great influence as well as a wide audience in his role as a professor at École Guérin in Paris, and several of his students followed in his footsteps, notably Paul Berthon (1872–1909), who, like his teacher, worked in the decorative arts. Berthon's posters similarly share a sense of timelessness, a quality he achieved by using a heavy black outline to evoke stained glass. In his poster advertising a Salon des Cent exhibition, he transformed a contemporary stage beauty (Cléo de Mérode) into an iconic, almost biblical figure who holds a lily as an attribute (pl. 3).

The Art Nouveau style would find its champion in the work of a relative latecomer to the Parisian poster scene, Alphonse Mucha (1860–1939). Born in the Moravian town of Ivančice in Austria (present-day Czech Republic), Mucha trained as an artist in Vienna and Munich before settling in Paris in 1890. Like Toulouse-Lautrec's before him, Mucha's first poster, which advertised Sarah Bernhardt in the role of Gismonda at the Théâtre de la Renaissance (pl. 66), made him an overnight celebrity and a new force in the Parisian *affiche illustrée*. He won the prestigious commission entirely by happenstance: the actress needed a poster in short order during the Christmas holidays of 1894, and Mucha was the only designer on hand at the Lemercier printing house. The actress was delighted with Mucha's poster and claimed him as her personal designer for years to come.

Mucha's style was based on elaborate ornamentation, stylized vegetal forms, classical draftsmanship, and exotic elements such as Byzantine mosaics. Eschewing any hint of contemporary Parisian life, Mucha was, in the words of critic P. G. Huardel, "the Apostle of the Beautiful and of the Ideal."[77] Whether he was advertising a play featuring Sarah Bernhardt, a bottle of champagne, or cigarette papers, Mucha strove for an ideal of beauty. His attention to ornament, which he employed to enhance both the decorative effect as well as the commercial aim of his posters, was unsurpassed. In *Job* (pl. 71), Mucha interwove the

letters J-O-B to produce a harmonious, patterned background to the lovely woman holding the cigarette papers, and whose dress is adorned with a Job clasp. Mucha's influence is evident in the work of his student Jane Atché (1872–1937), one of the very few women who worked in the poster field at the time. In her design for Job (pl. 1, in a proof before letters), she adopted Mucha's stylized smoke and ornate ornamentation, as seen in the gold and lace collar of the model, while avoiding the abundant and serpentine coiffure of so many of his maidens. Mucha was also a very accomplished lithographer and colorist; unlike Chéret or Toulouse-Lautrec who favored bold colors, Mucha preferred a subtle palette of mauves, greens, and, occasionally, metallics,

as in the pale silver of *La Dame aux Camélias* (pl. 68) or the golds of *Lorenzaccio* (pl. 67).[78]

Less prolific than either Grasset or Mucha, Manuel Orazi (1860–1934) nonetheless made a significant contribution to the Art Nouveau *affiche*. Born in Rome, Orazi worked most of his life in Paris as a decorative artist producing posters, jewelry, and illustrations. His finest poster designs date to the turn of the century and incorporate several key elements of Art Nouveau: sinuous line, flattened space, muted colors, and stylized shapes drawn from nature. In his poster announcing the opening of the new hippodrome on the rue Caulaincourt in Montmartre, Orazi used rich golds and heavy ornamentation to create a hieratic and imposing image (pl. 74).[79] His design for Loïe Fuller's appearance at the 1900 Exposition universelle relies on a sophisticated range of color and stylized floral forms (pl. 75). In *La Maison Moderne*, perhaps the best poster of his career, Orazi (who also created jewelry for this famous home décor store and art gallery) used a flowing line to describe the forms found in the shop vases, statuettes, and hair ornaments (pl. 73). Here the lettering is perfectly in keeping with the brand of the shop, both in the text at the upper right and in the elegant monogram "LMM" in the background.

THÉOPHILE-ALEXANDRE STEINLEN

Swiss-born Théophile-Alexandre Steinlen (1859–1923) was also among the five poster artists (together with Chéret, Lautrec, Grasset, and Mucha) consistently hailed as masters of the medium in the 1890s. Working in a Realist vein, Steinlen was active as a painter, printmaker, illustrator, and poster designer and was a key member of the artistic circle surrounding the Chat Noir, the *cabaret artistique* that did much to give Montmartre its bohemian character in the 1880s and 1890s. Like Toulouse-Lautrec, Steinlen made posters for many of the entertainments of Montmartre, and the two artists' careers were complementary, with performers preferring one or the other artist depending on the assignment. Cabaret sensation Aristide Bruant hired Lautrec for his posters (pls. 89, 90) and Steinlen for the cabaret's journal and his song sheets. Café-concert performer Yvette Guilbert rejected Lautrec's proposed design, claiming it made her too ugly (fig. 17), and turned to Steinlen instead, who endowed the performer with a statuesque grace (pl. 79).[80]

Figure 17
Henri de Toulouse-Lautrec
Yvette Guilbert, 1894
Charcoal heightened with *peinture à l'essence*
73 3/16 × 36 1/2 in.
Musée Toulouse-Lautrec, Albi

In the early 1890s, Steinlen's posters became icons in the city, beginning with his famous design for sterilized milk that featured his daughter, Colette, and three of the Steinlens' housecats (pl. 80). This image was printed in a run of ten thousand sheets. It was seen throughout the city and was beloved by Parisians. With his advertisement for Compagnie Française des Chocolats et des Thés the next year, he again included a cat and Colette, who protectively guards her cocoa from the feline (pl. 81). In Steinlen's treatment, the tender comforts of home and childhood are rescued from sentimentality by his firm draftsmanship, bold color schemes, and overall decorative harmony. He applied this same harmony of design in his chef-d'œuvre, a mural-sized *affiche* advertising the poster printer Charles Verneau (pl. 83, proof before letters). Steinlen marshaled fifteen figures (again including Colette, at center) to depict a typical street scene in Paris, including a nurse with a baby, a laundress toting a heavy basket, a milliner, a bourgeois matron, a top-hatted gentleman, an errand girl, and laborers, among others. It was quickly hailed as a masterpiece; F. Fiérens-Gevaert, writing in *Art et décoration*, called it "a composition without peer and without precedent" and the best example of *l'art démocratique* of the poster.[81]

Ironically, Steinlen is perhaps best known for a work that is, in many ways, an anomaly in his poster œuvre, more sinister than wholesome (pl. 82). The scruffy black cat of *Tournée du Chat Noir* (no plump housecat of the pure sterilized milk poster, he!) is surrounded by a halo bearing the words "Mont Joye Montmartre," referring to the illicit pleasures promised in Montmartre, and at the Chat Noir cabaret in particular. By the time the poster was made in 1896, the once outrageous and artistic Chat Noir cabaret had become more conventional, and the owner, the inimitable Rudolph Salis, was taking his troupe on tour to the provinces. Salis, a crafty and brilliant businessman with an outsized ego to match, was fiercely proud of the *cabaret artistique* he had founded; it was only when he became ill and could no longer perform with the company that the word *avec* (with) was pasted over with a scrap of paper that reads *de* (of, or belonging to), so the text becomes "Tour of the Chat Noir *of* Rodolphe Salis."

CAPPIELLO AND THE FIRST POSTERS OF THE TWENTIETH CENTURY

The man who best bridged the gap between the vast variety of styles of the 1890s and the new era of the twentieth century was Italian-born Leonetto Cappiello (1875–1942). Cappiello's early designs retain the visual language of the fin de siècle—women selling products, a lively whiplash line, and bright, eye-catching colors—but with his mature posters, Cappiello adhered to a greater simplicity, incorporated an element of surprise, and drove the movement to a more modern approach to design. As poster historian Jack Rennert summed up, Cappiello's synthesis created a new style entirely, one that "denied, surpassed, and eventually destroyed the past: simplification that obliterated all the elaborate ornamentation of Art Nouveau, clarity of vision that obviated the necessity for painstaking details of the pictorial style, and single-mindedness of purpose that eliminated the need for allegorical allusions and mythological references."[82] Cappiello's first poster for the humor magazine *Le Frou-Frou* is exemplary of his transitional style (pl. 12). On an unmodulated egg-yolk yellow background, a *parisienne* bedecked in gray ruffles, with coral-red bloomers, and wearing a plumed hat kicks up her legs. He depicted the *gaieté* and humor promised by the journal (which the woman holds aloft) while stripping out any distracting details. Restricted to just three colors (gray, yellow, and coral) plus black, he introduced a range of textures and effects by using a fine comb to create ribbing on the dancer's stockings, and a rain of orange and blue-gray spatter to pattern her yellow hair.

The element of surprise was also a hallmark of Cappiello's style. M. P. Verneuil compared the Italian poster designer to Chéret, writing that while Chéret "operates by charm," Cappiello attracts and retains attention by the "unexpected and bizarre," a comment apropos of Cappiello's watershed poster of 1903 (pl. 14).[83] In this fantastical image, a woman riding a red horse advertises Klaus chocolate. Nowhere is the product depicted, and no explanation for the green-clad woman or the airborne horse is supplied; it is pure non sequitur, an example of proto-surrealist pairing that created a highly successful image association in the minds of viewers. In a 1907 interview, Cappiello acknowledged the disjunction between sign and image, referring to his

composition as a "comique mathématique." He also recounted its success: "The green lady became an obsession, but I'd estimate that she achieved her goal, since the company's obtained results were conclusive and they discovered that many buyers were asking for 'Red Horse' chocolate."[84] The simple pairing of object and image, without distracting detail, was a formula Cappiello perfected. Even where there was little relationship between the picture and the product (as in *Chocolat Klaus*), the visual associations he forged served the products well.

Cappiello's designs also stood out for their sheer size. In *Automobiles Brasier*, the billboard-sized image overwhelms by not only its dimensions but also its intense hues of yellow, orange, green, and fuchsia swirling around the speeding automobile (pl. 17). This poster, created just seven years after Chéret's poster for Pippermint liqueur (pl. 44), belongs to another century in both chronology and style; it feels worlds away from the Rococo fantasyland of the man who brought the *affiche artistique* into existence.

THE ART OF COMMERCE

The poster, with its accolades, *affichomaniaques*, and astonishing array of styles, was, at heart, a commercial agent. Just as there was no single definitive poster style, there was no one accepted stance or strategy about the business of marketing. The poster industry, while in full bloom, was not highly systematized, and the science and psychology of advertising—how to gain viewers' attention and influence their consumption patterns—had not yet been perfected or codified. Rather, a heterogeneous mixture of attitudes and approaches for merging art and advertising marked the 1890s.

The *affiche artistique*, poised as it was at the intersection of commerce and art, presented many problems for those who sought to elevate the *affiche* into the canon of art history. Poster apologists struggled with the issue of commerce, offering up a gamut of responses that ran from eliding the existence of business interests entirely to complaining that the artists of the *affiche artistique* were, in fact, very poor advertisers. Ernest Maindron, the poster's greatest defender

and champion, represents one pole. He was never comfortable with the commercial aspect of the poster and omitted it entirely from his first major article on posters, published in the *Gazette des Beaux-Arts* in 1884. He focused his judgment of posters on their elegance of line, simplicity of composition, and sophisticated coloration, without reference to the objects or entertainments they sold.[85] As art historian Marcus Verhagen has written, Maindron saw the poster as everything *but* an advertisement; it was "a collector's item, a modern fresco, a learning aid, a vehicle for *la gaieté française*. It served too many different purposes, and in his breathless search for further justifications Maindron betrayed a certain nervousness…. He even suggested that its promotional function was purely incidental. 'Advertising,' [Maindron] wrote, 'is just a pretext,' a way of reaching a wider audience."[86]

Charles Hiatt, an Englishman based in London, was one of the most vocal commentators on French posters. His stance on commerce and art occupied a middle ground: a willingness to discuss the commercial role of the poster, but a far greater preference for and comfort with the artistic side. A good example can be found in Hiatt's treatment of Mucha's posters. Hiatt praised the artist's work for the subtlety of coloring and richness of detail. He acknowledged that such traits did not make his posters particularly powerful in the "battle of the hoardings" in which the brashest designs were sure to win. Thus, the more refined the art, the less successful the commercial design. One of Mucha's superb theater posters of Sarah Bernhardt, for example, "would simply be killed by its less august and refined neighbours," Hiatt conceded, a backhanded compliment that pays Mucha sly tribute for his artistic elegance while denigrating the other commercial posters next to which it appeared. He concludes, perhaps wryly, "The fact that you can make agreeable fire screens of the Sarah Bernhardt posters itself proves their unfitness for their avowed purpose of mural advertisement."[87]

Others judged a poster for its ostensible purpose—selling—and found the acknowledged masters greatly lacking. Critic and novelist Lucien Muhlfeld, writing in *L'Affichage moderne*, accused Lautrec's posters of being poor advertisements, images that did not advertise anything and were therefore "commercially useless."[88] Henri Bouchot,

curator of prints at the Bibliothèque Nationale de France, went further, admonishing artists to remember the poster's "practical purpose." In his 1898 article, he examined the top poster artists of the day and took the "king of the poster," Jules Chéret, to task, writing that "Chéret, in dribs and drabs of blues and yellows, [produces] an eternal chorus of Mimi Pinsons singing their similar verses for the most diverse things…. Without the letters of the poster, we would not easily grasp why these undressed people dance their bolero in front of a box of Géraudel [cough drops]." He chastised the posters of Mucha—"with their golds, their women with layered hair, their interesting search for the unusual and the improbable"—with "homogenizing and banalizing" their subjects and thereby "failing their obligations."[89] On the occasion of the appearance of Chéret's latest poster for the bal de l'Opéra, an article in *L'Estampe et l'affiche* noted the redundancy of his designs. In that case, the author blamed the entrepreneur who required that Chéret repeat his formula, rather than the artist himself.[90]

Interestingly, artists seemed to be less squeamish about the mixture of commerce and art than collectors or historians. Henri-Gustave Jossot addressed the advertising question directly in *L'Estampe et l'affiche*, reminding his fellow artists and *affichomaniaques* that posters are made not for collectors, but businesses, since "it is for the merchant or industry that the advertisement is made. It is he who commissions it and who pays." Jossot asserted that a poster was not the same as a fine art print, nor should its primary purpose be to simply please its audience. Instead, "The poster on a wall should howl, it should violate the gaze of the passerby." Referring to his large poster for Jockey-Club sardines (pl. 63), he bragged that his "noisy colors" and the "grotesque drawing pushed almost to the point of monstrosity" arrested viewers in their tracks: "The pedestrians, at first flabbergasted as if they had received a punch in the stomach, stop and look at it, that's what's essential."[91] This is not to say that Jossot always took the side of the businessman; in that same article, he complained that too often entrepreneurs spoiled the artist's work.[92] Toulouse-Lautrec got around the problem of the entrepreneur by funding many of his own posters. Like Jossot, Lautrec displayed no aversion to posters qua posters. Nor did he trouble himself

about the status of the poster, or struggle to elevate the artist from craftsman. Contemporary Théodore Duret noted that "Lautrec never recognized conventional restrictions, such as the distinction between fine art and industrial art." Chéret, too, accepted the commercial role of the poster; he commented that the designer, in addition to being a well-trained artist, also "needs to be a psychologist," a trait Chéret evinced with his use of seductive women to sell products. [93]

SELLING STRATEGIES AND THE WOMEN OF THE POSTERS

Despite the lack of consensus on what made for a good, commercially viable poster, there was more agreement on the French style and modes of selling. The French manner was, in many ways, largely defined by what it was not: American. American posters and publicity in general—especially as embodied in the work of P. T. Barnum and his famous circus—were considered gauche in the extreme, so much so that "barnum" became a disparaging term. Édouard Detaille, writing in *La Plume*, praised the work of French artists while hoping that their posters would make the "dreadful colorings of the English and American barnums" disappear forever from French walls.[94] Jules Chéret also professed a strong aversion to American posters: "I have always avoided the American style of advertising, for it appears to me to be hideous."[95]

The French poster, on the other hand, was considered (at least by the French) decorative, harmonious, and full of the *gaieté française*, a natural outgrowth of the French character. Overt commercial come-ons were to be avoided; instead of assaulting the viewer with the product in question, French poster designers (with the exception of a rare few, such as Jossot as just mentioned) favored a more narrative or implicit style that required the viewer to interpolate the meaning of the image.[96] Talmeyr characterized the French poster as subtle and full of innuendo. W. S. Rogers, a frequent commentator on British and French posters, referred to this as a certain "reticence" that "consists in leaving something for the imagination of the spectator to supply." Hiatt claimed that Lautrec's posters brought one to a standstill "until the significance of the legend has been mastered."[97] Wit, a certain lightness, and, at times, irony were the key factors.[98]

Charlotte Wiehe. 5132

Figure 18
Unknown artist
Postcard of
Charlotte Wiehe,
ca. 1906
Gelatin silver print
5 7/16 × 3 7/16 in.
Private collection

construction, the most celebrated stage actors of the day are assembled and carrying packages of Ferrari noodles (pl. 15). Aside from celebrities, men of the posters were in short supply.[101]

Images of women were the overwhelming motif in advertising. Young women were deemed appropriate to show how easily a new consumer product could be mastered, as seen in Steinlen's advertisement for motorized bicycles (pl. 86), or how much joy an item might bestow on the purchaser (as is apparent in the bliss-filled face of the *chérette* enjoying Saxoléine lamp oil, pl. 45). But it was the sexually desirable woman—generally young, lightly clad, and beautiful—that formed the crucial element of the French *affiche artistique* and its commercial and artistic appeal. In other words, sex sells, then as now. An article in *American Advertiser* quoted at length in the inaugural issue of *La Publicité moderne* points to two quintessentially French elements—the use of women to sell all manner of products, and divorcing the subject of the poster and the object for sale:

> Ordinarily the principal subject is a woman as pretty and suggestive in her pose and her clothing—or her absence of clothing—as an artistic master like Chéret, [Adolphe] Willette, or Albert Guillaume knows how to make. She rests from her fatigue day and night, depending on the season, arranging her diamond clasp or her garter, or spreading her luxurious hair in front of a mirror, thereby leaving no doubt about her charming form from whichever side we contemplate her. In America, a painting of this genre would seem, after examination, related to corsets or underwear. In France, it is an invitation to drink Alphonse absinthe or eat Gaston cookies.[102]

The ultimate sex symbol of the poster was the *chérette*, the smiling, endlessly gay and provocative young woman created by Chéret.[103] The *chérette* pervaded his posters from the late 1880s to the end of his career and was said to be based on the likeness of Danish actress Charlotte Wiehe (fig. 18). The *chérette* quickly became the object of great desire, even mania; critics wrote endlessly about her seductive charms and praised her as the quintessential *parisienne*. She was, in the

In this era before the codification of advertising tactics or the science of psychological influence, a variety of strategies and visual tropes were popular. Children and animals, perennial favorites, were used to promote sterilized milk (pl. 80) and cookies (pl. 13), for example, and had the advantage of naturalizing the act of mass consumption and making it seem, as art historian Karen L. Carter has written, "as if consumer choices were influenced only by an instinct common to all species…and not fueled by advertising campaigns or determined by social circumstances."[99] The celebrity endorsement was another marketing approach gaining momentum in this era, one wittily employed by Jossot in *Sardines Jockey-Club* (pl. 63), in which all manner of celebrities of the stage and politics gather to eat sardines right out of the can: *diseuse* Yvette Guilbert, famed *tragédienne* Sarah Bernhardt, and cabaret sensation Aristide Bruant sit side by side with legendary politician and journalist Henri Rochefort (center) and notorious politico Sidi-Ali Bey (at left).[100] In Cappiello's

eyes of many critics, elegant, teasing, and graceful, a "creature full of charm and exquisite grace," in the words of architect Frantz Jourdain.[104]

Many writers saw the *chérette* in a decidedly sexual vein. Among the most effusive odes to the sensuality of the *chérette* was that by art critic René Dubreuil. In language that reaches a frenzied pitch, Dubreuil described the "paradise" Chéret created with his posters: "And what a paradise! Populated with such women! Oh! Chéret's women!" He lauded the *chérette* as "a nervous woman who cries and laughs at the same time with her eyes and her lips"; she is "hysterical, crazy, with an exquisite body, arched and exposed."[105] The use of these terms is not accidental; at the time, the medical establishment believed excess sexual stimulation to be the cause of hysteria, and there was a strong assumed association between nervous conditions and prostitution.[106] Other writers used these terms to describe the *chérette* as well; Georges Rodenbach called her a "trophy of nerves."[107] Excessive joy and an arched body implied the *chérette*'s hysteria and nervous sexuality, which Chéret was skilled at both hiding and revealing. As Dubreuil notes, Chéret was a master *costumier*, clothing the *chérette* in simple yet seductive outfits, such as "a titillating tutu from which emerge two crazy and nervous legs; a bodice made from a hint of transparent cloth that allows one breast to escape and lets the other be easily glimpsed." Félix Fénéon got straight to the point: "The female types on his posters are very plump; they grind their asses, stick out their tits and grin from ear to ear." She was, in the words of Georges d'Avenel, "half fairy princess and half streetwalker."[108] The Rococo sensibility thinly veneered to this sexualized being transposed her into a fairy princess, thereby helping Chéret escape trouble with the censors. A vapid, endlessly reproducible motif, she was a perfect cipher for mass consumption.

The *chérette* was by far the leading lady of the poster, if not only for her physical charms, but also by sheer numbers. Chéret was the most prolific designer at the time, having produced hundreds of posters by 1893, when Dubreuil's words were written. But she was not the only woman used by designers to sell bicycles, dance halls, and lamp oil. Ernest Maindron compares the women of the poster, handily summing up the types, from the medieval maiden of Grasset,

"haloed and inspiring nothing but respect," to Chéret's saucy *chérette* "full of graces and seductions...a woman skilled in the art of pleasure."[109] Significantly, the Art Nouveau temptress of Alphonse Mucha was a latecomer to the scene, debuting around 1896 in posters such as *Salon des Cent* (pl. 69) and, thus, postdating these comments. In many ways, she combined the historical remove of the Grasset maiden with the sexual allure of the *chérette*. Soon, the "Mucha girl" was almost as familiar a sight.

The women of Toulouse-Lautrec's posters occupied another world. Maindron described Lautrec's typical poster girl as a woman who "no longer believes in anything, she is overwhelmed with weariness, she has seen all, she knows all."[110] Lautrec's knowing, jaded female type represents the opposite extreme of the *chérette*. Where the *chérette* was gleeful, smiling, and anonymous, Lautrec's women were almost always based on distinct personalities such as the dancers La Goulue, Jane Avril, and May Milton. He accentuated their individuality, heightening rather than glossing over their flaws, and rendered powerful, but not pretty, portraits of these performers. Even when he was depicting a fictional character such as the courtesan in Victor Joze's novel *Reine de Joie* (pl. 88), he created a believable individual instead of a Grasset maiden, an Art Nouveau goddess *à la* Mucha, or a *chérette*. Critics used a language of decadence when writing about Lautrec's women, describing them in terms that seem unflattering to readers today but that, then, signaled sophisticated debauchery. Frantz Jourdain, who greatly admired the mordant eye of Lautrec, praised the artist's image of Jane Avril in *Divan Japonais* (pl. 92), describing her as "a delightfully svelte spectator with a keen expression, provocative lips and a tall, slender, adorably licentious body. How elegant she is, this delightfully nervous and neurotic creature, exuding artistic corruption and unhealthy grace." Octave Uzanne reiterated this theme, referring to her as "a modern aesthete, half morphine-addict and half consumptive."[111] Lautrec amplified the decadent and corrosive effect with his use of color; his favorite ink for the keystone was not black but what critics dubbed "goose-shit green." Lautrec's women were also a successful selling strategy, albeit in a very different way than the *chérette*: for although they appealed to a smaller segment of the population, the ladies

Figure 19
Alexandre Cabanel
The Birth of Venus,
1863
Oil on canvas
41¾ × 71⅞ in.
The Metropolitan
Museum of Art,
Gift of John Wolfe,
1893

of Lautrec's posters were highly regarded by the Decadent writers and the bohemian world of Paris, precisely the audience he sought to reach in his *affiches.*

Women — whether Chéret's gay sprites, Mucha's languorous maidens, or Lautrec's decadent femme fatales — dominated the billboards. There was, nevertheless, a counter discourse that positioned women as agents rather than objects. Steinlen, in his advertisement for *Motocycles Comiot* (pl. 86), promoted the freedom that bicycles offered women; Jane Atché advanced the "new woman" as one who indulged in the previously forbidden pleasure of smoking (pl. 1); and both Maxime Dethomas and Georges de Feure depicted the sites to which autonomous, smartly dressed women might visit with the guidebooks advertised in the posters (pls. 49, 50). Women also exercised power as consumers, as portrayed in Steinlen's domestic scene of a mother serving her daughter cocoa (pl. 81), or the elegant female shopper in Cappeillo's *Paquet Pernot* (pl. 16).[112] Despite a handful of examples, though, it was the seductive female who ruled advertising.

CENSORSHIP AND SEX

Given the prominence of posters on the streets of Paris, the government sought to control and censor images it deemed inappropriate. The Press Law of 1881 removed the restriction that posters be approved prior to posting, but they were still subject to censorship once on public view.[113] To our contemporary eyes, it is difficult to determine which posters were considered scandalous to the censors, critics, and public of the 1890s, and for what reasons. Paging through the plate section of this catalogue, the reader might surmise that Henri Gray's erotic *Pétrole Stella* poster would have been regarded as objectionable (pl. 55). To convey the attractive qualities of Stella oil, Gray depicted a nude woman endowed with moth wings who is drawn to the warm light the oil produced. Her arms are akimbo behind her thrown-back head, thereby lifting her breasts into full view, while the light cast by the Stella oil bathes her body in a warm, coral glow. Pal's *affiche* for Rayon d'Or is in a similar vein, in which the light of the gas lamp caresses the marmoreal nude body of another moth-woman (pl. 77). Yet nude women in the guise of goddesses or mythological creatures did not alarm the censors, presumably because the depictions were drawn from classical sculpture or popular academic painting. Gray, for instance, took the pose for his moth-woman directly from the work of academic painter Alexandre Cabanel, whose erotic classical goddesses populated the state-sponsored Salons (fig. 19). Thus, innumerable nude goddesses and minor deities were deployed to sell products, and particularly bicycles, as seen

Figure 20
Weiluc
(Lucien-Henri Weil)
Le Frou-Frou, 1900
Color lithograph
62 ⅛ × 43 ½ in.
Private collection

in *Cycles Gladiator* by an unknown artist (pl. 104), *Cycles Sirius* by Henri Gray (pl. 56), and *Déesse* by Pal (pl. 78).

The contemporary viewer looking for censor-worthy material might also point to Weiluc's poster for the illustrated journal *Le Frou-Frou* (fig. 20). Here a sloe-eyed beauty lifts her skirt for a full view of her white petticoat, black-stockinged legs, and garter belts, placing her sex (not depicted) at the center of the composition. To further the erotic associations, she holds a cigarette in her right hand, the smoke of which forms the lettering of the title. Though becoming somewhat more common in posters, a woman smoking a cigarette was still considered scandalous, and such portrayals were often reserved for women at the margins of society: actresses, prostitutes, and the growing leagues of "new women" exercising their expanded social rights. The cancan girl of *Le Frou-Frou*, when compared to Atché's smoking woman, is surely not an emancipated "new woman," but she also did not provoke censure (pl. 1).[114] Similarly, one might

suspect that work by Toulouse-Lautrec—rife with masturbatory imagery and the ever-present erect cane, staff, or thumb—would elicit censorship, but his posters sailed past the censors without comment, even if the sexual innuendo was well noted (and appreciated) by critics.[115]

Despite the thriving discourse about the affront to public morality that posters presented, actual censorship in France was, in fact, somewhat rare. One artist targeted by the censors was Alfred Choubrac, who was charged in 1891 with *outrage aux bonnes mœurs* (insult to public decency) for two of his designs.[116] Today, Choubrac's *affiches* appear no more erotic than Chéret's lightly clad *chérettes* or the nude goddesses of the bicycle merchants; in fact, his poster for the periodical *Fin de Siècle* featured a *chérette*-esque woman seated on a crescent moon (pl. 46). The censor found it obscene and denied permission to post the image. Choubrac, who must have possessed a keen sense of humor, capitalized on the situation, reprinting the poster and covering the offending section with the words "this part of the drawing was censored" (pl. 47), which had the effect of drawing even greater attention to the poster and increasing public curiosity. Choubrac furthered the joke by printing, at his own expense, a poster advertising fig leaves that could be used to cover the offending bits of illustrated posters. Both the censored and uncensored versions became collectors' items, and in 1896, impressions fetched no less than fifty francs, more than twenty times the amount for which his posters generally sold.[117] Choubrac's poster for performer Ilka Demynn, in which she wears a body stocking and is lightly draped with a transparent veil, was also suppressed in 1891. After sifting through the critical discourse, art historian Karen L. Carter found that Choubrac's biggest crime in the eyes of his contemporaries was lack of talent. While Chéret's *chérette*s were also nearly nude, or draped only in transparent bits of fabric, they slipped past the censors due to the artist's technical ability. As Carter relates, critics "maintained that the condemned posters were hardly 'scandalous,' but were merely guilty of presenting mediocre designs that depicted women in a clumsy and inept manner."[118] Chéret himself, though beloved in France, apparently did not always pass by the English censors. In an interview with Charles Hiatt in May 1900, Chéret

mentioned that in England some of his designs had been deemed indelicate or indecent, a fact that pained him greatly.[119]

Paradoxically, one of the champions of the poor and downtrodden, and a man who never resorted to titillation in his posters—Théophile-Alexandre Steinlen—found himself in the midst of a censorship battle. In 1899 he was commissioned to design a poster advertising Jean-Louis Dubut de Laforest's novel *La Traîte des Blanches* (The White Slave Trade), a sensational tome that discussed how orphans, naïve young women from the provinces, and abandoned girls were sold into prostitution (pl. 84). Dubut de Laforest and the editor of *Le Journal* (where the novel was first serialized before being published by Fayard in 1900) were brought before the courts to defend the book. Both men were acquitted, but the controversy continued with the suppression of Steinlen's work. The artist's first version of the poster includes one woman with bare breasts. The Préfecture of Police refused the poster, and Steinlen was forced to amend it, covering her breasts with a chemise (fig. 21). Compared to other images of women discussed here, this seems extreme, but it is likely that the furor over the novel itself had raised sensitivities to the point where the prefect was responding more to the uproar over the novel and the contemporary discourse on the white slave trade than to Steinlen's none-too-erotic poster.[120] Contrary to the censor's intentions, collectors immediately searched for the first, unaltered version of Steinlen's poster; then, as today, *affichomaniaques* sought both images for their collections.[121]

FIN DE SIÈCLE, *FIN DE L'AFFICHOMANIE*

By the end of the 1890s, there were hints that posters were falling out of favor, at least in some quarters. Even as productions such as *Les Maîtres de l'affiche* that celebrated the best posters of previous decades were launched, critics were lamenting the decline in quality of contemporary posters. In 1899 art historian Charles Crauzat bemoaned that the contemporary poster was "bankrupt," had "plunged into the doldrums," and was "progressing in an inverse sense." "One is heart-broken," he wrote, "to see the lack of inspiration and the poverty of execution; not a breath of wind could stir any intelligence; no shock could produce any spark of genius."[122] Multiple factors brought about the end of this

first golden age of the poster. After 1895 Chéret made very few posters in order to devote himself to decorative projects.[123] Léon Deschamps, the force behind the influential Salon des Cent exhibitions, died in 1899; Henri de Toulouse-Lautrec died just two years later. By 1900 Grasset had largely ceased making posters, and Mucha spent most of the years 1904–10 in the United States. In addition to the loss of the top practitioners and their promoters, early poster enthusiasts and arts reformers such as Ernest Maindron and Roger Marx grew disenchanted with posters; they had hoped the *affiche* would bring about a liberating art for the people. Instead, as historian Miriam Levin explains, Maindron, Marx, and others saw the poster subsumed as "part of a new, highly commercialized industrial world in which it

Figure 21
Théophile-Alexandre Steinlen
La Traîte des Blanches, 1899
Color lithograph
73⅜ × 48½ in.
Milwaukee Art Museum, Gift of Seidel Tanning Corporation

served ends completely different from the ones reformers had expected."[124]

The "spectacle on the street" that had begun in the 1880s was starting to wear out its welcome. The proliferation of images, the increasing pace of life, and the crowding of the city all contributed to a type of media and information overload that twenty-first-century readers might understand well. The spectacle no longer charmed and entertained, but confronted and annoyed. Maurice Talmeyr, whose quote opened this essay, found the spectacle of the street a nuisance; he decried the aggressive and ubiquitous presence of posters in the city, pointing out characteristics that made the poster modern but also objectionable. He asserted, "Nothing is really of a more violent modernity, nothing dates so insolently from today [as] the illustrated poster, with its combative color, its mad drawing and fantastic character, announcing everywhere in thousands of papers that other thousands of papers will have covered over tomorrow, an oil, a bouillon, a fuel, a polish or a new chocolate."[125] The rapid cycling of products, the violent and insolent quality of the poster, and the frenetic pace of everyday life were taking their toll.

Furthermore, the turn of the century was a period of transformation in how publicity and poster advertising were handled. The rich diversity of the *affiche artistique* gave way to the more systematic mode of advertising and persuasion. Historian Marc Martin has noted how the science of publicity entered a professionalized phase in the early years of the new century. Monthly advertising journals such as *La Publicité*, *La Publicité française*, and *Atlas* were all inaugurated in the first decade of the twentieth century, establishing industry standards. These were followed by publicity manuals including J. Arren's *La Publicité lucrative et raisonnée* (1909) and Désiré-Constant-Albert Hémet's two-volume treatise *Traité pratique de publicité commerciale et industrielle* (1912).[126] Dufayel began conducting market surveys and selling the results to merchants who sought to pinpoint the demographics of their target audiences.[127] Increasingly, poster artists came from the ranks of the new breed of graphic designers and architects, and products were launched by firms that pursued a unified branding campaign that considered all aspects of messaging, from logo to lettering to copy. This highly organized system launched a second golden era of French posters in the 1920s as seen in the art of A. M. Cassandre (fig. 22). But it was the rich free-for-all that characterized poster design and advertising of the 1890s that created the spectacle in the streets and the first flowering of the *affiche artistique*.

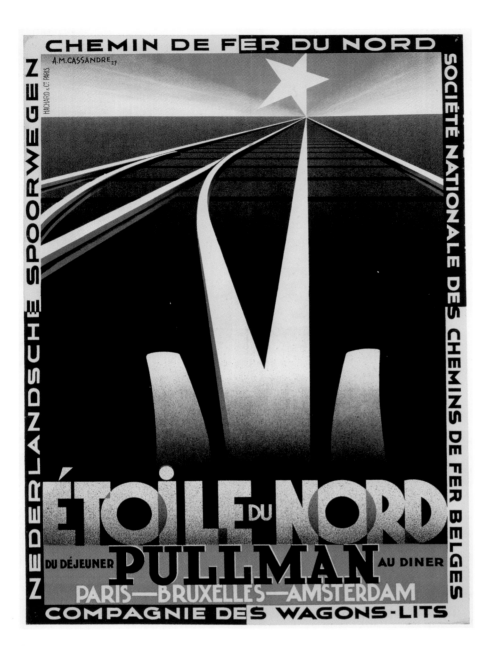

Figure 22
A. M. Cassandre
Étoile du Nord, 1927
Color lithograph
41 ⅛ × 29 ¾ in.
Milwaukee Art
Museum, Gift of Mr.
Philip Miller

1 Maurice Talmeyr, "L'Âge de l'affiche," *Revue des deux mondes*, September 1, 1896, p. 201 (emphasis added).

2 Ibid., pp. 204, 202; Georges d'Avenel, *Le Mécanisme de la vie moderne* (Paris: Librairie Armand Colin, 1902), p. 162.

3 Raoul Sertat, "Merci à Chéret!" *La Plume*, November 15, 1893, p. 501.

4 Joris-Karl Huysmans, *Certains* (Paris: Tresse & Stock, 1889), p. 58. Huysmans continued in a rapturous tone, calling Chéret's essence of Paris "a delicious tipsiness of sparkling wine, a fuming tipsiness tinted rose." This sort of embellished language would become a hallmark of the discourse surrounding posters; Georges Rodenbach, *L'Élite: Écrivains, orateurs sacrés, peintres, sculpteurs* (Paris, 1899), p. 251.

5 Noriko Yoshida, "Jules Chéret et la critique d'art, de Roger Marx à Gustave Kahn," in *La Belle Époque de Jules Chéret: De l'affiche au décor*, eds. Réjane Bargiel and Ségolène Le Men (Paris: Les Arts Décoratifs / Bibliothèque Nationale de France, 2010), p. 110.

6 Vanessa R. Schwartz, *Spectacular Realities: Early Mass Culture in Fin-de-Siècle Paris* (Berkeley: University of California Press, 1998), p. 10. Although Schwartz does not discuss posters in depth, her arguments have been very influential to my thinking. I am also indebted to the work of H. Hazel Hahn; see especially Hahn, "Boulevard Culture and Advertising as Spectacle in Nineteenth-Century Paris," in *The City and the Senses: Urban Culture since 1500*, eds. Alexander Cowan and Jill Steward (Burlington, VT: Ashgate, 2007), pp. 156–175.

7 Louis-Sébastien Mercier's *Le Nouveau Paris*, a portrait of life in the city, was published in 1798. For selections, see *The Picture of Paris, Before and After the Revolution*, trans. Wilfrid S. Jackson and Emilie Jackson (New York: The Dial Press, 1929), p. 234.

8 On the bookshop poster, see Bradford Ray Collins, Jr., "Jules Chéret and the Nineteenth-Century French Poster" (PhD diss., Yale University, 1980), chap. 3; and Réjane Bargiel and Ségolène Le Men, *L'Affiche de librairie au XIXᵉ siècle* (Paris: Réunion des musées nationaux, 1987).

9 The term *les grands boulevards* is often used to refer to the new streets planned by Georges-Eugène Haussmann, but historian Vanessa R. Schwartz points out that for Parisians, *les grands boulevards* referred to the eighteenth-century network of streets that predated his transformations. *Spectacular Realities*, pp. 16–18. Hahn also makes this clarification, noting that "Baron Haussmann created a network of wide boulevards modeled on the original set of Grands Boulevards, which, however, remained largely intact, apart from a couple of piercings." "Boulevard Culture and Advertising," p. 159.

10 H. Hazel Hahn, *Scenes of Parisian Modernity: Culture and Consumption in the Nineteenth Century* (New York: Palgrave Macmillan, 2009), p. 149.

11 D'Avenel, *Mécanisme*, pp. 173–174.

12 Except for a brief enrollment in a drawing class at the École nationale de dessin during his teens, Chéret was almost entirely self-taught as an artist, visiting museums with his brother Joseph (who became a sculptor) to educate his eye. On Chéret's early life and art education, see Collins, "Jules Chéret," pp. 54–56, and Anne-Marie Sauvage, "Les débuts de Jules Chéret jusqu'à 1881," in *Belle Époque de Jules Chéret*, pp. 34–75.

13 Bradford Ray Collins, Jr., "The Poster as Art: Jules Chéret and the Struggle for the Equality of the Arts in Late Nineteenth-Century France," *Design Issues* II, no. 1 (Spring 1985), p. 45.

14 Ibid.

15 For a consideration of this first exhibition, see Ségolène Le Men, "L'Art de l'affiche à l'Exposition Universelle de 1889," *Revue de la Bibliothèque Nationale*, June 1991, pp. 64–71; on the Nantes exhibition, see Nicholas-Henri Zmelty, "L'Affiche illustrée en France (1889–1905): Naissance d'un genre?" (PhD diss., Université de Picardie Jules Verne, 2010), pp. 28–32.

16 Author Félicien Champsaur first dubbed Chéret the "roi de l'affiche" in 1885. See Bargiel and Le Men, *Belle Époque de Jules Chéret*, p. 53.

17 As Aaron J. Segal notes, the list "included artists on the margins of official culture such as Albert Besnard and Eugène Carrière, academics such as Jules Dalou, Alfred Philippe Roll, and Albert Ernest Carrier-Belleuse, symbolists such as [Joris-Karl] Huysmans and Félicien Rops, establishment critics such as Arsène Alexandre and Roger Marx, the conservative critic Jules Lemaître and others." "Commercial Immanence: The Poster and Urban Territory in Nineteenth-Century France," in *Advertising and the European City: Historical Perspectives*, eds. Clemens Wischermann and Elliott Shore (Aldershot, Hants, England: Ashgate, 2000), p. 122.

18 Bargiel and Le Men, *Belle Époque de Jules Chéret*, p. 125; Edmond and Jules de Goncourt, *Journal* (Paris: Robert Laffont, 1898), vol. 3, p. 413, entry for April 16, 1890.

19 Sertat, "Merci à Chéret!" p. 501; Charles Hiatt, *Picture Posters: A Short History of the Illustrated Placard* (London: G. Bell and Sons, 1896), pp. 23–24; Huysmans, *Certains*, p. 51; Maillard, "Les Affiches illustrées," *La Plume*, November 15, 1893, p. 485.

20 Jules Claretie, "Quelques opinions sur les affiches illustrées," *La Plume*, November 15, 1893, p. 495.

21 Nicholas-Henri Zmelty, "L'Affiche illustrée: miroir de la modernité esthétique et culturelle en France à la fin du XIX^e siècle," in *Le Salon de la rue: l'affiche illustrée de 1880 à 1910*, eds. Marie-Jeanne Geyer and Thierry Laps (Strasbourg: Musées de Strasbourg, 2007), p. 31.

22 Jean Richepin, "Quelques opinions sur les affiches illustrées," *La Plume*, November 15, 1893, p. 498.

23 Réjane Bargiel-Harry and Christophe Zagrodzki, *Le Livre de l'affiche: The Book of the Poster* (Paris: Éditions alternatives, 1985), p. 14.

24 H. Sevin, "French Billposting — Ancient and Modern," *The Poster*, December 1900, p. 141.

25 Segal, "Commercial Immanence," p. 123.

26 Hahn, *Scenes of Parisian Modernity*, p. 153.

27 Ernest Maindron, "La Publicité sculpturale," *La Plume*, February 1, 1894, p. 41; sandwich-board carriers were the topic of much discussion both in France and abroad. The *femme-sandwich* caused an uproar in London. One French writer reported that authorities were forced to prohibit *femmes-sandwiches* since the women were often subject to harassment and their responses to public teasing caused a scandal. H.-R. Woestyn, "Quelques modes bizarres de publicité," *La Publicité moderne: Revue mensuelle*, September 1907, p. 7.

Two months later in this same periodical, an unsigned article reported the use of *chiens-sandwiches* in London and praised "the devotion and docility of these brave little doggies." "Échos nouvelles," *La Publicité moderne: Revue mensuelle*, November 1907, p. 7.

28 D'Avenel noted in *Mécanisme* (p. 168), that the poorly paid pullers of these carts had little incentive to battle the traffic and often took refuge in side streets or parked their carts and took a nap beneath them. Enough cart pullers must have taken their job seriously, though, because traffic jams were often reported.

29 Philip Huisman and M.-G. Dortu, *Lautrec by Lautrec*, trans. Corinne Bellow (New York: Viking, 1968), p. 91.

30 George Bastard, *Paris qui roule* (Paris: Georges Chamerot, 1889), p. 174.

31 Segal, "Commercial Immanence," p. 123. On mobile advertising, see also Hahn, "Boulevard Culture and Advertising," p. 164.

32 As Parisian critic Paul Duverney recorded, "The appearance of each one of [Chéret's] new posters is always a noted little event in Paris." Duverney, trans. H.-R. Woestyn, "Jules Chéret," *The Poster*, June–July 1899, p. 229.

33 Arsène Alexandre, "French Posters and Book-Covers," *Scribner's Magazine* 17, May 1895, p. 612.

34 Félix Fénéon, "Chez les Barbouilleurs, les affiches en couleurs," *Le Père peinard*, April 30, 1893, reprinted in Fénéon, *Œuvres plus que complètes*, ed. Joan U. Halperin (Geneva: Droz, 1970), p. 231. Fénéon championed the art of the poster over that found in galleries, continuing, "A Lautrec or a Chéret in your house, that's what enlightens, great God! It makes the room an unexpected mess of color and laughter. Sure! Posters make you goddamn dashing. Thus, you can cheaply get yourself a cooler picture than the ugly, badly painted works that make the upper-class assholes rejoice."

35 Alexandre notes that the lowly *afficheur* wielded great power over besotted collectors: "How many great collectors, honorable and honored men, rich and well placed in life, have bowed down before His Majesty the Bill-poster! The paster of posters, realizing a sum which varied with the importance or the vogue of the matter in hand, came to deserve the name of the *un*-paster of posters." "French Posters and Book-Covers," pp. 612–613. Collector W. S. Rogers noted that another method to obtain a desired poster was to write "a politely worded letter addressed to headquarters" and followed by a personal visit, if necessary. "On Poster Collecting," *The Poster* I, no. 4, October 1898, p. 149.

36 Alexandre, "French Posters and Book-Covers," p. 613.

37 D'Avenel, *Mécanisme*, p. 166.

38 Sagot's catalogue of 1891 lists 2,233 posters including deluxe impressions on special papers, proofs before letters, and maquettes.

39 Phillip Dennis Cate gives the context of the cost of living and entertainment at the time in "The Popularization of Lautrec," in *Henri de Toulouse-Lautrec: Images of the 1890s*, eds. Riva Castleman and Wolfgang Wittrock (New York: Museum of Modern Art, 1986), pp. 90–91.

40 Rogers, "On Poster Collecting," p. 150.

41 Alexandre, "French Posters and Book-Covers," p. 613.

42 Sertat, "Merci à Chéret," p. 501.

43 Cited in Bargiel and Le Men, *Belle Époque de Jules Chéret*, p. 27. Charles Hiatt also pointed to this aspect, writing that Chéret's *panneaux décoratifs* and proofs before letters were much improved without the lettering, not just because of the connection to commerce, but also because of clumsy design: "The designs gain immensely, insomuch as they are not disfigured with a legend, for, in

spite of the fact that the disposal of the lettering is of the very essence of a poster, Chéret, for some reason known only to himself, leaves that detail of his work to another designer, with results by no means uniformly fortunate." *Picture Posters*, p. 47.

44 Edmond de Goncourt's journal entry of February 12, 1888, makes note of a dinner party at the home of Paul Bonnetain and remarks that Bonnetain had covered two screens with Chéret's posters. *Journal des Goncourt: Mémoires de la vie littéraire* 7 (Paris: Charpentier, 1894), pp. 241–242. For an illustration of Mucha posters mounted to a folding screen, see Jack Rennert, *Posters of the Belle Époque: The Wine Spectator Collection* (New York: Wine Spectator Press, 1990), n.p.

45 For a list of standard poster sizes, see Jane Abdy, *The French Poster: Chéret to Cappiello* (New York: Clarkson N. Potter, Inc., 1969), p. 171.

46 Alain Weill, introduction to *Masters of the Poster 1896–1900*, by Roger Marx (New York: Images Graphiques, Inc., 1977), pp. 4–5. See also Cate, "The Popularization of Lautrec," pp. 90–91.

47 Phillip Dennis Cate, "Prints Abound: Paris in the 1890s," in *Prints Abound: Paris in the 1890s*, by Phillip Dennis Cate, Gale B. Murray, Richard Thomson (Washington, DC: National Gallery of Art, 2000), p. 30.

48 Karen L. Carter, "L'Âge de l'affiche: Critics, Collectors, and Urban Contexts," in *Toulouse-Lautrec and the French Imprint: Fin-de-Siècle Posters in Paris, Brussels, and Barcelona*, ed. Phillip Dennis Cate (New Brunswick, NJ: Jane Voorhees Zimmerli Art Museum, Rutgers, The State University of New Jersey, 2005), p. 27, note 66.

49 Segal, "Commercial Immanence," p. 123.

50 Hahn, *Scenes of Parisian Modernity*, p. 171; a clipping from the *Washington Times*, December 8, 1895, in *The Collector and the Poster*, 12 illus. newspaper clippings in 2 booklets, Library of Congress, LOT 9601 (f) [P&P].

51 *The Poster* (New York), March 1896, p. 38.

52 Chéret was not alone in his inspiration; beginning in the 1830s, Théophile Gautier and his circle looked to the art of the eighteenth century as a model for the integration of decorative and fine arts into daily life. On the Rococo revival, see Debora L. Silverman, *Art Nouveau in Fin-de-Siècle France: Politics, Psychology, and Style* (Berkeley: University of California Press, 1989), and Carol Green Duncan, *The Pursuit of Pleasure: The Rococo Revival in French Romantic Art* (New York: Garland Press, 1976); on Chéret and aims of the Rococo revival, see Collins, Jr., "The Poster as Art," pp. 41–50.

53 Félicien Champsaur, "Le Roi de l'affiche," *La Plume*, November 15, 1893, p. 481.

54 On the dating of *Les Girard*, see Bargiel and Le Men, *Belle Époque de Jules Chéret*, p. 160, pl. 198.

55 J.-K. Huysmans recorded his impression of this theater troupe and Chéret's poster, writing, "Who can forget the incomparable gaiety of Chéret's Agoust conducting the Hanlon Lees in *Do mi sol do*? This man in vermillion tights, nodding his pear-shaped head, crowned with two tufts of hair, his eyes starting from their sockets, his mouth contorted by a lunatic laugh to the shape of a horse-shoe, conducting a mad orchestra, above which a miniature train flashed past like a rocket. Agoust seemed almost satanic in this drawing in scarlet on a greenish background carelessly spotted with ink, the whole surmounted by brilliant white letters outlined in black." Huysmans, "Chéret,"

first published in *Certains*, translated and reprinted in *The Poster*, 1902, p. 52.

For a history of the Hanlon troupe, see John A. McKinven, *The Hanlon Brothers: Their Amazing Acrobatics, Pantomimes and Stage Spectacles* (Glenwood, IL: David Meyer Magic Books, 1998), and Mark Cosdon, *The Hanlon Brothers: From Daredevil Acrobatics to Spectacle Pantomime, 1833–1931* (Carbondale: Southern Illinois University Press, 2009).

56 In Manet's composition, the poster is hung in the window of the brasserie, facing the street, so the letters are seen from the interior in reverse. Conservation analysis reveals that the poster is depicted in real size, indicating that Manet owned a copy of the *affiche* and traced the image and lettering onto his canvas. Juliet Wilson-Bareau, "Édouard Manet's *Reichshoffen*: The Hidden Story," in *Division and Revision: Manet's Reichshoffen Revealed*, by Juliet Wilson-Bareau and Malcolm Park (London: Paul Holberton, 2008), p. 49.

57 See Robert L. Herbert, "Seurat and Jules Chéret," *Art Bulletin* 40, no. 2 (June 1958), pp. 156–158; and Ségolène Le Men, *Seurat & Chéret: le peintre, le cirque et l'affiche* (Paris: CNRS Éditions, 2003).

58 Antoine Terrasse, *Bonnard, affiches et lithographies* (Paris: Fernand Hazan, 1970), n.p.

59 Helen Emery Giambruni, "Early Bonnard, 1885–1900" (PhD diss., University of California, Berkeley, 1983), p. 82. The art of Paul Gauguin, which Bonnard had first seen in 1889, with its deliberate naiveté and simplicity, was another source of inspiration.

60 Francis Jourdain, quoted in Claude Roger-Marx, *Bonnard lithographe* (Monte Carlo: André Sauret, 1952), p. 16.

61 Thadée Natanson, trans. in *Toulouse-Lautrec: A Retrospective*, ed. Gale B. Murray (New York: Hugh Lauter Levine Associates, 1992), p. 138. Lautrec's discovery of Bonnard's poster was fortuitous: Natanson recalls that not many examples of *France-Champagne* were posted, and that Bonnard himself had trouble locating them in the city. For another version of how Lautrec was introduced to lithography, see Gustave Coquiot, who points to Rupert Carabin or Henri-Gabriel Ibels as the artist who influenced that decision. *Lautrec, ou quinze ans de mœurs parisiennes, 1885–1900* (Paris: Librairie Ollendorff, 1921), pp. 169–170.

62 Antoine Terrasse, introduction to *Bonnard: The Complete Graphic Work*, by Francis Bouvet, trans. Jane Brenton (New York: Rizzoli, 1981), p. 5.

63 Colta Ives, "City Life," in *Pierre Bonnard: The Graphic Art*, by Colta Ives, Helen Giambruni, and Sasha M. Newman (New York: The Metropolitan Museum of Art, 1989), p. 109.

64 Note that many of the surviving *Moulin Rouge — La Goulue* posters have just the bottom two sheets of paper and lack the smaller third sheet at the top. Such is the case of the example at the Milwaukee Art Museum; a modern facsimile of the top strip was added in the twentieth century to complete the composition.

65 On Lautrec, celebrity, and the Moulin Rouge, see Mary Weaver Chapin, "Toulouse-Lautrec and the Culture of Celebrity," in *Toulouse-Lautrec and Montmartre*, by Richard Thomson, Phillip Dennis Cate, and Mary Weaver Chapin (Washington, DC: National Gallery of Art, 2005), pp. 46–63.

66 Gustave Coquiot, trans. in Murray, *Toulouse-Lautrec*, p. 137.

67 Charles Hiatt, "Toulouse-Lautrec and His Posters," *The Poster*, May 1899, p. 184. Hiatt makes a similar link between the greatness and the disagreeableness of Lautrec's posters in *Picture Posters* (p. 62), writing that Lautrec's "extraordinary *Reine de Joie*, perhaps the most powerful, and certainly the least agreeable, of his posters, is a statement of fact rather than a criticism."

68 Rodolphe Darzens, *Nuits à Paris* (Paris: Dentu, 1889), p. 78.

69 Richard Thomson et al., *Toulouse-Lautrec* (New Haven: Yale University Press, 1991), p. 286.

70 Fénéon, "Henri de Toulouse-Lautrec et Charles Maurin," *L'En Dehors*, February 12, 1893, reprinted in *Œuvres plus que complètes*, ed. Halperin, p. 217.

71 On Picasso's reliance on the styles of Toulouse-Lautrec, Steinlen, and other members of the Montmartre circle of the 1890s, see Phillip Dennis Cate, "Fumism and Other Aspects of Parisian Modernism in Picasso's Early Drawings," in *Picasso, The Early Years: 1892–1906*, ed. Marilyn McCully (Washington, DC: National Gallery of Art, 1997), pp. 133–141; on the influence of poster artists on Picasso, see also John Barnicoat, *Posters: A Concise History* (London: Thames & Hudson, 1972, 2003), pp. 26–27. Page numbers are to the 2003 edition.

72 Zmelty, "L'Affiche illustrée en France," p. 271. After many years of neglect, Grasset's œuvre is being reconsidered by scholars. See *Eugène Grasset, 1845–1917: L'art et l'ornement*, ed. Catherine Lepdor (Milan: 5 Continents, 2011), and especially the essay by Nicholas-Henri Zmelty therein, "Eugène Grasset, l'autre roi de l'affiche," pp. 67–73.

73 Yves Plantin, *Eugène Grasset, Lausanne 1841–Sceaux 1917* (Paris: Yves Plantin & Françoise Blondel, 1980), p. 1.

74 Hiatt, *Picture Posters*, pp. 48–53.

75 The actress was apparently not satisfied with the appearance of her hair or her likeness in Grasset's poster and demanded that he produce a revised version. Numerous copies of the first version had already been printed, however; the poster exhibited here is the first, rejected version which was, nonetheless, still popular with poster collectors. For an image of the second version, see Hermann Schardt, ed., *Paris 1900: Masterworks of French Poster Art* (New York: G. P. Putnam's Sons, 1970), p. 99.

76 Maindron, "L'Affiche illustrée," *La Plume*, November 15, 1893, p. 477.

77 P. G. Huardel, "A Chat with Mucha," *The Poster*, March 1900, p. 31.

78 Occasionally, Mucha's heavy use of gold and his Byzantine motifs made him the object of jokes; in one notable example, illustrator Adolphe Willette depicted a young girl praying to a Mucha poster, mistaking the woman depicted (selling Meuse beer) for the Virgin Mary.

79 On the opening of the new hippodrome, see Phillip Dennis Cate, "Paris Seen through Artists' Eyes," in *The Graphic Arts and French Society, 1871–1914*, ed. Phillip Dennis Cate (New Brunswick, NJ: Rutgers University Press, 1988), p. 33.

80 In a letter of July 1894, Guilbert implored Lautrec, "For the love of Heaven, don't make me so ugly! Just a bit less! A number of people who came to see me let out barbaric howls when they saw the colour design." It is not known if Guilbert was responding to the maquette illustrated here (fig. 17) or another drawing (now in the Cleveland Museum of Art). On Lautrec's unrealized poster for Guilbert, see Thomson et al., *Toulouse-Lautrec*, p. 328, pl. 97.

81 F. Fiérens-Gevaert, "Un Maître affichiste: Steinlen," *Art et décoration* II, no. 2 (December 1897), p. 22.

82 Rennert, *Wine Spectator Collection*, n.p.

83 M. P. Verneuil, "Cappiello," *Art et décoration* XXII (July–December 1907), p. 194.

84 Quoted in Jack Rennert, *Cappiello: The Posters of Leonetto Cappiello* (New York: Poster Art Library, Posters Please, Inc., 2004), p. 66.

85 Maindron, "Les Affiches illustrées," *Gazette des Beaux-Arts* (December 1884), p. 546.

86 Marcus Verhagen, "The Poster in Fin-de-Siècle Paris: 'That Mobile and Degenerate Art,'" in *Cinema and the Invention of Modern Life*, eds. Leo Charney and Vanessa R. Schwartz (Berkeley: University of California Press, 1995), p. 111.

87 Hiatt, "The Posters at the Advertisers' Exhibition," *The Poster*, June 1900, p. 145; Hiatt, "Sarah Bernhardt, Mucha, & Some Posters," *The Poster*, June–July 1899, p. 240; Hiatt, "Advertisers' Exhibition," p. 146.

88 Cited in Jean Adhémar, *Toulouse-Lautrec: His Complete Lithographs and Drypoints* (New York: Harry N. Abrams, Inc., 1965), p. xxx.

89 Henri Bouchot, "Propos sur l'affiche," *Art et décoration* III, 1898, pp. 115–122; ibid., p. 118.

90 Zmelty, "L'Affiche illustrée en France," pp. 267–268.

91 Henri-Gustave Jossot, "L'Affiche caricaturale," *L'Estampe et l'affiche*, no. 10 (December 15, 1897), pp. 239.

92 Ibid., pp. 238–240.

93 Théodore Duret, *Lautrec* (Paris: Bernheim-Jeune & Cie., 1920), p. 104; Chéret, "The Art of the Hoarding," *The New Review* 60 (July 1894), p. 50.

94 Édouard Detaille, "Quelques opinions sur les affiches illustrées," *La Plume*, November 15, 1893, p. 495. For a discussion of French perceptions of American posters, see Zmelty, "L'Affiche illustrée en France," pp. 201–207. Numerous articles of the time point to the Americans as the most gauche, aggressive, or outlandish of all advertisers. See, for example, Woestyn, "Quelques modes bizarre de publicité," p. 7.

95 Chéret, "The Art of the Hoarding," p. 47.

96 H. Hazel Hahn has referred to this oblique style as a "cinematic sensibility," in which the viewer is invited to complete the visual narrative. "Boulevard Culture and Advertising," p. 169. Hahn further notes that while Anglo-American advertising used repetition to make an impression on the viewer, French advertising, according to critic Octave Uzanne, aspired to be "fantastic and amusing." Ibid., p. 173.

97 Talmeyr, "L'Âge de l'affiche," p. 205; W. S. Rogers, "The Modern Poster: Its Essentials and Significance," *London Journal of the Royal Society of Arts* LXII (January 1914), pp. 186–192, reprinted in *L'affiche anglaise*, by Laurence Bossé, Anne Kimmel, Dominique Negel, Roland Barthes, and Geneviève Picon (Paris: Musée des Arts décoratifs, 1972), n.p.; Charles Hiatt, *The Poster*, May 1899, pp. 183–184.

98 As Susan Sontag has written, these early commercial posters all advertised goods and services that were "socially marginal," that is, luxuries, rather than necessities, and thus lent themselves to a witty treatment. Sontag, "Posters: Advertisement, Art, Political Artifact, Commodity," in *The Art of Revolution* (New York: McGraw-Hill Book Company, 1970), p. x.

99 Karen L. Carter, "L'Âge de l'affiche: The Reception, Display and Collection of Posters in Fin-de-Siècle Paris" (PhD diss., University of Chicago, 2001), p. 195.

100 On the use of celebrities in posters, see Anne-Claude Lelieur and Raymond Bachollet, *Célébrités à l'affiche* (Paris: Conti, 1989); on the symbiotic relationship between Henri de Toulouse-Lautrec and the celebrities he depicted in posters and prints, see Mary Weaver Chapin, "Henri de Toulouse-Lautrec and the Café-Concert: Printmaking, Publicity, and Celebrity in Fin-de-Siècle Paris" (PhD diss., Institute of Fine Arts, New York University, 2002).

101 Men of course did appear in posters but not nearly in the same numbers as women. For a representative sample, see the exhibition checklist in *L'Homme à l'affiche* (Paris: Société des Amis de la Bibliothèque Forney, 1977).

102 "La Publicité en France," *La Publicité moderne*, no. 1 (November 1905), p. 15.

103 On the *chérette*, see especially Marcus Verhagen, "Refigurations of the Carnival: The Comic Performer in Fin-de-Siècle Parisian Art" (PhD diss., University of California, Berkeley, 1994), chap. 3, as well as Verhagen, "The Poster in Fin-de-Siècle Paris," pp. 103–129, and Carter, "Reception, Display and Collection of Posters," chap. 3, partially reprinted in Carter, "Critics, Collectors, and Urban Contexts," pp. 11–14.

104 Frantz Jourdain was the father of Francis Jourdain, quoted earlier. It is likely that Francis, the son, wrote this article, signing the name of his father, Frantz, who was much better known. Jourdain, "L'Affiche moderne et Henri de Toulouse-Lautrec," *La Plume*, November 15, 1893, p. 489. This entire issue of *La Plume* was devoted to the topic of the *affiche illustrée* and contains several articles that discuss Chéret's œuvre and the *chérette*.

105 René Dubreuil, "Sur les 'femmes' de Jules Chéret," *La Plume*, November 15, 1893, p. 493.

106 On hysteria, madness, and prostitution, see, for example, Alain Corbin, *Women for Hire: Prostitution and Sexuality in France after 1850*, trans. Alan Sheridan (Cambridge, MA: Harvard University Press, 1990).

107 Rodenbach, *L'Élite: Écrivains, orateurs sacrés, peintres, sculpteurs*, p. 247.

108 Dubreuil, "Sur les 'femmes',", p. 494; Fénéon, *Le Père peinard*, reprinted in *Œuvres plus que complètes*, ed. Halperin, p. 230; D'Avenel, *Mécanisme*, p. 177.

109 Maindron, "L'Affiche illustrée," *La Plume*, November 15, 1893, p. 478.

110 Ibid.

111 Frantz Jourdain, "L'Affiche moderne," p. 490; Uzanne, cited in Murray, *Toulouse-Lautrec*, p. 245. Interestingly, like the "hysterical" *chérette*, Avril suffered from a nervous condition in her youth and was a patient at the Salpêtrière Hospital in Paris, where neurologist Jean-Martin Charcot pioneered the diagnosis of many disorders. Critics like Jourdain often referred to Avril as "neurotic" and employed a language of madness and nerves akin to the discourse surrounding the *chérette*.

Avril referred to her illness as St. Vitus's dance; it was most likely Sydenham's chorea. See Nancy Ireson, "Dancing in the *Asile:* Jane Avril and Chorea," in *Toulouse-Lautrec and Jane Avril* (London: The Courtauld Gallery, 2011), pp. 43–57.

112 Ruth E. Iskin has written extensively on the subject of female agency in Paris; see especially "Popularising New Women in Belle Époque Advertising Posters," in *"A Belle Époque"? Women and Feminism in French Society and Culture 1890–1910s*, eds. D. Holmes and C. Tarr (Oxford: Berghahn Books, 2005); "The *Flâneuse* in French Fin-de-Siècle Posters: Advertising Images of Modern Women in Paris," in *The Invisible Flâneuse? Gender, Public Space, and Visual Culture in Nineteenth-Century Paris*, eds. Aruna d'Souza and Tom McDonough (Manchester: Manchester University Press, 2006), pp. 234–266. See also Karen L. Carter's discussion of the female consumer in fin-de-siècle posters in "Reception, Display and Collection of Posters," pp. 169–198. For a case study of women consumers, posters, and sewing machines, see Judith G. Coffin, "Credit, Consumption, and Images of Women's Desires: Selling the Sewing Machine in Late Nineteenth-Century France," *French Historical Studies* 18, no. 3 (Spring 1994), pp. 749–783.

113 For an introduction to poster censorship, see Maurice Rickards, *Banned Posters* (Park Ridge, NJ: Noyes Press, 1972).

114 On the female smoker, see Dolores Mitchell, "The 'New Woman' as Prometheus: Women Artists Depict Women Smoking," *Woman's Art Journal* 12, no. 1 (Spring/Summer 1991), pp. 3–9.

115 Lautrec's sexual jokes generally referenced male rather than female sexuality, which may be a reason that they were not deemed inappropriate.

116 On Choubrac and censorship, see Rennert, *Wine Spectator Collection*, n.p. For a detailed case study of censored posters by Choubrac and the critical discourse surrounding the morality of the *affiche illustrée* in general, see Karen L. Carter, "Unfit for Public Display: Female Sexuality and the Censorship of Fin-de-Siècle Publicity Posters," *Early Popular Visual Culture* 8, no. 2 (May 2010), pp. 107–124.

117 Hiatt, *Picture Posters*, p. 146.

118 Carter, "Critics, Collectors, and Urban Contexts," p. 14.

119 Hiatt, "A Morning with Jules Chéret," *The Poster* 4, no. 22 (May 1900), p. 106.

120 The white slave trade was highly topical throughout the end of the 1890s and into the early twentieth century. See Corbin, *Women for Hire*, pp. 275–298. For another artistic treatment of the subject, see André Ibels, "La Traîte des Blanches," *L'Assiette au beurre*, no. 273 (June 23, 1906). Illustrations by Henri-Gabriel Ibels. I would like to thank Christa Story for sharing this reference with me.

121 There is little literature on the Steinlen poster controversy and none in depth. For the basic outline, see Réjane Bargiel and Christophe Zagrodzki, *Steinlen affichiste: Catalogue raisonné* (Lausanne: Éditions du Grand-Pont, 1986), p. 58.

122 Charles Crauzat, "Murailles," *L'Estampe et l'affiche*, no. 1 (January 15, 1899), p. 11, and Crauzet, "Murailles," *L'Estampe et l'affiche*, February 15, 1898, p. 36.

123 On Chéret's decorative projects, see Réjane Bargiel, "Jules Chéret décorateur," in *Belle Époque de Jules Chéret*, pp. 76–107.

124 Miriam Levin, "Democratic Vistas — Democratic Media: Defining a Role for Printed Images in Industrializing France," *French Historical Studies* 18, no. 1 (Spring 1993), p. 102.

125 Talmeyr, "L'Âge de l'affiche," p. 201.

126 Marc Martin, "L'Affiche de publicité à Paris et en France à la fin du XIXe siècle," in *La Terre et la cité: Mélanges offerts à Philippe Vigier*, eds. Alain Faure, Alain Plessis, and Jean-Claude Farcy (Paris: Créaphis, 1994), p. 373, and p. 386, note 1.

127 Coffin, "Credit, Consumption, and Images of Women's Desires," p. 764.

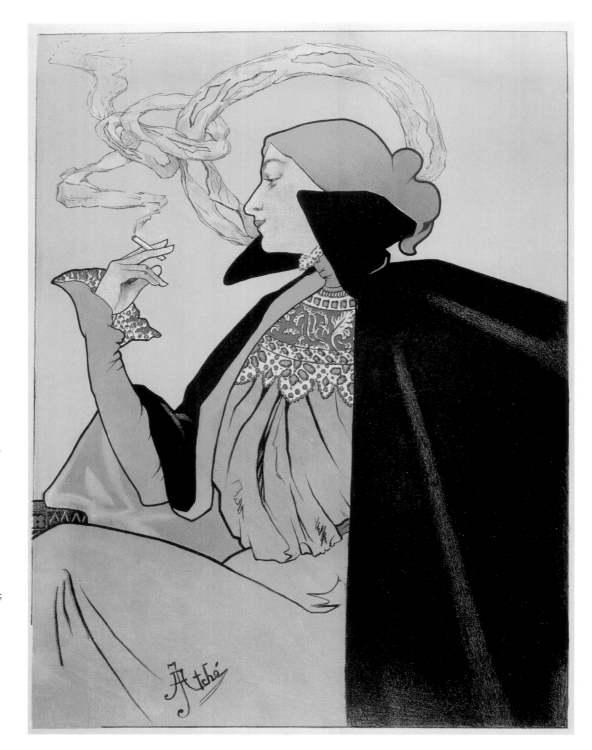

The plate section is organized alphabetically by artist, then by date. In a few cases, the chronology has been altered to facilitate visual comparisons.

1
Jane Atché
*Papier à Cigarettes
Job,* 1896

Advertisement for
Job cigarette papers;
proof before letters

2
Marc-Auguste Bastard
Bières de la Meuse,
1896

Advertisement for
a French brewing
company

3

Paul Berthon
Salon des Cent,
1895

Poster for the
seventeenth group
exhibition of the
Salon des Cent
(Salon of 100)

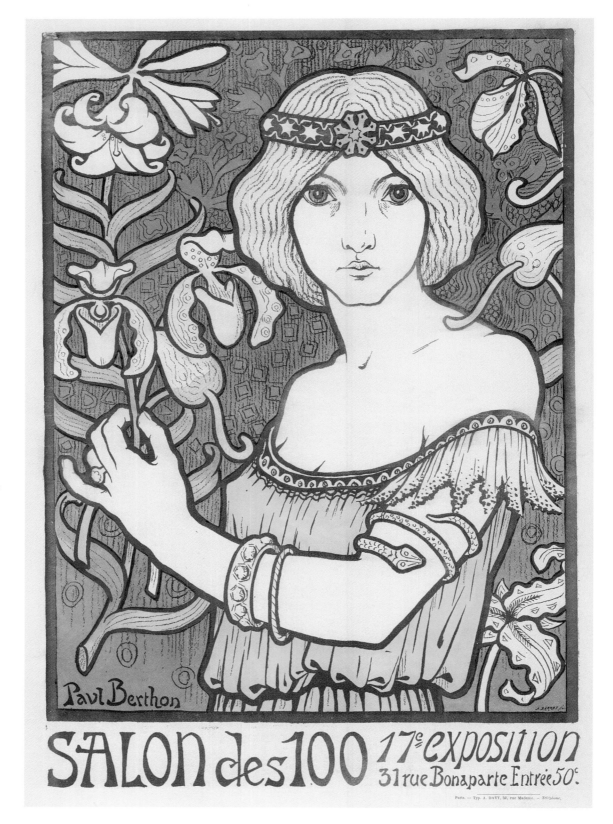

4
Paul Berthon
Source des Roches,
1899

Poster for spring
water bottled by
J. Giot, Cherbourg,
France

5
Paul Berthon
*Les Boules de
neige*, 1900

Decorative panel
designed for
home display

Panneaux décoratifs
(decorative panels)
bridged the gap
between prints
and posters.

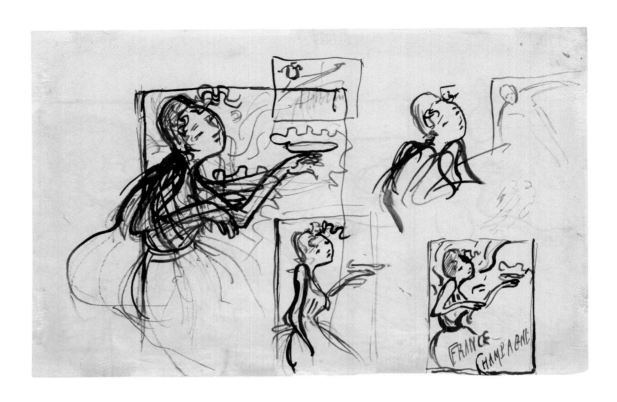

6
Pierre Bonnard
Study for
France-Champagne,
ca. 1889

Study for pl. 7

top
verso

bottom
recto

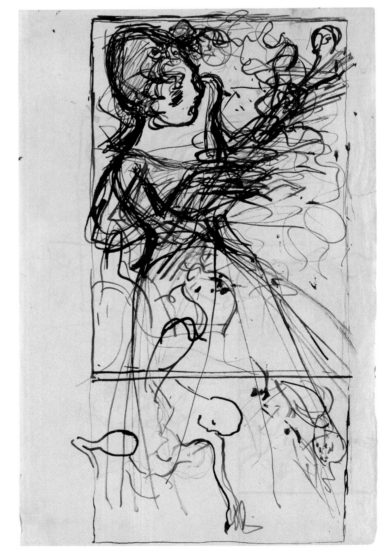

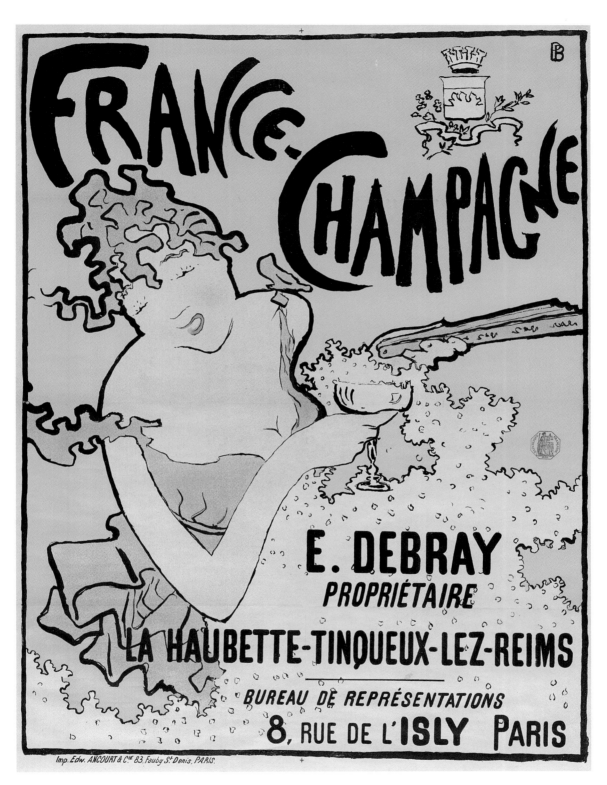

7
Pierre Bonnard
France-Champagne,
1889–91

Advertisement
for E. Debray's
champagne made
near Reims

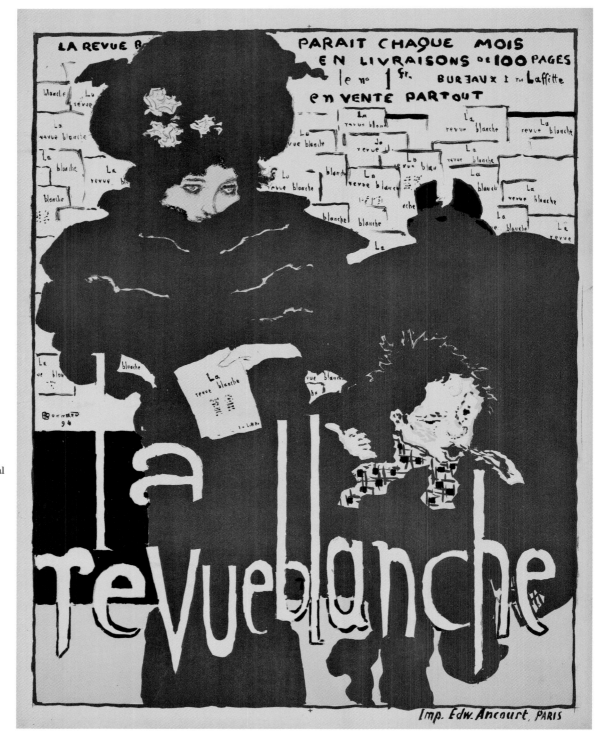

8
Pierre Bonnard
La Revue blanche,
1894

Poster for the
Symbolist periodical
La Revue blanche
(see also pl. 97)

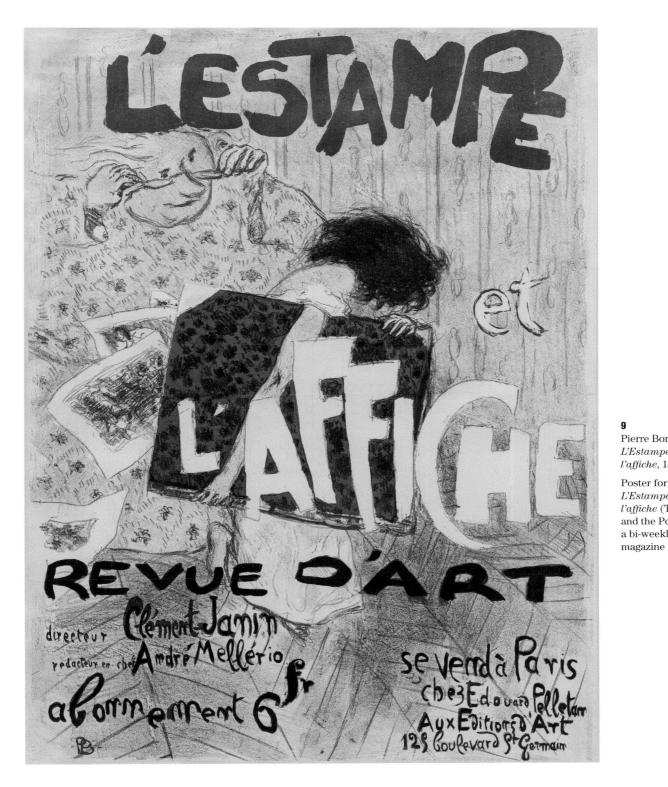

9
Pierre Bonnard
*L'Estampe et
l'affiche*, 1897

Poster for
*L'Estampe et
l'affiche* (The Print
and the Poster),
a bi-weekly arts
magazine

10
Pierre Bonnard
Salon des Cent
(Study for a poster),
ca. 1896

Preliminary study
for pl. 11

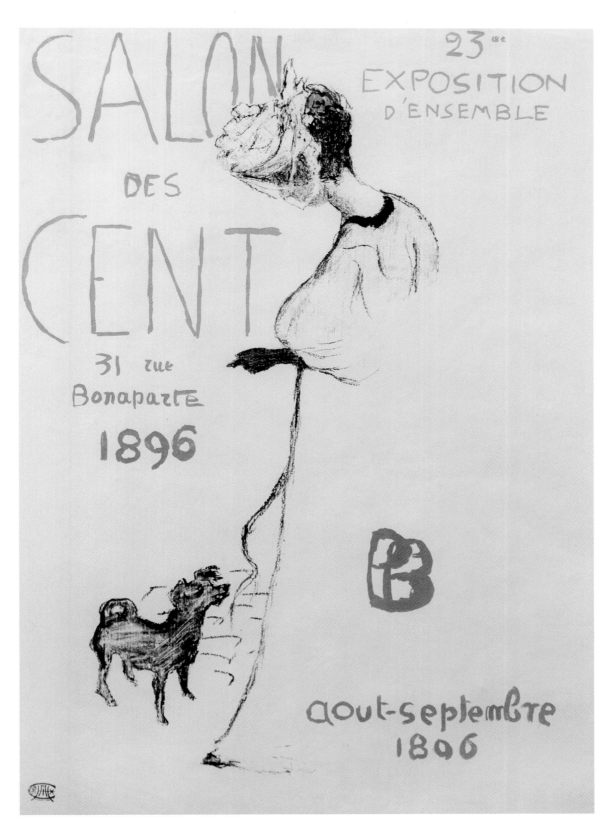

11
Pierre Bonnard
Salon des Cent, 1896

Poster for the
twenty-third
exhibition of the
Salon des Cent,
August–September
1896

12
Leonetto Cappiello
Le Frou-Frou,
1899

Advertisement
for the humor
magazine
Le Frou-Frou
(Rustle)

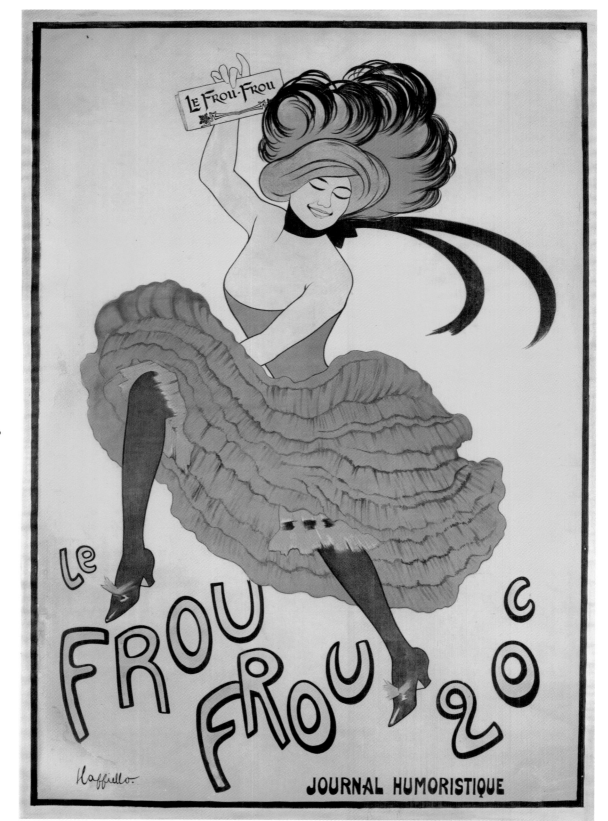

13
Leonetto Cappiello
Le Petit Coquin, 1901

Poster advertising
Petit Coquin cookies,
an "exquisite dessert"
and "the best of
the best"

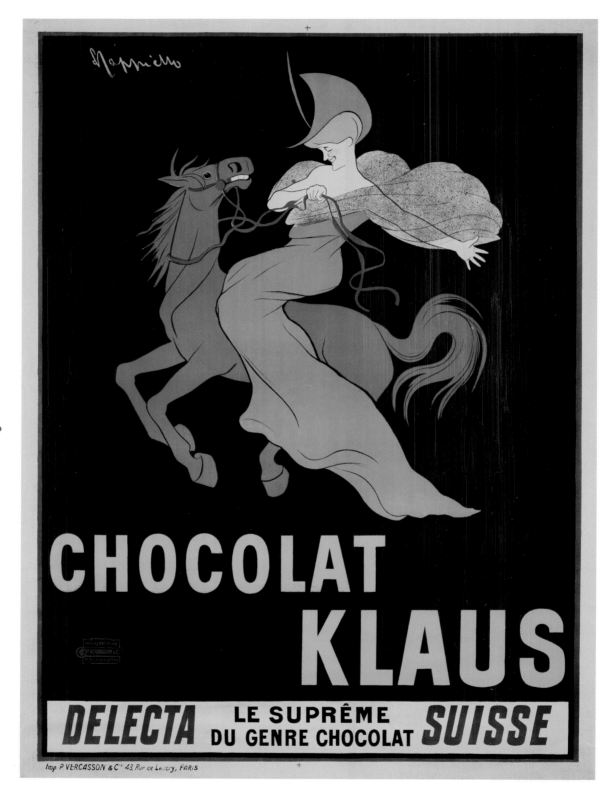

14
Leonetto Cappiello
Chocolat Klaus,
1903

Poster advertising
"the supreme"
Delecta chocolate,
manufactured
by the Swiss
company founded
by Jacques Klaus

15
Leonetto Cappiello
*Ferrari Nouilles
Macaronis*, ca. 1903

Poster advertising
vegetable and egg
noodles made by
Ferrari, featuring
theatrical stars of
the day

16
Leonetto Cappiello
Paquet Pernot, 1905

Advertisement for
the cookie company
Biscuits Pernot

17

Leonetto Cappiello
*Automobiles
Brasier*, 1906

Poster advertising
the new small cars
for Automobiles
Brasier

Brasier was in
business with
Georges Richard,
the bicycle and
automobile manu-
facturer. Richard's
trademark, the four-
leaf clover, can be
seen in the upper-
left corner of this
poster. The quatre-
foil design is a
prominent motif in
Eugène Grasset's
design for Georges
Richard bicycles
(pl. 54).

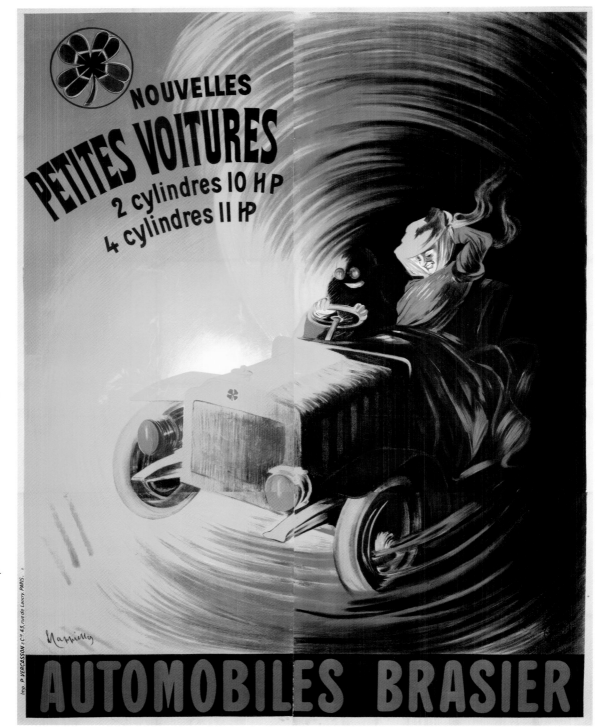

18
Leonetto Cappiello
Maurin Quina, 1908

Advertisement for
the cherry-flavored
aperitif made by
Maurin Brenas in Le
Puy, France

19
Jules Chéret
La Quenouille de verre, 1873

Poster advertising the three-act comic operetta *La Quenouille de verre* (The Glass Distaff) at the Théâtre des Bouffes Parisiens

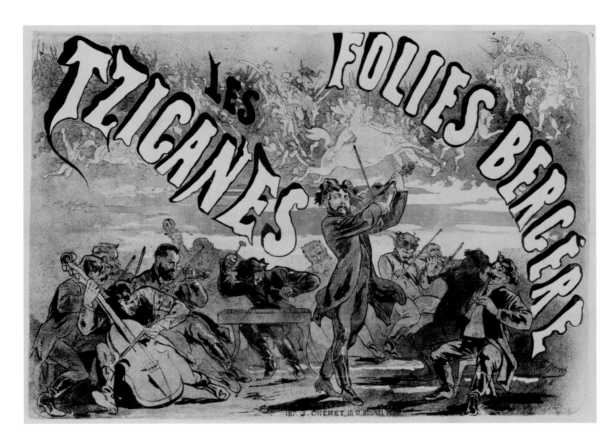

20
Jules Chéret
Folies-Bergère: Les Tziganes, 1874

Poster advertising the performance of Johann Strauss's operetta *The Gypsy Baron* at the Folies-Bergère

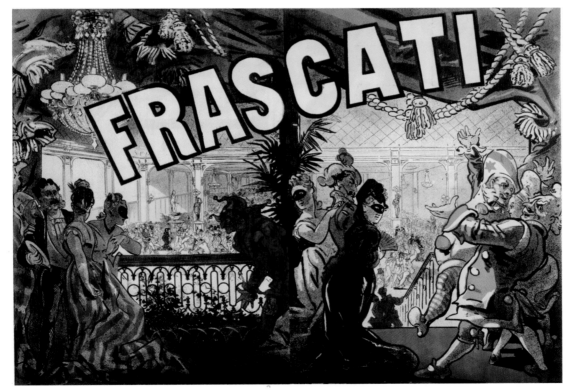

21
Jules Chéret
Frascati, 1874

Poster advertising the masked ball at the Frascati dance and concert hall

22
Jules Chéret
Folies-Bergère:
Le Dompteur
noir, 1875

Advertisement for
the wild-animal
trainer Delmonico

23
Jules Chéret
*Folies-Bergère:
La Charmeuse de
serpents*, 1875

Poster advertising
the nightly
performance of
a snake charmer

24
Jules Chéret
Maquette for
*L'Horloge Champs-
Élysées*, 1876

Study for pl. 25

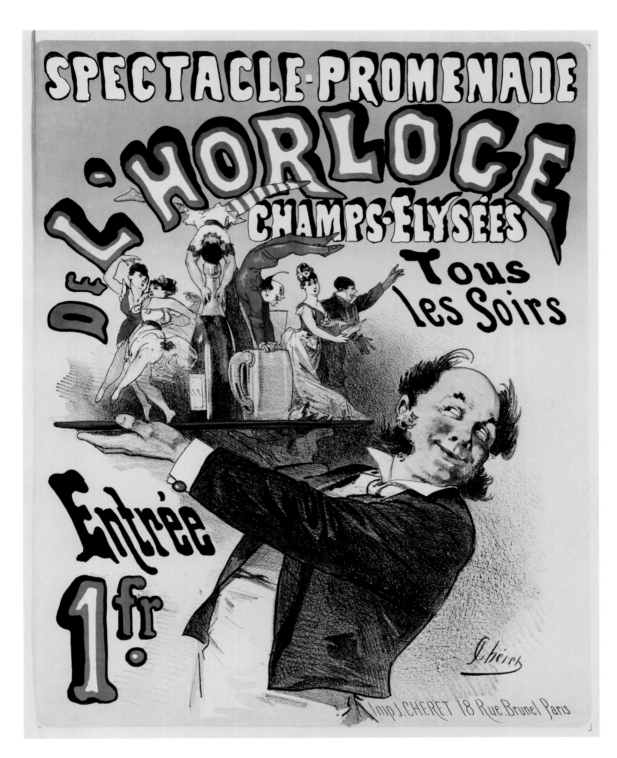

25

Jules Chéret
L'Horloge Champs-Élysées, 1876

Poster for the
Horloge, a small
café-concert on the
Champs-Élysées

26

Jules Chéret
*Folies-Bergère:
Les Hanlon-Lees,*
1878

Poster for the
British theatrical
acrobatic comedy
troupe composed
of the six Hanlon
brothers and
John Lees

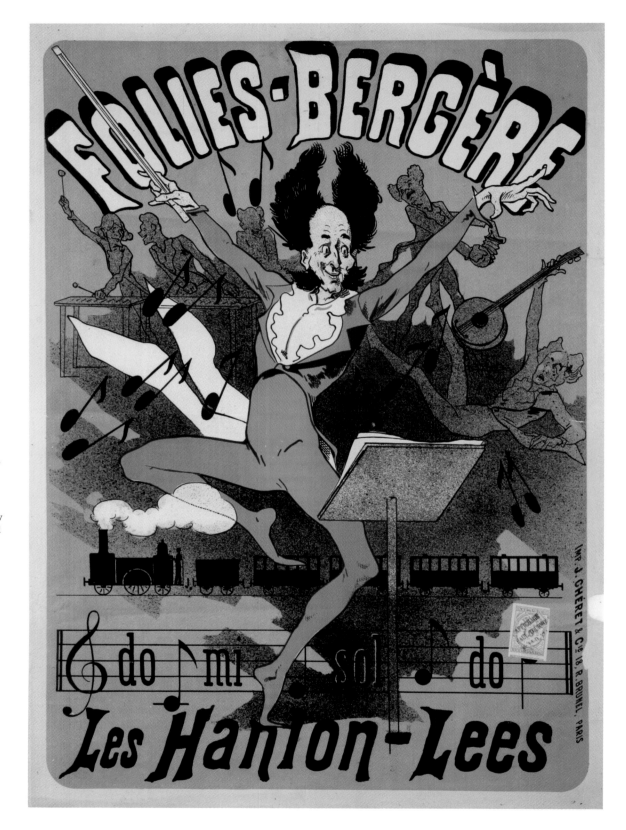

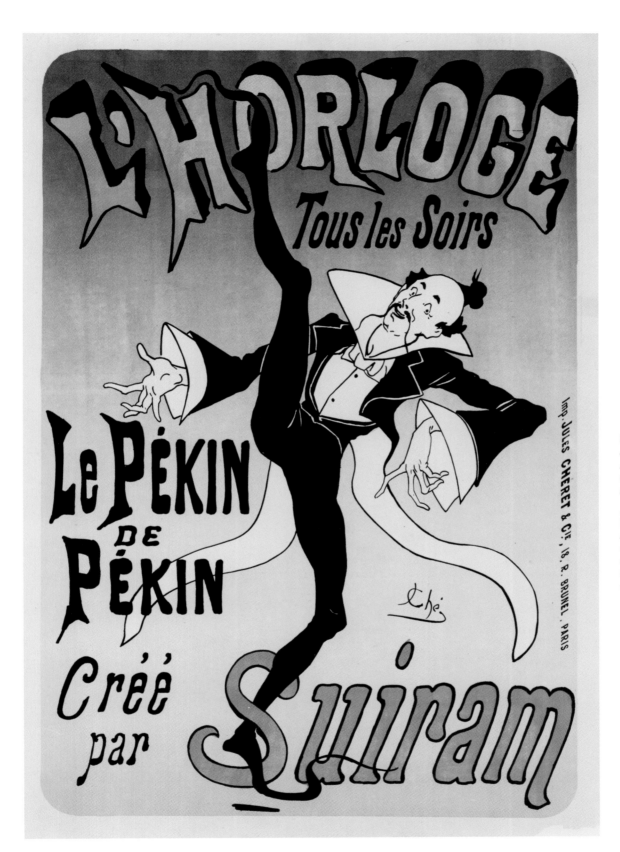

27
Jules Chéret
L'Horloge: Le Pékin de Pékin créé par Suiram, 1878

Advertisement for *The Peking from Peking*, created and performed by actor Suiram at the Horloge café-concert

28
Jules Chéret
Les Girard, 1875/78
or 1880/81

Study for pl. 29

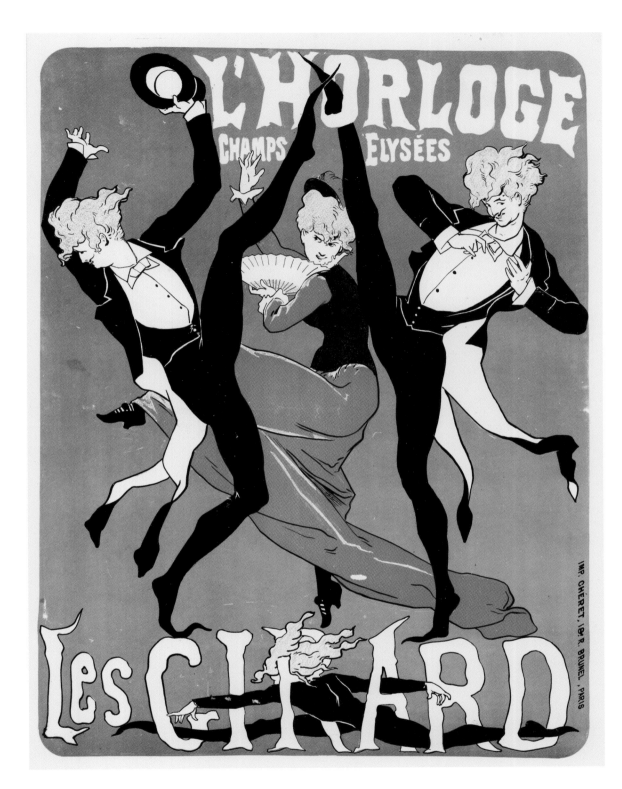

29
Jules Chéret
*L'Horloge: Les
Girard,* 1875/78 or
1880/81

Poster for a
performance by
contortionists at the
Horloge café-concert

30
Jules Chéret
Concert Ambassadeurs, 1881

Poster advertising the performers at the Ambassadeurs café-concert

The Ambassadeurs was a fashionable music hall near the Champs-Élysées.

31
Jules Chéret
*Bal du Moulin
Rouge*, 1889

Poster for the
Moulin Rouge
dance hall

The hall featured
"performances
every evening and
Sunday afternoon,"
plus "special
performances on
Wednesdays and
Saturdays."

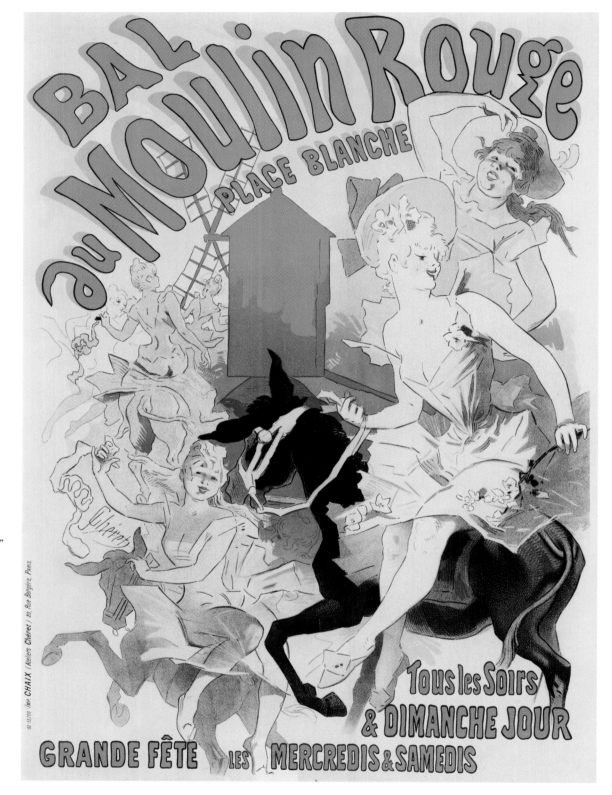

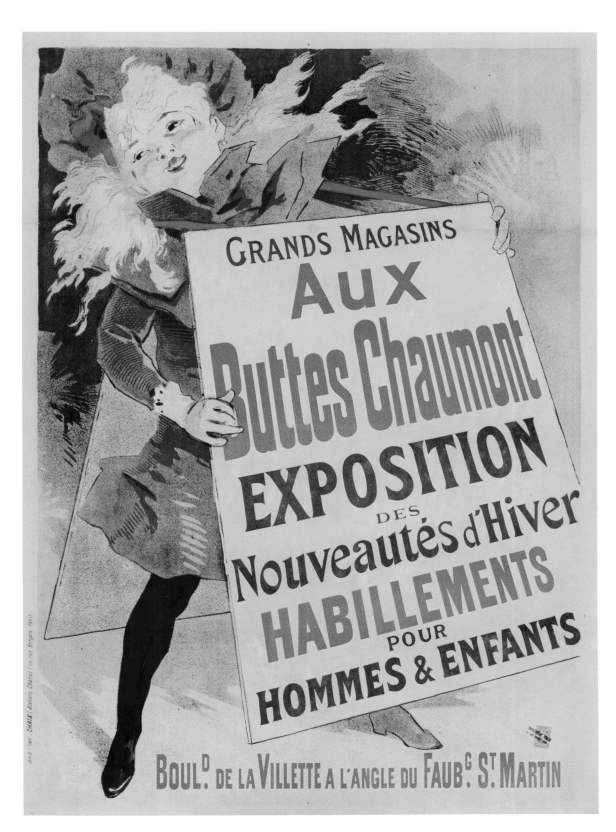

32
Jules Chéret
Aux Buttes Chaumont, 1890

Advertisement for the department store Aux Buttes Chaumont

The ad announces the new winter line of "clothing for men and children."

33
Jules Chéret
Jardin de Paris,
1890

Poster advertising
the Jardin de Paris
dance hall

The poster bills
"Every evening:
spectacle, concert,
evening show. Ball
every Tuesday,
Wednesday, Friday
and Saturday."

See also Picasso's
unrealized design
for a poster for the
Jardin de Paris,
p. 27, fig. 16.

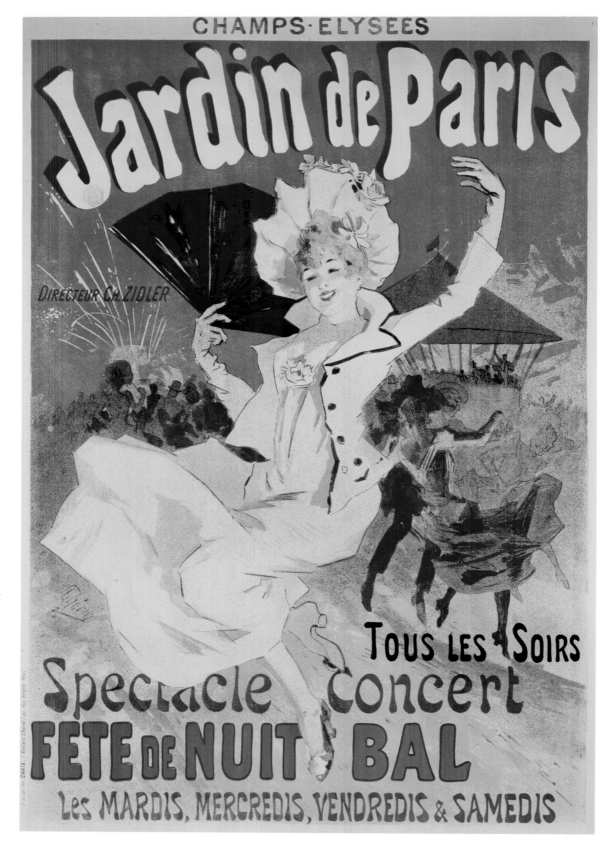

34
Jules Chéret
Alcazar d'Été, 1890

Poster for Léon
Garnier's *Revue de
fin de siècle* at the
Alcazar d'Été café-
concert

35
Jules Chéret
La Pantomime,
1891

Panneau décoratif
(decorative panel)
used for home décor

36
Jules Chéret
La Musique, 1891

Panneau décoratif
(decorative panel)
used for home décor

37
Jules Chéret
La Danse, 1891

Panneau décoratif
(decorative panel)
used for home décor

38
Jules Chéret
La Comédie, 1891

Panneau décoratif
(decorative panel)
used for home décor

39
Jules Chéret
*Pantomimes
lumineuses*, 1892

Advertisement for
the premiere of
Emile Reynaud's
"Luminous
Pantomimes"

This ad marks the
dawn of modern
cinema, as this was
the first projection
of moving images.

40
Jules Chéret
*Folies-Bergère:
La Loïe Fuller*, 1893

Poster advertising
the dancer Loïe
Fuller's performance
at the Folies-Bergère

41
Jules Chéret
Folies-Bergère:
La Danse du Feu,
1897

Poster advertising
Loïe Fuller's
"Fire Dance" at
the Folies-Bergère

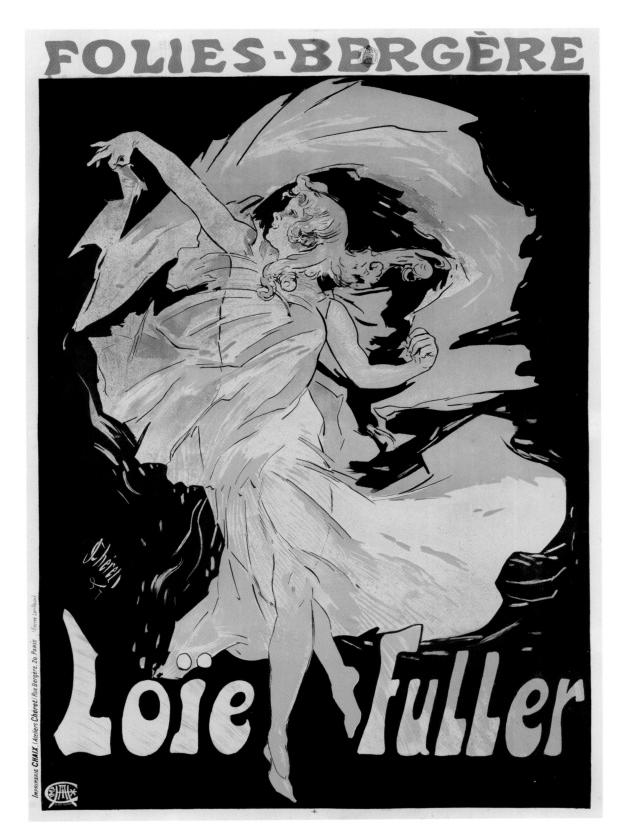

42
Jules Chéret
*Folies-Bergère:
Loïe Fuller*, 1897

Poster advertising
Loïe Fuller's
performance at the
Folies-Bergère

43

Jules Chéret
Pastilles Géraudel,
1895

Poster advertising
Géraudel cough
drops

"If you cough, take
Géraudel lozenges."

44
Jules Chéret
Pippermint, 1899

Poster advertising
the mint liqueur
Pippermint

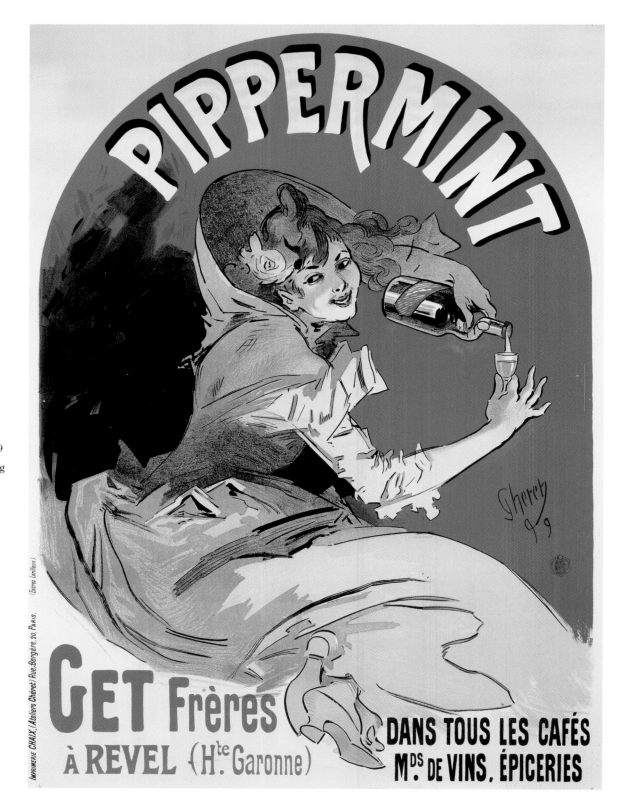

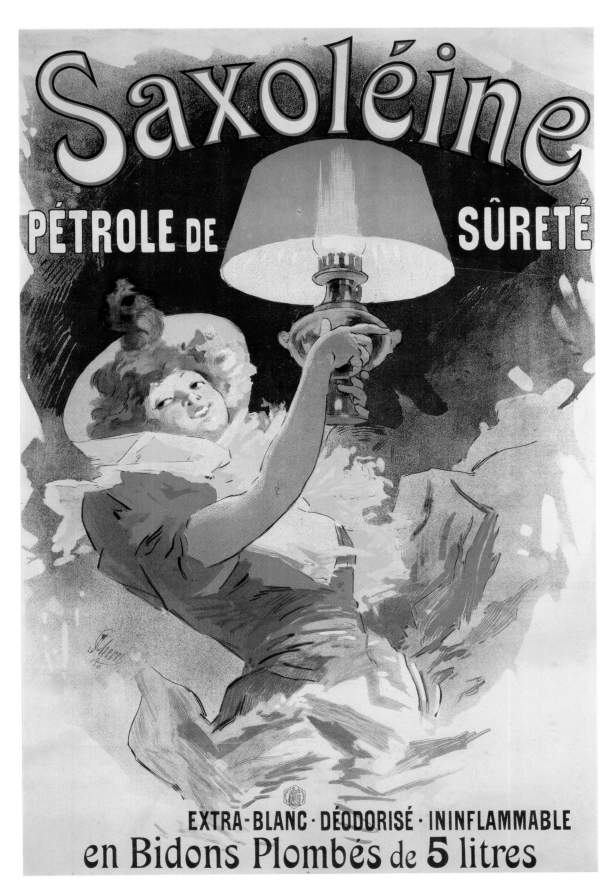

45
Jules Chéret
Saxoléine, 1900

Poster advertising the kerosene Saxoléine

The kerosene was "extra white, deodorized, nonflammable" and available "in 5-liter sealed canisters."

46
Alfred Choubrac
Fin de Siècle, 1891

Advertisement
for the illustrated
periodical *Fin de
Siècle*

The journal
published "novels,
stories, songs,
and news."

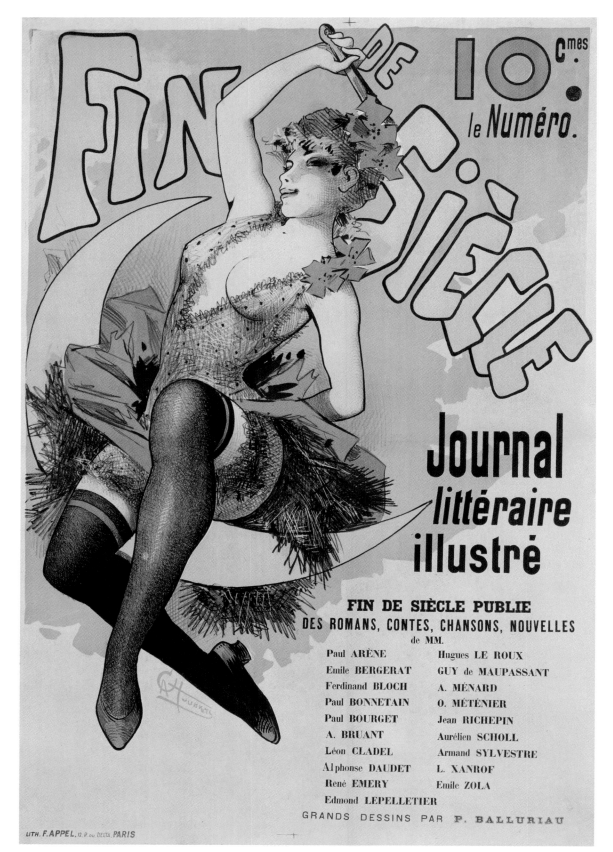

47
Alfred Choubrac
Fin de Siècle
(Censored), 1891

Revised
advertisement
for the illustrated
periodical *Fin de
Siècle*

Choubrac's first ad
was censored for
"insult to public
decency." Choubrac
mocked the censors
by adding the words
"this part of the
design has been
censored" and
reprinting the poster.

48

Maurice Denis
*La Dépêche de
Toulouse*, 1892

Poster for the
newspaper *The
Toulouse Dispatch*

The text in the
lower-right
corner lists the
kiosks where the
newspaper could
be purchased
in Paris.

49
Maxime Dethomas
Montmartre, 1897

Poster advertising
a guidebook
to Montmartre,
the artistic and
bohemian district
in the 18th arron-
dissement of Paris

50

Georges de Feure
Paris-Almanach,
1895

Poster advertising
a guide to Parisian
attractions

The guide was
issued by the
publisher and print
and poster dealer
Edmond Sagot.

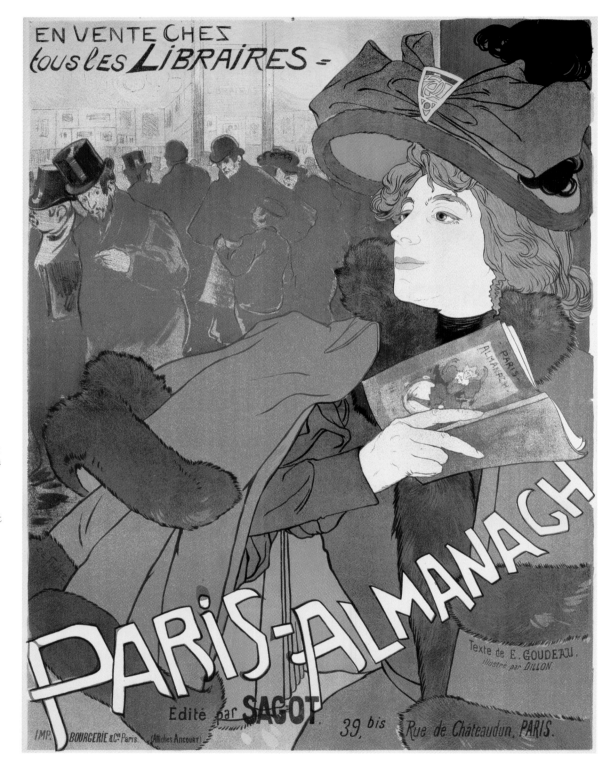

51

Georges de Feure

Affiches et Estampes Pierrefort, 1898

Advertisement for the poster and print dealer Pierrefort

Pierrefort was one of the most important dealers of *affiches* in fin-de-siècle Paris. Henri-Gabriel Ibels also created a poster for Pierrefort (pl. 62), and Pierrefort published several lithographs by Henri de Toulouse-Lautrec in 1898.

52
Eugène Grasset
Jeanne d'Arc, Sarah Bernhardt, 1889/90

Poster promoting
Sarah Bernhardt's
performance as Joan
of Arc at the Théâtre
de la Porte-St. Martin

The actress rejected
this design, so
Grasset created
a second version,
modifying her
hairstyle and facial
expression.

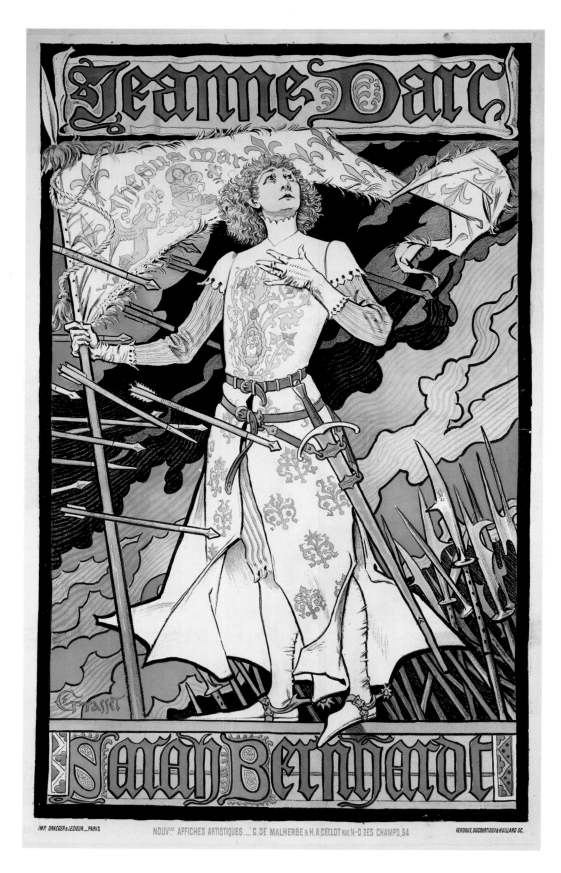

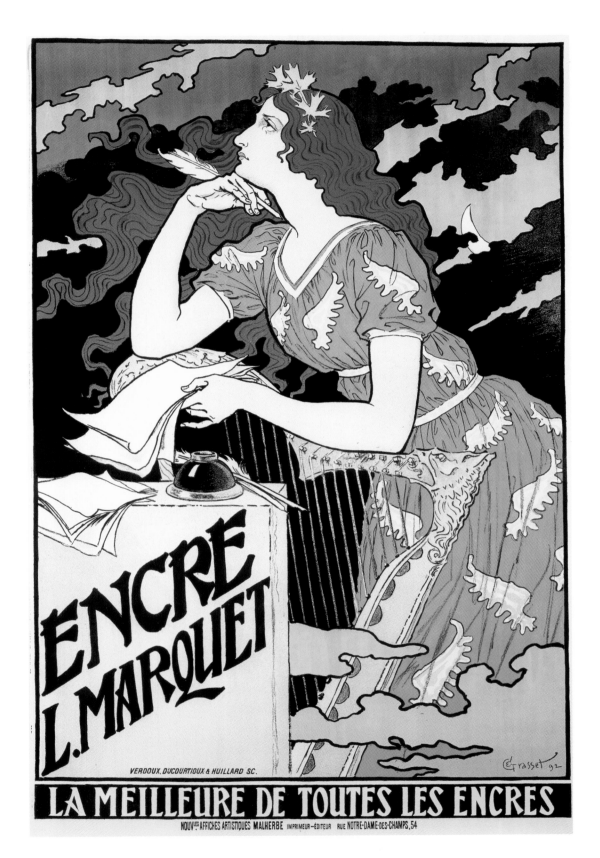

53
Eugène Grasset
Encre L. Marquet,
1892

Poster advertising
Marquet, "The best
of all inks."

54
Eugène Grasset
*Marque Georges
Richard Cycles &
Automobiles*, 1899

Advertisement
for Georges
Richard Cycles &
Automobiles

The manufacturer's
symbol—the four-
leaf clover— is
highlighted in
the center. This
motif also appears
in pl. 17.

55
Henri Gray
Pétrole Stella, 1897

Advertisement
for Stella Oil

The oil was
available in
"5- and 2-liter
sealed canisters."

56
Henri Gray
Cycles Sirius, 1899

Poster for Sirius
Bicycles, a German
brand manufactured
in Nuremberg

57
Jules-Alexandre Grün
*Guide de
l'étranger à
Montmartre*, 1900

Advertisement
for a visitor's
guide to
Montmartre

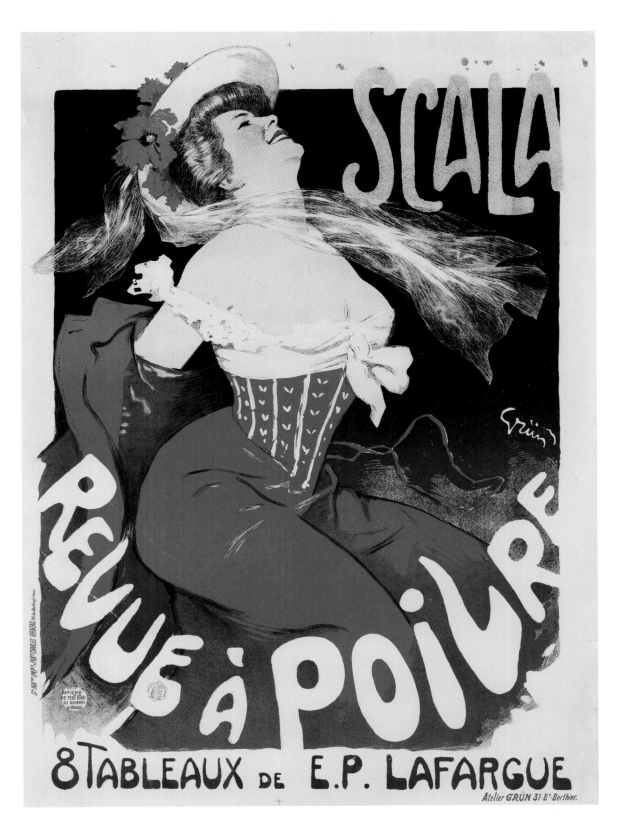

58
Jules-Alexandre Grün
Revue à Poivre,
1904

Poster for the
production *Revue à
Poivre* at the Scala

59
René Georges
Hermann-Paul
Salon des Cent,
1895

Poster for the
January 1895
Salon des Cent
exhibition

This is a self-
portrait of the
artist.

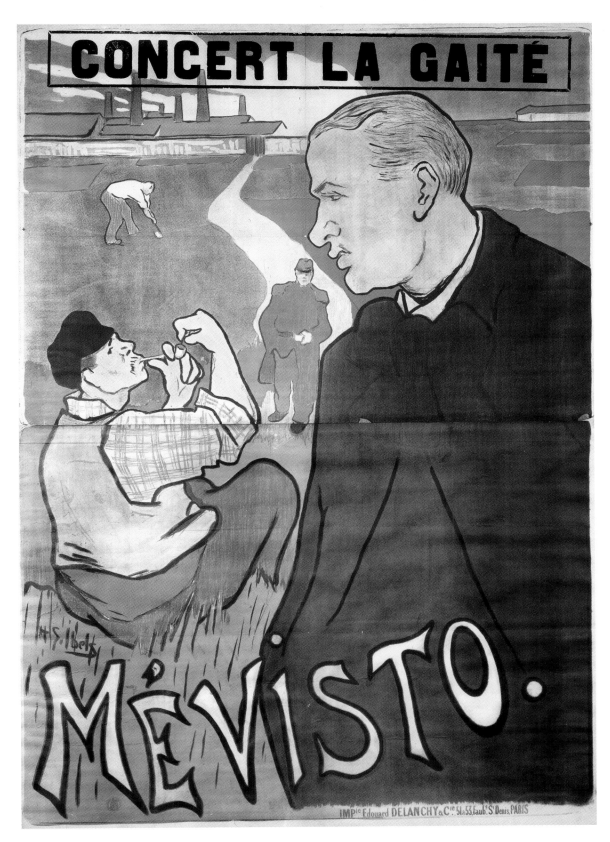

60
Henri-Gabriel Ibels
Mévisto, 1892

Poster advertisement for the cabaret singer Jules Mévisto at the Théâtre de la Gaieté

61
Henri-Gabriel Ibels
Salon des Cent,
1893

Advertisement
for the first group
exhibition of the
Salon des Cent

See also pl. 3.

62
Henri-Gabriel Ibels
Pierrefort, 1897

Poster for "drawings, paintings, artistic posters"
at the Pierrefort Gallery

See also pl. 51.

63
Henri Gustave Jossot
Sardines Jockey-Club, 1897

Advertisement for Jockey-Club Sardines
made by Saupiquet in Nantes

The ad depicts celebrities and politicians
of the day enjoying the sardines.

64
Ernest Kalas
*Exposition
d'affiches
artistiques*, 1896

Poster advertising
the "Exhibition of
Artistic Posters,
French and foreign,
modern and
retrospective"

More than 1,300
posters were shown
in this monumental
exhibition at the
Cirque de Reims in
November 1896.

65

Lucien-Marie-François Métivet
Eugénie Buffet:
Ambassadeurs, 1893

Poster advertising a
performance by the singer
Eugénie Buffet at the
Ambassadeurs café-concert

Like Aristide Bruant (pls. 89,
90), Buffet specialized in songs
about the marginalized and
downtrodden, often from the
point-of-view of a *pierreuse*
(streetwalker).

66
Alphonse Mucha
Gismonda, 1894–95

Poster advertising the play
Gismonda, starring Sarah
Bernhardt at the Théâtre
de la Renaissance

67
Alphonse Mucha
Lorenzaccio, 1896

Poster advertising an adaptation
of Alfred de Musset's 1863 play

This new version starred Sarah
Bernhardt in the lead male role.

68
Alphonse Mucha
La Dame aux Camélias, 1896

Poster advertising the play
The Lady of the Camellias by
Alexandre Dumas, fils

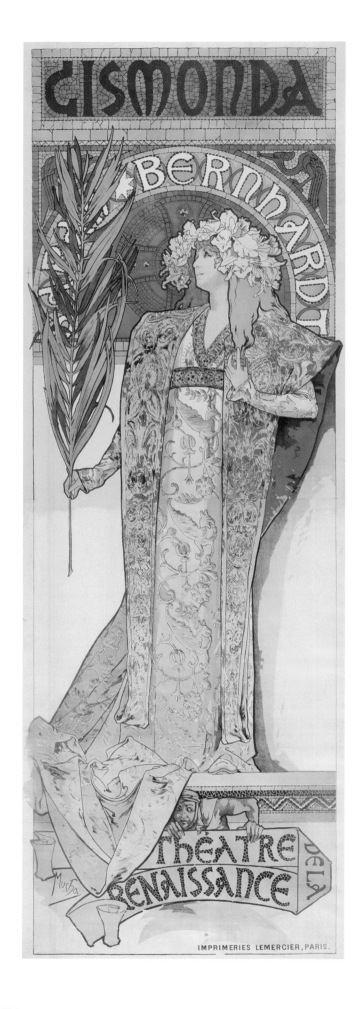

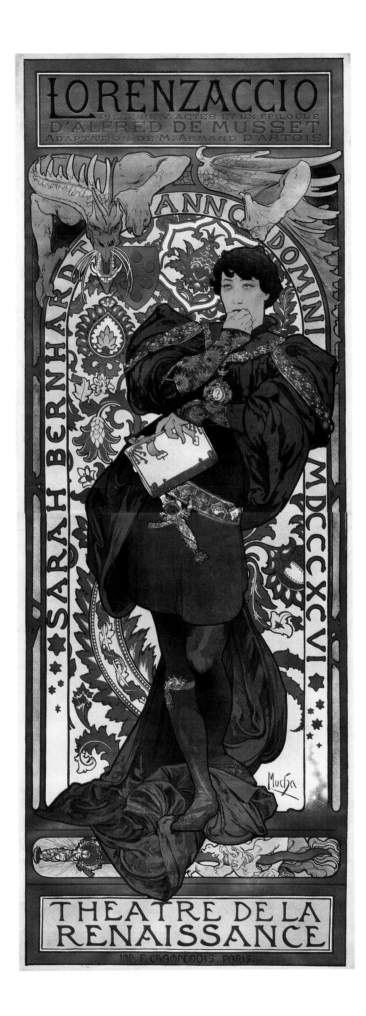

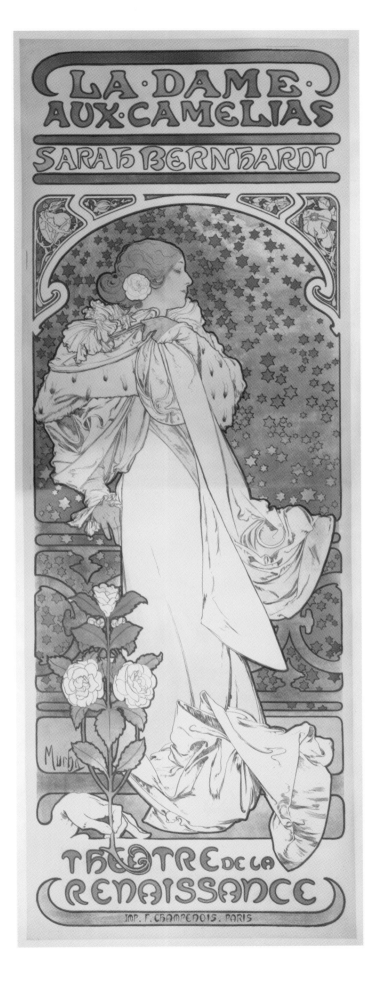

69
Alphonse Mucha
Salon des Cent,
1896

Poster for the
twentieth exhibition
of the Salon
des Cent, March–
April 1896

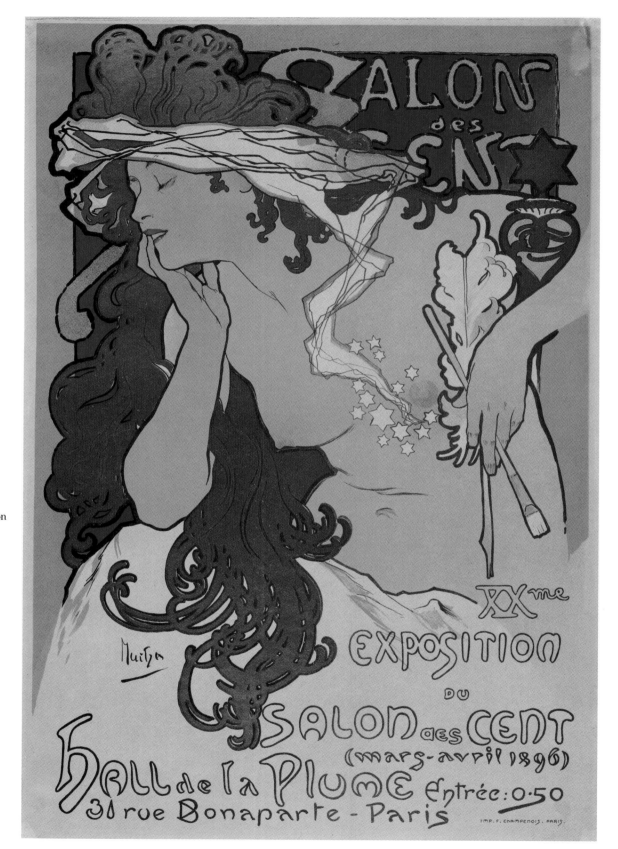

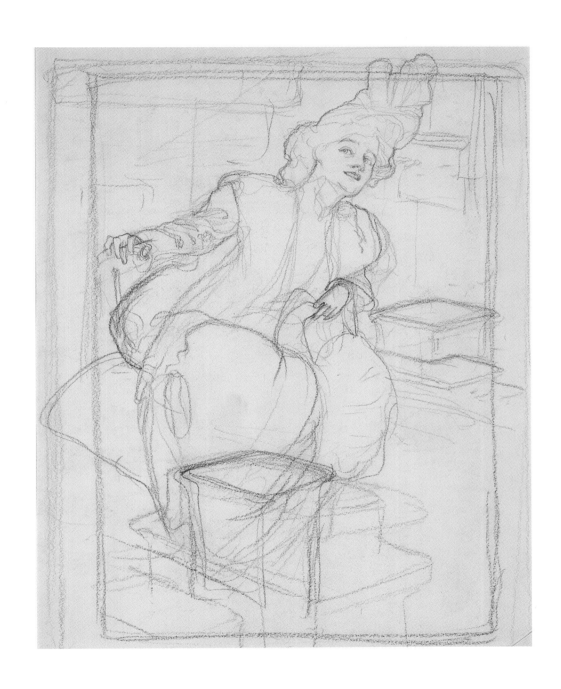

70

Alphonse Mucha
Sarah Bernhardt,
ca. 1898

Study of the actress
Sarah Bernhardt

Mucha was Bernhardt's
preferred *affichiste*.

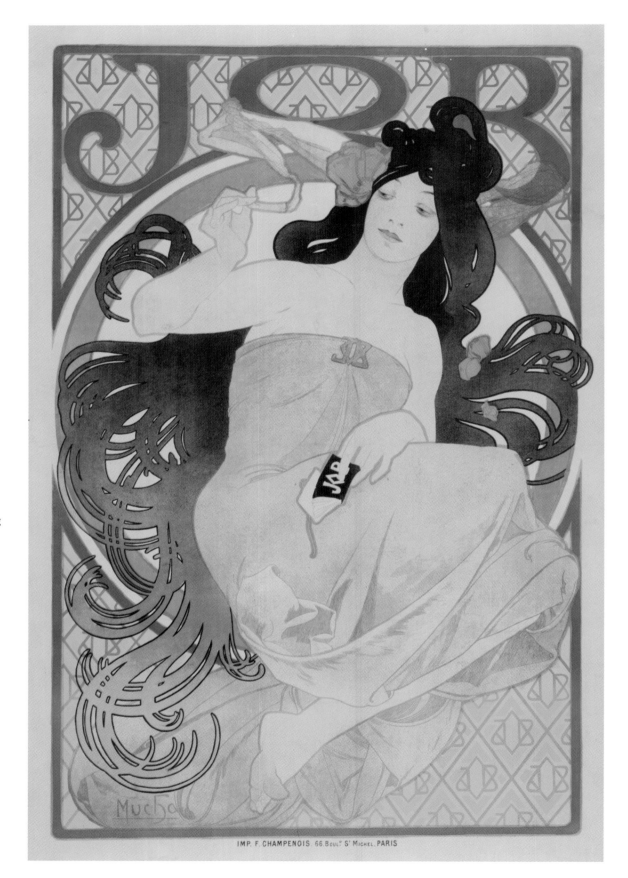

71
Alphonse Mucha
Job, 1898

Poster advertising
Job cigarette
papers

See also pl. 1.

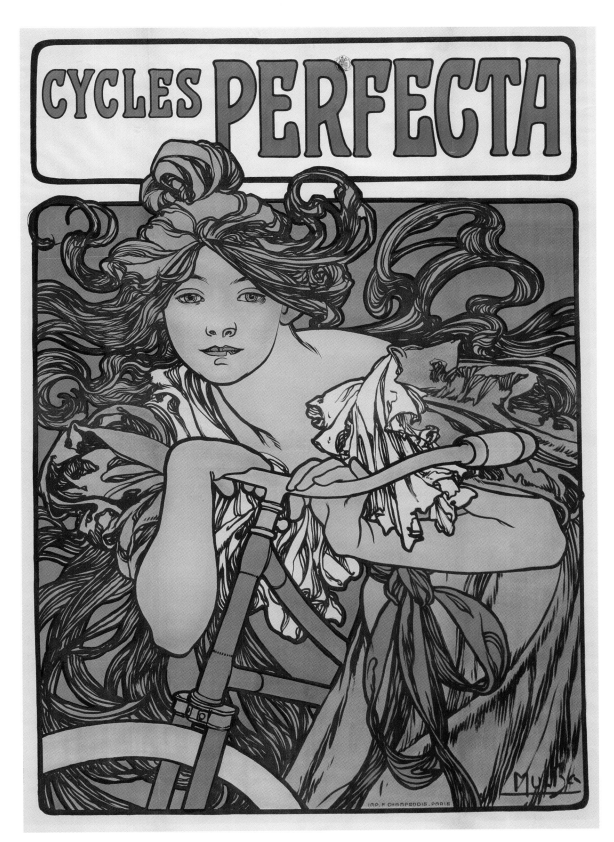

72
Alphonse Mucha
Cycles Perfecta, 1902

Poster advertising
the English-made
bicycle Perfecta

These cycles were
sold in France, and
many posters bear
the stamp of the
local dealer carrying
this brand.

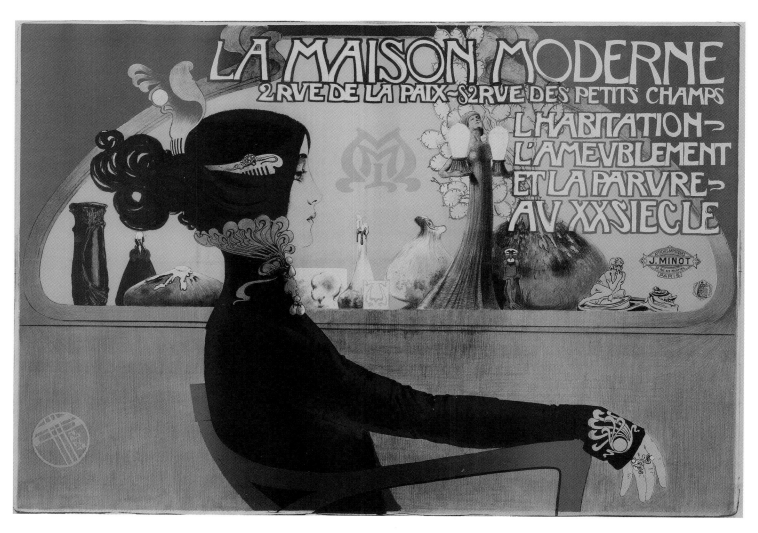

73

Manuel Orazi
La Maison Moderne, 1900

Advertisement for La Maison Moderne

This fashionable new home décor shop featured "home wares, furniture, and finery of the twentieth century."

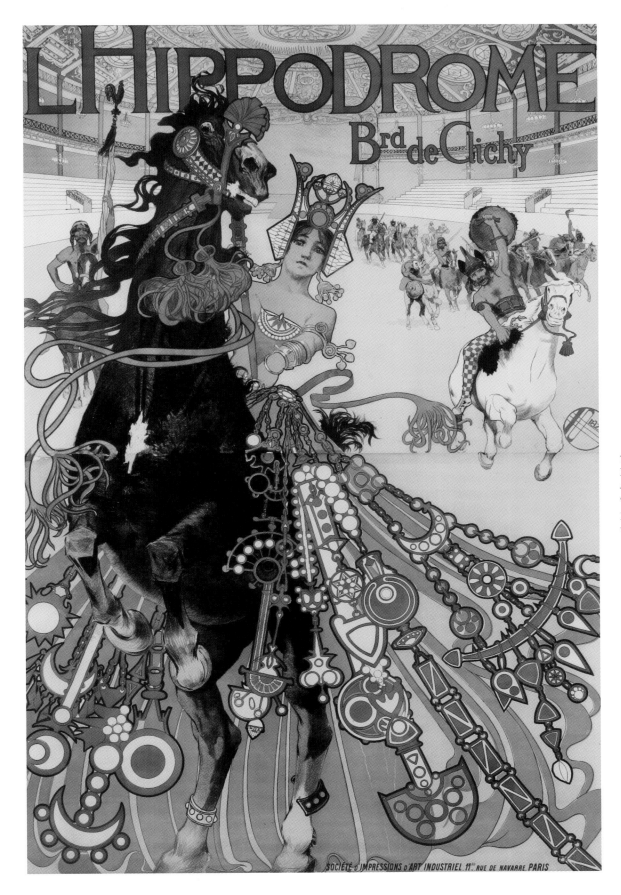

74

Manuel Orazi
L'Hippodrome,
ca. 1900

Poster advertising
the new hippodrome

75
Manuel Orazi
Loïe Fuller, 1900

Poster for
Loïe Fuller's
appearance at the
1900 Exposition
universelle in Paris

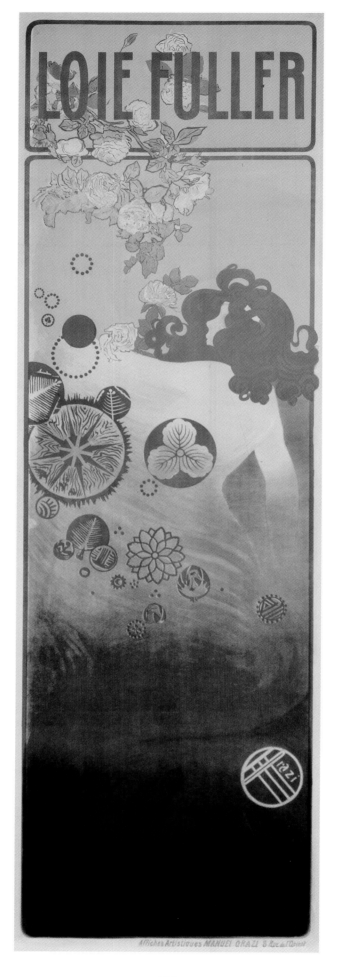

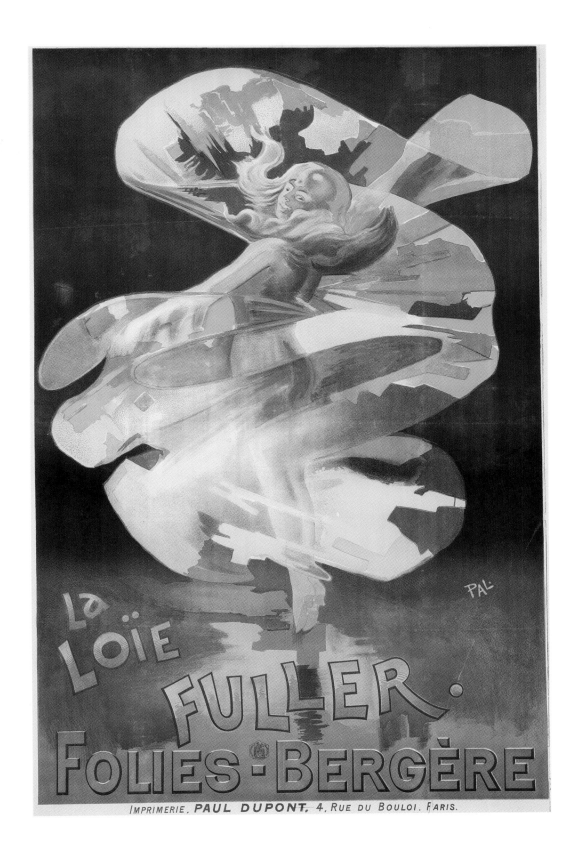

76
Pal
(Jean de Paléologue)
La Loïe Fuller,
ca. 1893

Poster for Loïe
Fuller's performance
at the Folies-Bergère
music hall

77
Pal
(Jean de Paléologue)
Rayon d'Or, 1895

Poster advertising
the kerosene lamp
Rayon d'Or

The ad boasts that
Rayon d'Or
(Golden Beam)
is the "last word
on illumination."

78
Pal
(Jean de Paléologue)
Déesse, ca. 1898

Advertisement for
Déesse (Goddess)
bicycles

The poster also
highlights the "non-
skid" Kosmos tires.

79
Théophile-
Alexandre
Steinlen
Yvette Guilbert,
1894

Poster for the
diseuse Yvette
Guibert at the
Ambassadeurs
café-concert

See also Toulouse-
Lautrec's design for
a poster for Guilbert,
p. 29, fig. 17, which
the singer rejected.

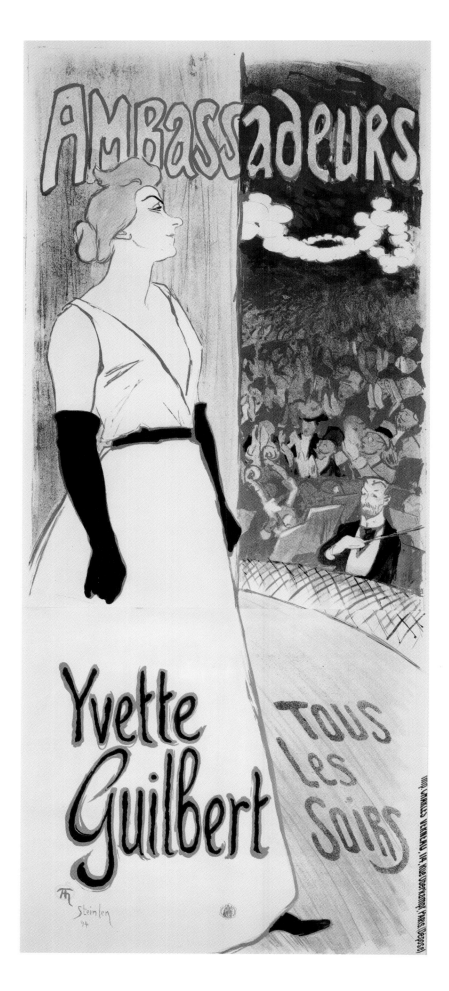

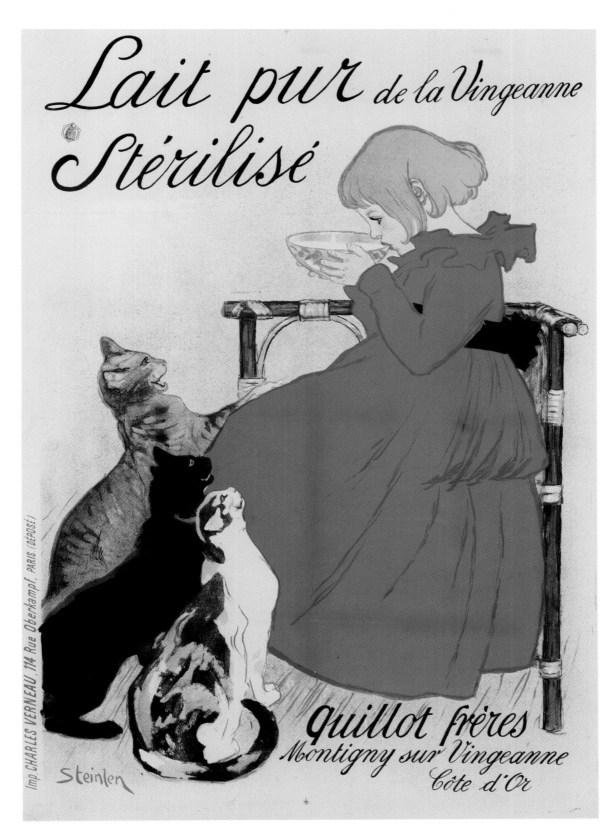

80
Théophile-
Alexandre
Steinlen
*Lait pur stérilisé de
la Vingeanne*, 1894

Poster advertising
sterilized pure milk
from Montigny-sur-
Vigeanne, a rural
town in eastern
France

81
Théophile-
Alexandre
Steinlen
*Compagnie
Française des
Chocolats et des
Thés,* 1895

Advertisement
for cocoa and tea
sold by the French
Chocolate and
Tea Company

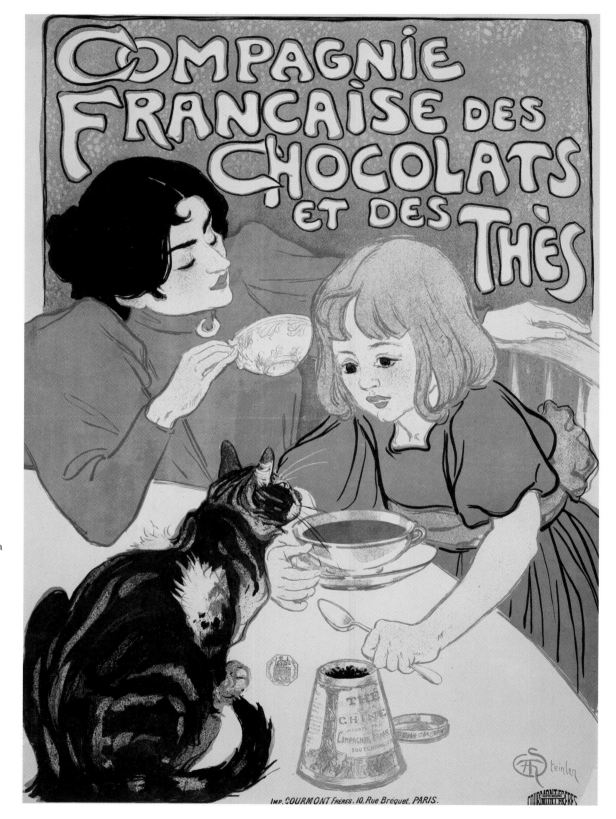

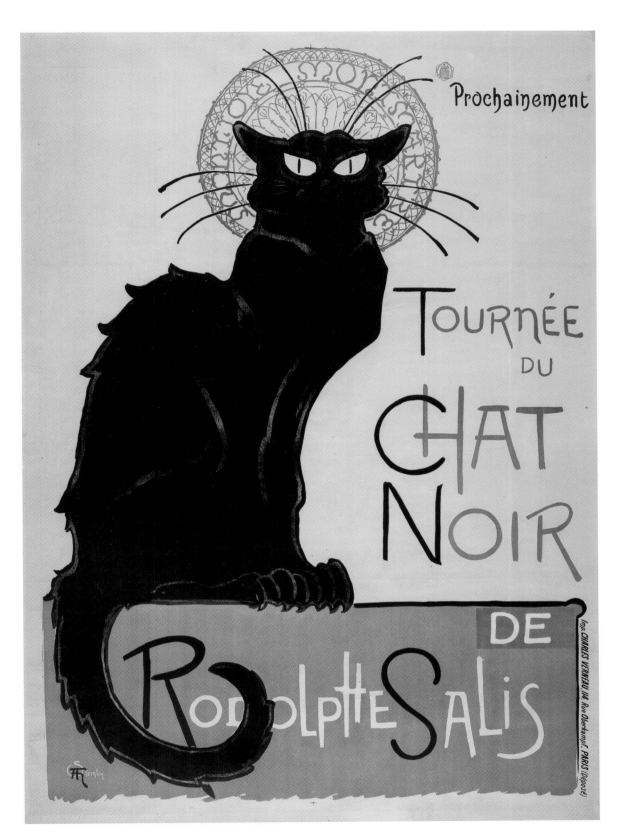

82
Théophile-
Alexandre
Steinlen
*Tournée du Chat Noir
de Rodolphe Salis*,
1896

Poster advertising
a tour by a troupe
from Rodolphe Salis's
Montmartre cabaret,
the Chat Noir

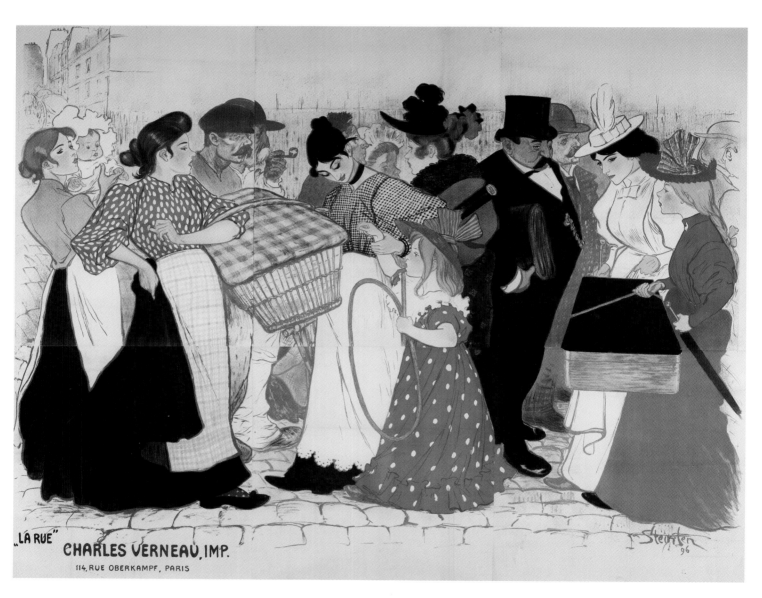

83

Théophile-Alexandre Steinlen
La Rue, 1896

Poster for the Parisian color lithographic printer Verneau,
before the text "Affiches Charles Verneau" was added in
the upper register

Verneau was one of the leading poster printers of the day.

84
Théophile-
Alexandre
Steinlen
*La Traîte des
Blanches*, 1899

Advertisement for
the novel *Le Traîte
des Blanches* (The
White Slave Trade)
serialized by *Le
Journal*

This poster was
censored, and
Steinlen was forced
to modify the
design by covering
the breasts of the
redheaded woman
at right. See p. 37,
fig. 21.

85
Théophile-
Alexandre
Steinlen
Cocorico, 1899

Poster for the
periodical
Cocorico (French
onomatopoeia
for "cock-a-
doodle-doo")

The journal
included work
by many of
the leading artists
of the time.

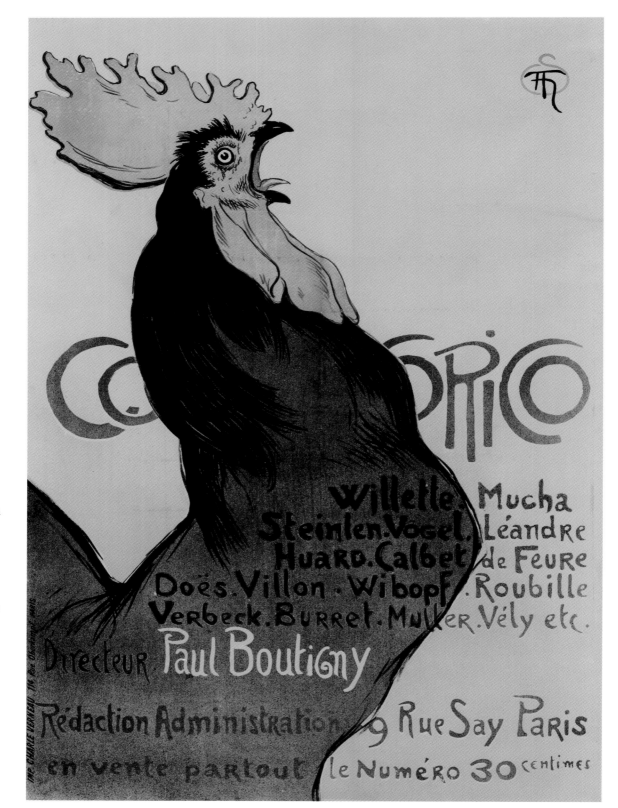

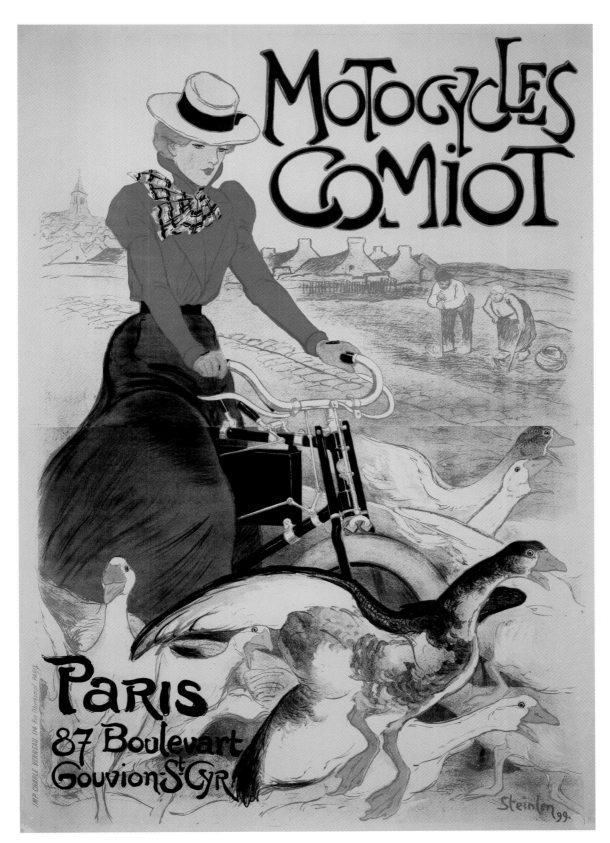

86
Théophile-
Alexandre
Steinlen
Motocycles Comiot,
1899

Advertisement for
Comiot mopeds

87
Henri de
Toulouse-Lautrec
*Moulin Rouge—
La Goulue*, 1891

Poster advertising
a performance
at the dance hall
Moulin Rouge

The performance
advertised featured
dancer La Goulue
(The Glutton) and
her partner, Valentin
le Désossé (Valentin
the Boneless).
This was Toulouse-
Lautrec's first poster.

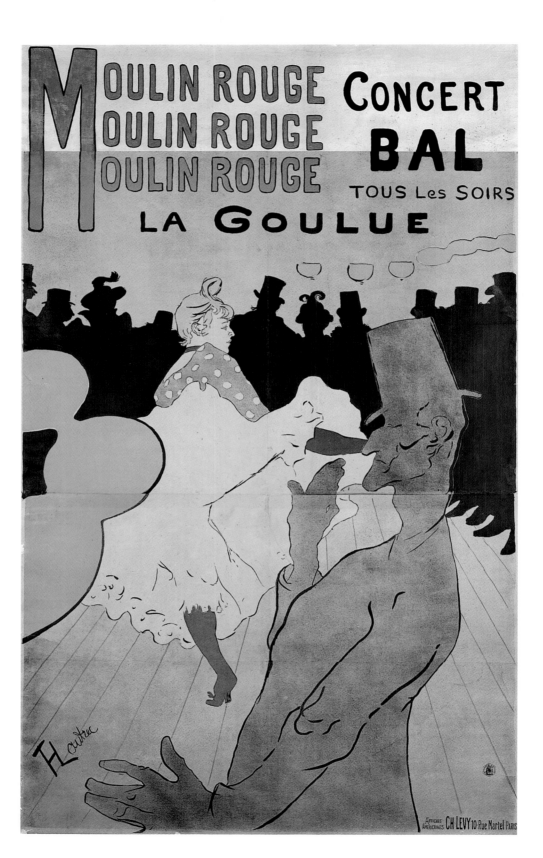

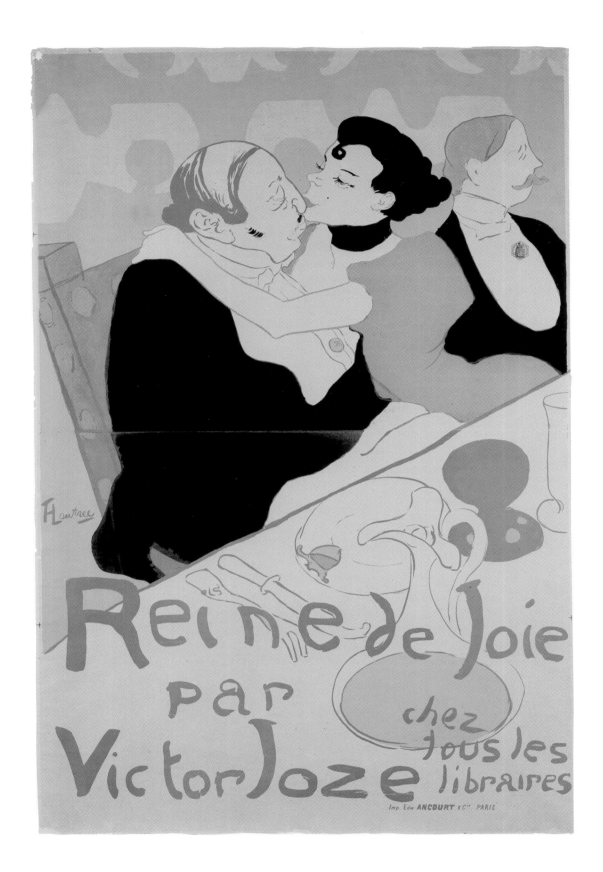

88
Henri de Toulouse-Lautrec
Reine de Joie, 1892

Poster for the novel *Reine de Joie: Mœurs du Demi-Monde* (Queen of Joy: Customs of the Demi-Monde) by Victor Joze (Victor Dobrski)

89
Henri de
Toulouse-Lautrec
Ambassadeurs:
Aristide Bruant,
1892

Poster announcing
Aristide Bruant's
debut at the
Ambassadeurs
café-concert

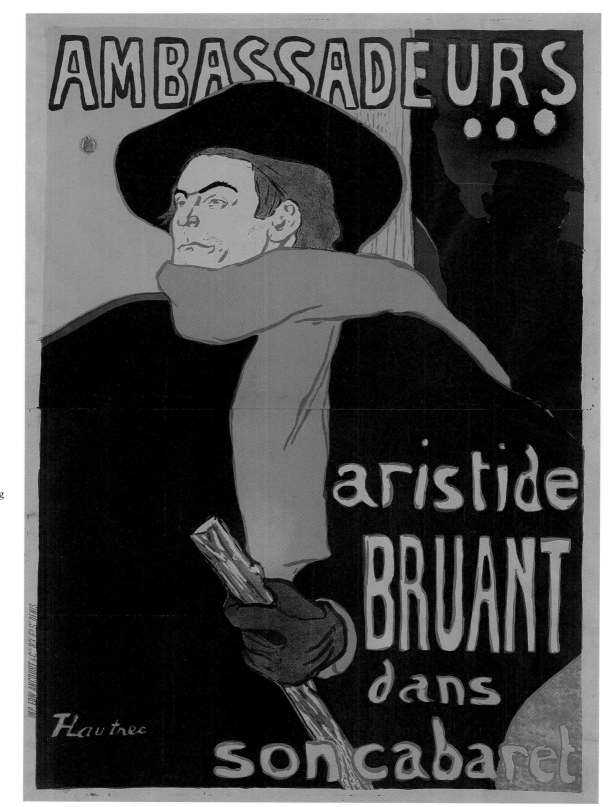

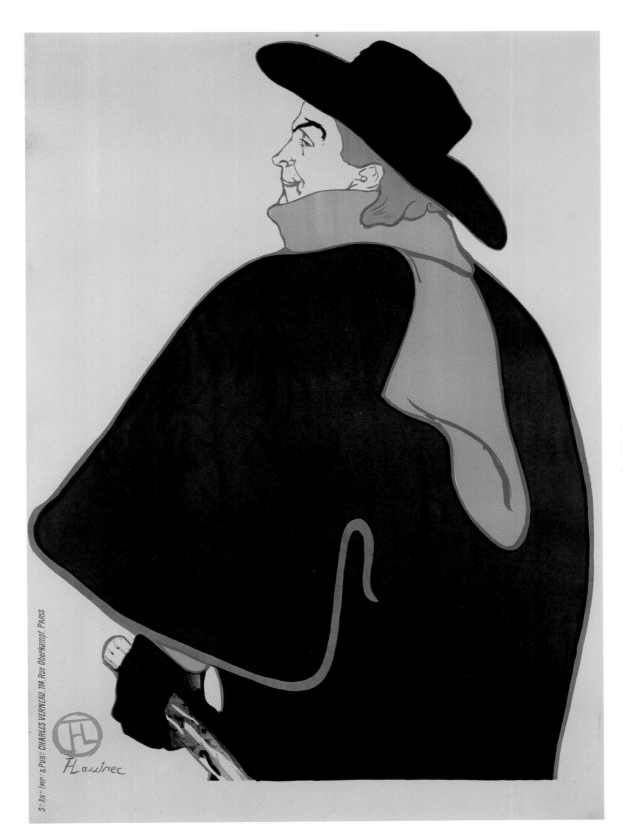

90
Henri de
Toulouse-Lautrec
*Aristide Bruant
dans son cabaret,*
1893

Poster, before
letters, advertising
the cabaret artist
Aristide Bruant

91
Henri de
Toulouse-Lautrec
Study for *Divan
Japonais*, 1893

Study for pl. 92

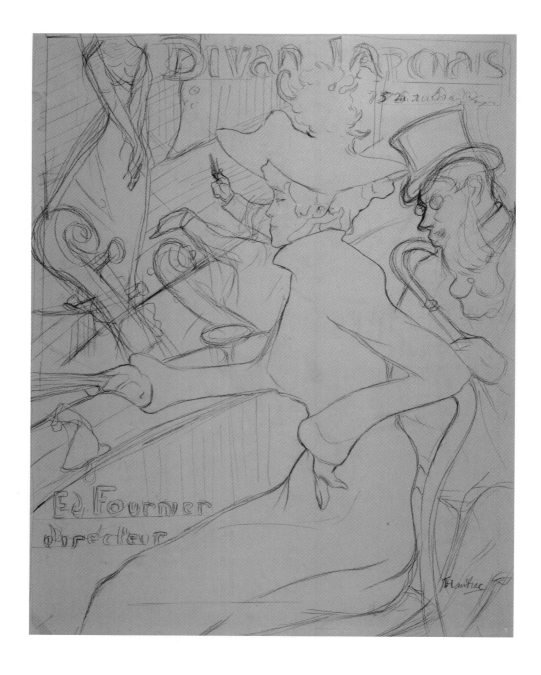

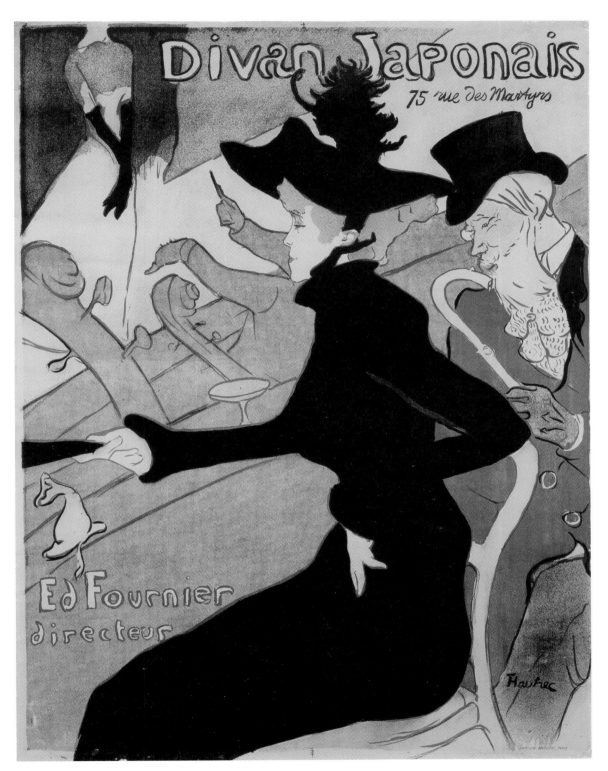

92

Henri de
Toulouse-Lautrec
Divan Japonais,
1893

Poster for the
café-concert the
Divan Japonais

The poster depicts
three celebrities:
the dancer Jane
Avril (center), critic
Édouard Dujardin
(right), and singer
Yvette Guilbert
(upper-left corner),
who is recognizable
by her trademark
black gloves, long
neck, and gaunt
figure.

93
Henri de
Toulouse-Lautrec
Confetti, 1894

Advertisement
for confetti
manufactured by
the paper company
J. & E. Bella in
London

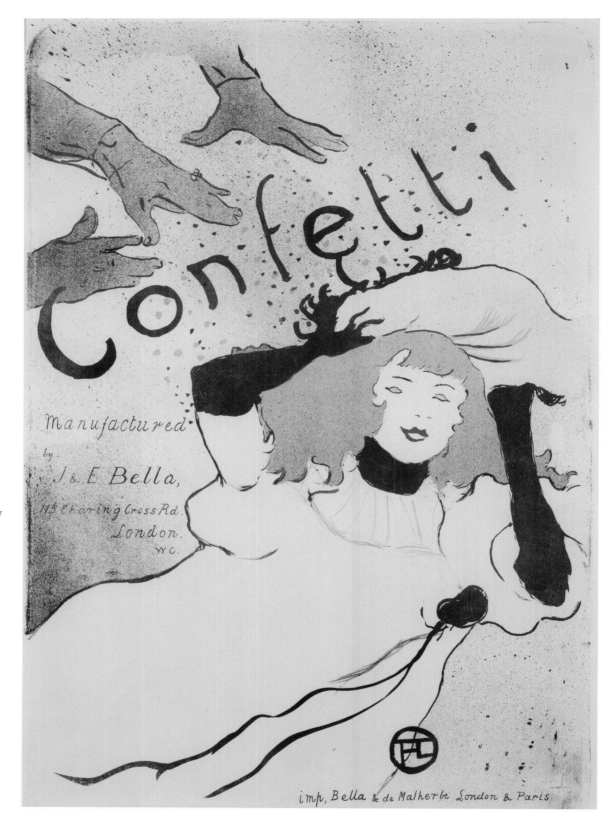

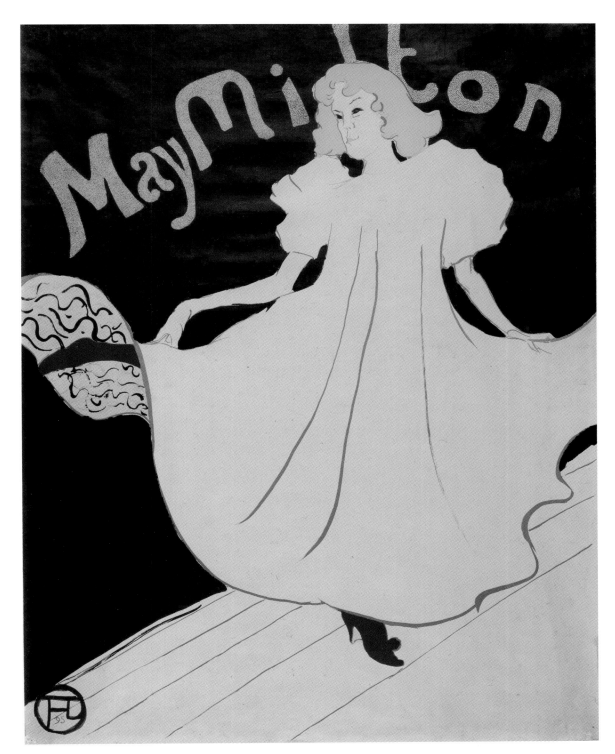

94
Henri de
Toulouse-Lautrec
May Milton, 1895

Poster for May
Milton's American
tour

The English dancer
commissioned the
poster, whose study
can be found on
p. 26, fig. 15.

95
Henri de
Toulouse-Lautrec
Miss May Belfort,
1895

Study for pl. 96

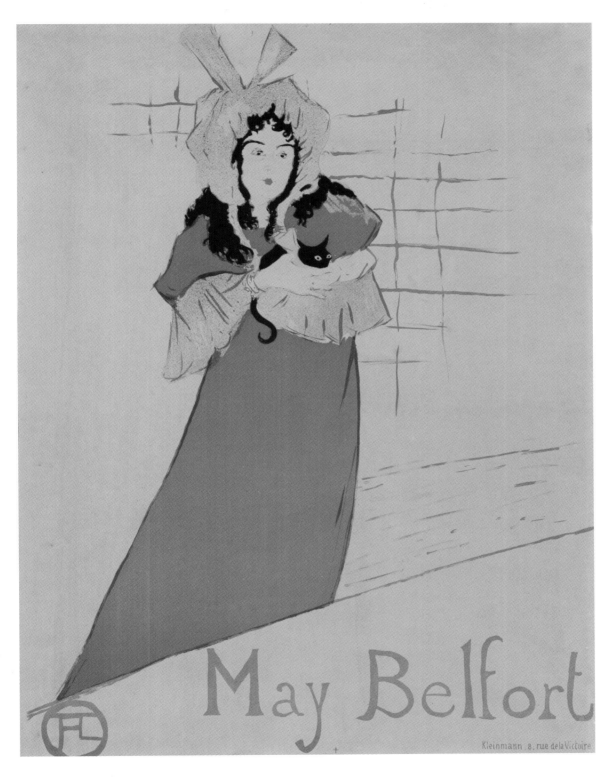

96
Henri de
Toulouse-Lautrec
May Belfort, 1895

Poster for the Irish
singer May Belfort,
performing at the
Petit Casino

Belfort often wore
childlike clothing
and carried a
black kitten as she
sang songs full of
suggestive lyrics.

97
Henri de
Toulouse-Lautrec
La Revue blanche,
1895

Poster for the
journal *La Revue
blanche*

This example is
one of the special
*publications
artistiques* printed
without letters for
poster collectors.

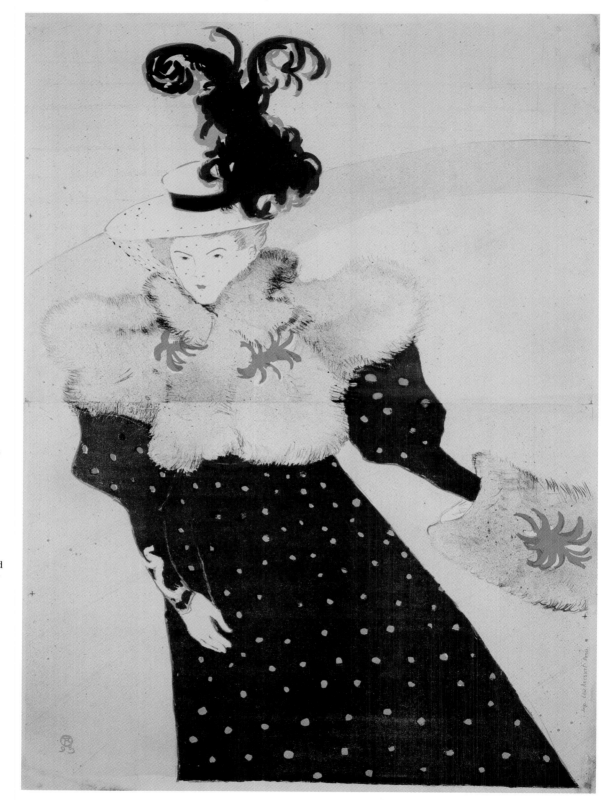

98
Henri de Toulouse-Lautrec
The Ault & Wiborg Co. (Au concert), 1896

Poster for Ault & Wiborg Co. of Cincinnati

The company was an American manufacturer of printing inks.

99
Henri de
Toulouse-Lautrec
L'Artisan Moderne,
1896

Poster for the
designers' collective
L'Artisan Moderne,
founded by André
Marty

The Belgian artisan
Henri Nocq is
depicted to the
right carrying
a toolbox with the
name Niederkorn
(a furniture designer
from the group)
and Lautrec's
monogram.

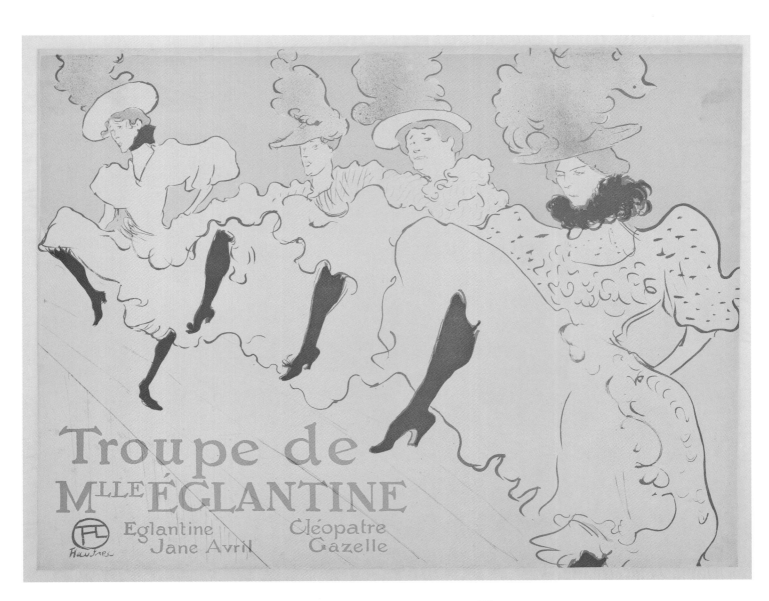

100

Henri de Toulouse-Lautrec
Troupe de Mademoiselle Églantine, 1896

Poster for the London appearance of a dance troupe

Jane Avril commissioned the poster for the company, which consisted of herself, Cléopatre, Églantine, and Gazelle.

101
Henri de Toulouse-Lautrec
L'Aube, 1896

Poster for the illustrated left-
wing periodical *L'Aube* (Dawn)

26 quai d'Orle

102
Henri de
Toulouse-Lautrec
Jane Avril, 1899

Poster
commissioned
by the dancer
Jane Avril

For reasons
unknown, the
poster was never
distributed or
posted throughout
the city.

- 150 -

103
Henri de
Toulouse-Lautrec
La Gitane, 1899

Poster for the
play *La Gitane*
(The Gypsy) by
Jean Richepin

This example is
an extremely rare
color variant. It
was Lautrec's last
poster before
his death in 1901.

104
Unknown (L.W.)
Cycles Gladiator, ca. 1895

Poster advertising Gladiator Bicycles

Nothing is known of this artist other
than his/her initials, "L.W."

105
Jacques Villon
Le Grillon, 1899

Poster for Le Grillon,
an American cabaret
in the Latin Quarter

Jane Atché
(French, 1872–1937)
Papier à Cigarettes Job, 1896
Color lithograph
sheet: 28 ¾ × 21 ¼ in. (73 × 54 cm)
Los Angeles County Museum of Art,
Kurt J. Wagner, M.D., and C. Kathleen
Wagner Collection (M.87.294.1)
plate 1

Marc-Auguste Bastard
(Swiss, 1863–1926)
Bières de la Meuse, 1896
Color lithograph
image: 56 ¾ × 35 ⁹⁄₁₆ in. (144.2 × 90.3 cm)
sheet: 59 ³⁄₁₆ × 38 ⁵⁄₁₆ in. (150.3 × 97.3 cm)
Milwaukee Art Museum, Gift of Dr.
and Mrs. Milton F. Gutglass, M1988.159
plate 2

Paul Berthon
(French, 1872–1909)

Salon des Cent, 1895
Color lithograph
sheet: 20 ½ × 14 ³⁄₁₆ in. (52.1 × 36 cm)
Los Angeles County Museum of Art,
Kurt J. Wagner, M.D., and C. Kathleen
Wagner Collection (M.87.294.3)
plate 3

Cover for *Les Maîtres de l'affiche*, 1898
Embossed cloth binding
16 × 12 ½ × ½ in. (40.6 × 31.8 × 1.3 cm)
Collection of William V. DeLind
figure 10

Source des Roches, 1899
Color lithograph
image: 16 ⅛ × 18 ⅝ in. (41 × 47.3 cm)
sheet: 18 ⅛ × 20 ⅝ in. (46 × 52.4 cm)
Milwaukee Art Museum, Gift of Dr.
and Mrs. Milton F. Gutglass, M1998.156
plate 4

Les Boules de neige, 1900
Color lithograph
image: 15 ½ × 21 ⅛ in. (39.4 × 53.7 cm)
sheet: 19 ¾ × 25 ¾ in. (50.2 × 65.4 cm)
Milwaukee Art Museum, Gift of Dr.
and Mrs. Milton F. Gutglass, M1998.155
plate 5

Pierre Bonnard
(French, 1867–1947)

France-Champagne, Study for [recto/
verso], ca. 1889
Pen and black ink on paper
sheet: 12 ³⁄₁₆ × 7 ¹³⁄₁₆ in. (30.9 × 19.9 cm)
National Gallery of Art, Washington,
Virginia and Ira Jackson Collection,
2001.136.30a,b
plate 6

France-Champagne, 1889–91
Color lithograph
image: 30 ½ × 22 ¾ in. (77.4 × 57.8 cm)
sheet: 31 ¾ × 23 ¹³⁄₁₆ in. (80.6 × 60.5 cm)
The Art Institute of Chicago,
Restricted Gift of Dr. and Mrs. Martin
L. Gecht, 1991.218
plate 7

La Revue blanche, 1894
Color lithograph
image: 22 ⅞ × 20 ½ in. (58.1 × 52.1 cm)
sheet: 29 ⅜ × 22 ¹³⁄₁₆ in. (74.6 × 57.9 cm)
Grand Rapids Art Museum, Purchase,
Peter M. Wege, 2005.5
plate 8

Salon des Cent (Study for a poster),
ca. 1896
Pastel, white heightening, and colored
crayon on paper
sheet: 9 ¹⁄₁₆ × 7 ⅞ in. (23 × 20 cm)
Galerie Berès, Paris
plate 10

Salon des Cent, 1896
Color lithograph
image: 24 ³⁄₁₆ × 16 ½ in. (61.4 × 41.9 cm)
sheet: 24 ¹³⁄₁₆ × 17 ¹¹⁄₁₆ in. (63.1 × 45 cm)
Grand Rapids Art Museum, Purchase,
Peter M. Wege, 2007.15
plate 11

L'Estampe et l'affiche, 1897
Color lithograph
sheet: 31 ¹³⁄₁₆ × 23 ⅝ in. (80.8 × 60 cm)
National Gallery of Art, Washington,
Virginia and Ira Jackson Collection,
2000.180.6
plate 9

Félix-Hilaire Buhot
(French, 1847–1898)
Winter in Paris or *Paris in the Snow*,
1879
Etching, aquatint, spit bite etching,
soft-ground etching, drypoint, and
scraping
plate: 9 ¼ × 13 ⅝ in. (23.5 × 34.6 cm)
sheet: 11 ⅞ × 16 ¹⁵⁄₁₆ in. (30.2 × 43 cm)
Milwaukee Art Museum, Purchase,
Edna Lee Hass Fund, M2011.21
figure 3

Leonetto Cappiello
(Italian, 1875–1942, active in France)

Le Frou-Frou, 1899
Color lithograph
image: 59 ¹⁄₁₆ × 39 ¹⁵⁄₁₆ in. (150 × 101.5 cm)
sheet: 68 ⅛ × 58 ¼ in. (173.1 × 148 cm)
Collection Zimmerli Art Museum at
Rutgers University, Gift of Mr. and
Mrs. Edward Quinn, 1986.0852
plate 12

Le Petit Coquin, 1901
Color lithograph
sheet: 55 ⅛ × 39 ⅜ in. (140 × 100 cm)
Prints & Photographs Division, Library
of Congress, Washington, DC
plate 13

Leonetto Cappiello (continued)

Ferrari Nouilles Macaronis, ca. 1903
Color lithograph
sheet: 45 ¾ × 62 in. (116.2 × 157.5 cm)
Prints & Photographs Division, Library
of Congress, Washington, DC
plate 15

Chocolat Klaus, 1903
Color lithograph
sheet: 62 ¾ × 45 ⅝ in. (159.4 × 115.9 cm)
The Rennert Collection, New York City
plate 14

Paquet Pernot, 1905
Color lithograph
sheet: 63 × 42 ⅝ in. (160 × 108.3 cm)
Prints & Photographs Division, Library
of Congress, Washington, DC
plate 16

Automobiles Brasier, 1906
Color lithograph
image: 114 × 43 ½ in. (289.5 × 110.5 cm)
sheet: 119 ¹¹⁄₁₆ × 49 ⁷⁄₁₆ in.
(304 × 125.5 cm)
Collection Zimmerli Art Museum at
Rutgers University, museum purchase,
David A. and Mildred H. Morse Art
Acquisition Fund, 1989.1385.001
plate 17

Maurin Quina, 1908
Color lithograph
image: 59 ⅛ × 42 ⅜ in. (150.2 × 107.6 cm)
sheet: 63 ³⁄₁₆ × 46 ¹³⁄₁₆ in.
(160.5 × 118.9 cm)
Milwaukee Art Museum, Purchase,
Peer Birch Memorial Fund, M2008.88
plate 18

Jules Chéret
(French, 1836–1932)

La Quenouille de verre, 1873
Color lithograph
image: 26 ¹¹⁄₁₆ × 20 ¹⁵⁄₁₆ in. (67.8 × 53.2 cm)
sheet: 30 × 22 ⅛ in. (76.2 × 56.2 cm)
Milwaukee Art Museum, Gift of Mrs.
Richard Peltz, M2010.53
plate 19

Folies-Bergère: Les Tziganes, 1874
Color lithograph
image: 33 ¾ × 47 in. (85.7 × 119.4 cm)
sheet: 35 ⅜ × 49 ¼ in. (89.9 × 125.1 cm)
Collection of Jim and Sue Wiechmann
plate 20

Frascati, 1874
Color lithograph
image: 44 ¾ × 62 ½ in. (113.7 × 158.7 cm)
sheet: 47 ⁷⁄₁₆ × 66 ¹⁵⁄₁₆ in. (120.5 × 170 cm)
Collection Zimmerli Art Museum at
Rutgers University, museum purchase,
Class of 1937 Art Purchase Fund,
82.053.001
plate 21

*Folies-Bergère: La Charmeuse
de serpents*, 1875
Color lithograph
image: 28 ¹⁵⁄₁₆ × 22 ³⁄₁₆ in. (73.5 × 56.4 cm)
sheet: 31 ¼ × 24 ⅜ in. (79.4 × 61.9 cm)
Collection of Jim and Sue Wiechmann
plate 23

Folies-Bergère: Le Dompteur noir,
1875
Color lithograph
image: 30 ¼ × 22 ¹³⁄₁₆ in. (76.8 × 57.9 cm)
sheet: 31 ½ × 24 in. (80 × 61 cm)
Collection of Jim and Sue Wiechmann
plate 22

Les Girard, 1875/78 or 1880/81
Charcoal on beige laid paper
22 ³⁄₁₆ × 16 ⁷⁄₁₆ in. (56.4 × 41.8 cm)
Princeton University Art Museum,
Bequest of Dan Fellows Platt,
Class of 1895, x1948-1110
plate 28

L'Horloge: Les Girard,
1875/78 or 1880/81
Color lithograph
image: 21 ⅜ × 16 ⅛ in. (54.3 × 41 cm)
sheet: 22 ¾ × 17 ¼ in. (57.8 × 43.8 cm)
Collection of Jim and Sue Wiechmann
plate 29

L'Horloge Champs-Élysées,
Maquette for, 1876
Watercolor and gouache on paper
sheet: 45 × 31 ⅞ in. (114.3 × 81 cm)
Collection of Jim and Sue Wiechmann
plate 24

L'Horloge Champs-Élysées, 1876
Color lithograph
image: 21 ¹⁄₁₆ × 16 ½ in. (53.5 × 41.9 cm)
sheet: 21 ¹³⁄₁₆ × 17 ⅛ in. (55.4 × 43.5 cm)
Collection of Jim and Sue Wiechmann
plate 25

Folies-Bergère: Les Hanlon-Lees, 1878
Color lithograph
image: 22 ⅛ × 15 ⁹⁄₁₆ in. (56.2 × 39.5 cm)
sheet: 23 ¼ × 16 ⅝ in. (59.1 × 42.2 cm)
Collection Zimmerli Art Museum at
Rutgers University, museum purchase,
Mindy and Ramon Tublitz Fund,
1992.1393
plate 26

*L'Horloge: Le Pékin de Pékin
créé par Suiram*, 1878
Color lithograph
image: 21 ½ × 14 ½ in. (54.6 × 36.8 cm)
sheet: 23 ⁹⁄₁₆ × 16 ⅝ in. (59.9 × 42.2 cm)
Collection of Jim and Sue Wiechmann
plate 27

Concert Ambassadeurs, 1881
Color lithograph
image: 45 ⅞ × 31 ⁵⁄₁₆ in. (116.5 × 79.5 cm)
sheet: 47 ¹¹⁄₁₆ × 33 ⅜ in. (121.1 × 84.8 cm)
Collection of Jim and Sue Wiechmann
plate 30

Bal du Moulin Rouge, 1889
Color lithograph
image: 47 ¾ × 34 in. (121.3 × 86.4 cm)
sheet: 48 ½ × 35 in. (123.2 × 88.9 cm)
Collection of Jim and Sue Wiechmann
plate 31

Alcazar d'Été, 1890
Color lithograph
image: 45 ⅞ × 32 in. (116.5 × 81.3 cm)
sheet: 48 ⅞ × 34 in. (124.1 × 86.4 cm)
Milwaukee Art Museum, Gift of Dr.
and Mrs. Milton F. Gutglass, M1998.157
plate 34

Aux Buttes Chaumont, 1890
Color lithograph
image: 46 × 32 ³⁄₁₆ in. (116.8 × 81.8 cm)
sheet: 48 ¹⁄₁₆ × 34 ¼ in. (122.1 × 87 cm)
Collection of Jim and Sue Wiechmann
plate 32

Jardin de Paris, 1890
Color lithograph
image: 48 ⅜ × 32 ⅜ in. (122.9 × 82.2 cm)
sheet: 49 ⅛ × 33 ¾ in. (124.8 × 85.7 cm)
Milwaukee Art Museum, Gift of Dr.
and Mrs. Milton F. Gutglass, M1998.158
plate 33

La Comédie, 1891
Color lithograph
image: 46 ¹⁵⁄₁₆ × 32 ¼ in. (119.2 × 81.9 cm)
sheet: 49 × 34 ½ in. (124.5 × 87.6 cm)
Collection of Jim and Sue Wiechmann
plate 38

La Danse, 1891
Color lithograph
image: 47 × 32 ⅛ in. (119.4 × 81.6 cm)
sheet: 49 ¼ × 39 ½ in. (125.1 × 100.3 cm)
Collection of Jim and Sue Wiechmann
plate 37

La Musique, 1891
Color lithograph
image: 46 ⅞ × 32 in. (119.1 × 81.3 cm)
sheet: 49 × 34 ⁵⁄₁₆ in. (124.5 × 87.2 cm)
Collection of Jim and Sue Wiechmann
plate 36

La Pantomime, 1891
Color lithograph
image: 47 × 32 ⅛ in. (119.4 × 81.6 cm)
sheet: 49 ⅛ × 34 ⅛ in. (124.8 × 86.7 cm)
Collection of Jim and Sue Wiechmann
plate 35

Pantomimes lumineuses, 1892
Color lithograph
image: 46½ × 31 ⅝ in. (118.1 × 80.3 cm)
sheet: 48 ¾ × 34 ¾ in. (123.8 × 88.3 cm)
Milwaukee Art Museum, Gift of Dr.
and Mrs. Milton F. Gutglass, M1998.160
plate 39

Folies-Bergère: La Loïe Fuller, 1893
Color lithograph
image: 47 × 32½ in. (119.4 × 82.6 cm)
sheet: 48 ⅛ × 32½ in. (122.2 × 82.6 cm)
Collection of Jim and Sue Wiechmann
plate 40

Pastilles Géraudel, 1895
Color lithograph
image: 46⅝ × 33 ¾ in. (118.4 × 85.7 cm)
sheet: 48 ⅞ × 34½ in. (124.1 × 87.6 cm)
Collection of Jim and Sue Wiechmann
plate 43

Folies-Bergère: La Danse du Feu,
1897
Color lithograph
image: 47 ¾ × 32 in. (121.3 × 81.3 cm)
sheet: 49 ⅛ × 34½ in. (124.8 × 87.6 cm)
Collection of Jim and Sue Wiechmann
plate 41

Folies-Bergère: Loïe Fuller, 1897
Color lithograph
image: 46 ¾ × 32 ¼ in. (118.8 × 81.9 cm)
sheet: 48 × 33 ⅞ in. (121.9 × 86 cm)
Collection of Jim and Sue Wiechmann
plate 42

Pippermint, 1899
Color lithograph
image: 45 ⅛ × 32 ¼ in. (114.6 × 81.9 cm)
sheet: 49 × 34 ⅞ in. (124.5 × 88.6 cm)
Milwaukee Art Museum, Gift of Dr.
and Mrs. Milton F. Gutglass, M1998.161
plate 44

Saxoléine, 1900
Color lithograph
image: 48 × 31 ¾ in. (121.9 × 80.7 cm)
sheet: 50 × 31 ¾ in. (127 × 80.7 cm)
Milwaukee Art Museum, Gift of Dr.
and Mrs. Milton F. Gutglass, M1998.159
plate 45

Alfred Choubrac
(French, 1853–1902)

Fin de Siècle, 1891
Color lithograph
sheet: 47 ¼ × 31½ in. (120 × 80 cm)
The Rennert Collection, New York City
plate 46

Fin de Siècle (Censored), 1891
Color lithograph
sheet: 63 × 46 ⁵⁄₁₆ in. (160 × 117.7 cm)
The Rennert Collection, New York City
plate 47

Maurice Denis
(French, 1870–1943)
La Dépêche de Toulouse, 1892
Color lithograph
sheet: 54½ × 37½ in. (138.4 × 95.3 cm)
The Museum of Modern Art, New York
plate 48

Maxime Dethomas
(French, 1867–1929)
Montmartre, 1897
Color lithograph
image: 30⅞ × 22¹⁵⁄₁₆ in. (78.4 × 58.3 cm)
sheet: 31½ × 23 ¹¹⁄₁₆ in. (80 × 60.2 cm)
Collection Zimmerli Art Museum at
Rutgers University, Gift of Herbert D.
and Ruth Schimmel, 1994.0382
plate 49

Georges de Feure
(French, 1868–1928)

Paris-Almanach, 1895
Color lithograph
image: 31 ⅛ × 23⅜ in. (79.1 × 59.4 cm)
sheet: 31 ¾ × 24 ⅝ in. (80.7 × 62.6 cm)
Milwaukee Art Museum, Gift of Dr.
and Mrs. Milton F. Gutglass, M1998.162
plate 50

Affiches et Estampes Pierrefort, 1898
Color lithograph
sheet: 24 ¼ × 31⅜ in. (61.6 × 79.7 cm)
The Rennert Collection, New York City
plate 51

Eugène Grasset
(French, b. Switzerland, 1845–1917)

Jeanne d'Arc, Sarah Bernhardt,
1889/90
Color lithograph
sheet: 47 ⅛ × 29 ⁷⁄₁₆ in. (119.7 × 74.8 cm)
Milwaukee Art Museum, Gift of Dr.
and Mrs. Milton F. Gutglass, M1986.103
plate 52

Encre L. Marquet, 1892
Color lithograph
image: 42½ × 28 ¾ in. (108 × 73 cm)
sheet: 44⅜ × 29 ⅝ in. (112.7 × 75.3 cm)
Milwaukee Art Museum, Gift of Dr.
and Mrs. Milton F. Gutglass, M1998.163
plate 53

*Marque Georges Richard Cycles
& Automobiles*, 1899
Color lithograph
image: 40 ¼ × 57 ⁹⁄₁₆ in. (102.2 × 145.3 cm)
sheet: 42½ × 59 in. (108 × 149.9 cm)
Machinery Row Bicycles, Madison, WI
plate 54

Henri Gray
(French, 1858–1924)

Pétrole Stella, 1897
Color lithograph
image: 51 × 39 in. (129.5 × 99.1 cm)
Prints & Photographs Division, Library
of Congress, Washington, DC
plate 55

Cycles Sirius, 1899
Color lithograph
sheet: 55 × 38⅝ in. (139.7 × 98.1 cm)
The Rennert Collection, New York City
plate 56

Jules-Alexandre Grün
(French, 1868–1934)

Guide de l'étranger à Montmartre,
1900
Color lithograph
image: 23⅝ × 15 ¹⁵⁄₁₆ in. (60 × 40.5 cm)
sheet: 25 ¹³⁄₁₆ × 18 ⅛ in. (65.5 × 46 cm)
Collection Zimmerli Art Museum
at Rutgers University, museum
purchase, The Phillip Dennis Cate 25th
Anniversary Fund, 1995.0127
plate 57

Revue à Poivre, 1904
Color lithograph
image: 47 × 31½ in. (119.4 × 80 cm)
sheet: 48⅜ × 34 ¹⁵⁄₁₆ in. (122.9 × 88.7 cm)
Collection of Jim and Sue Wiechmann
plate 58

René Georges Hermann-Paul
(French, 1874–1940)
Salon des Cent, 1895
Color lithograph
image: 22 ⁷⁄₁₆ × 14 ¾ in. (57 × 37.5 cm)
sheet: 24 ⅛ × 16 ¹³⁄₁₆ in. (61.2 × 42.7 cm)
Collection Zimmerli Art Museum at
Rutgers University, Gift of Ralph and
Barbara Voorhees, 85.141.033
plate 59

Henri-Gabriel Ibels
(French, 1867–1936)

Mévisto, 1892
Color lithograph
image and sheet: 66 7/16 × 46 5/8 in.
(168.8 × 118.5 cm)
Collection Zimmerli Art Museum at
Rutgers University, museum purchase,
Friends Purchase Fund, 76.031.006
plate 60

L'Escarmouche; plate 6 from the series
*Les Maîtres de l'affiche (Masters
of the Poster)*, original design 1893,
series reprinting 1896
Color lithograph
image: 11 7/16 × 8 3/4 in. (29.1 × 22.2 cm)
sheet: 15 5/8 × 11 1/16 in. (39.7 × 28.1 cm)
Milwaukee Art Museum, Gift of Kent
and Cecile Anderson, M1991.523
Not illustrated

Salon des Cent, 1893
Color lithograph
image: 23 3/8 × 15 15/16 in. (59.4 × 40.5 cm)
sheet: 24 5/8 × 17 1/2 in. (62.6 × 44.5 cm)
Collection Zimmerli Art Museum at
Rutgers University, museum purchase,
David A. and Mildred H. Morse Art
Acquisition Fund, 82.022.003
plate 61

Mévisto; plate 78 from the series
*Les Maîtres de l'affiche (Masters
of the Poster)*, original design 1892,
published 1897
Color lithograph
image: 12 7/16 × 9 1/8 in. (31.6 × 23.2 cm)
sheet: 15 7/16 × 11 1/16 in. (39.3 × 28.1 cm)
Milwaukee Art Museum, Gift of Kent
and Cecile Anderson, M1991.524
Not illustrated

Pierrefort, 1897
Color lithograph
sheet: 24 1/4 × 31 5/8 in. (61.6 × 80.3 cm)
The Rennert Collection, New York City
plate 62

Henri Gustave Jossot
(French, 1866–1951)
Sardines Jockey-Club, 1897
Color lithograph
image: 46 1/4 × 74 5/16 in. (117.5 × 188.8 cm)
sheet: 55 1/8 × 83 11/16 in. (140 × 212.5 cm)
Collection Zimmerli Art Museum at
Rutgers University, museum purchase,
Class of 1937 Art Purchase Fund,
1991.0020
plate 63

Ernest Kalas
(French, 1861–1928)
Exposition d'affiches artistiques, 1896
Color lithograph
sheet: 52 5/8 × 33 1/4 in. (133.7 × 84.5 cm)
The Rennert Collection, New York City
plate 64

Maximilien Luce
(French, 1858–1941)
La Rue Mouffetard, 1889–90
Oil on canvas
31 5/8 × 25 3/16 in. (80.3 × 64 cm)
Indianapolis Museum of Art,
The Holliday Collection
figure 1

Lucien-Marie-François Métivet
(French, 1863–1930)
Eugénie Buffet: Ambassadeurs, 1893
Color lithograph
sheet: 45 7/8 × 29 1/2 in. (116.5 × 74.9 cm)
Los Angeles County Museum of Art,
Kurt J. Wagner, M.D., and C. Kathleen
Wagner Collection (M.87.294.36)
plate 65

Alphonse Mucha
(Czech, 1860–1939)

Gismonda, 1894–95
Color lithograph
sheet: 83 7/8 × 29 1/2 in. (213 × 74.9 cm)
Los Angeles County Museum of Art,
Kurt J. Wagner, M.D., and C. Kathleen
Wagner Collection (M.87.294.1)
plate 66

La Dame aux Camélias, 1896
Color lithograph
sheet: 81 1/2 × 29 15/16 in. (207 × 76 cm)
Prints & Photographs Division, Library
of Congress, Washington, DC
plate 68

Lorenzaccio, 1896
Color lithograph
sheet: 76 3/4 × 27 1/2 in. (195 × 69.9 cm)
Los Angeles County Museum of
Art, Gift of Kurt J. Wagner, M.D.,
and C. Kathleen Wagner Collection
(M.86.363.5)
plate 67

Salon des Cent, 1896
Color lithograph
sheet: 25 1/4 × 17 in. (64.1 × 43.2 cm)
The Museum of Modern Art, New
York, Gift of Ludwig Charell
plate 69

Sarah Bernhardt, ca. 1898
Chalk on paper
sheet: 19 9/16 × 16 5/16 in. (49.7 × 41.4 cm)
The Art Institute of Chicago,
Restricted Gift of Katherine Kuh,
1965.236
plate 70

Job, 1898
Color lithograph
image: 55 5/16 × 36 3/8 in. (140.5 × 92.4 cm)
sheet: 59 5/8 × 40 in. (151.5 × 101.6 cm)
Milwaukee Art Museum, Purchase,
Gertrude Nunnemacher Schuchardt
Fund, presented by William H.
Schuchardt, M1969.43
plate 71

Cycles Perfecta, 1902
Color lithograph
sheet: 59 1/16 × 41 5/16 in. (150 × 105 cm)
Los Angeles County Museum of Art,
Kurt J. Wagner, M.D., and C. Kathleen
Wagner Collection (M.87.294.40)
plate 72

Manuel Orazi
(Italian, active 1860–1934)
Marie François August Gorguet
(French, 1862–1927)
Theodora; plate 24 from the series
*Les Maîtres de l'affiche (Masters
of the Poster)*, original design 1884,
published 1900
Color lithograph
image: 11 3/8 × 8 1/8 in. (28.9 × 20.6 cm)
sheet: 15 3/4 × 11 3/8 in. (40 × 28.9 cm)
Milwaukee Art Museum, Gift of Kent
and Cecile Anderson, M1992.267
Not illustrated

Manuel Orazi
(Italian, active 1860–1934)

L'Hippodrome, ca. 1900
Color lithograph
image: 89 × 59 1/16 in. (226 × 150 cm)
sheet: 92 × 62 in. (233.7 × 157.5 cm)
Collection Zimmerli Art Museum at
Rutgers University, museum purchase,
Class of 1937 Art Purchase Fund,
84.023.003
plate 74

Loïe Fuller, 1900
Color lithograph
sheet: 79½ × 25 in. (202 × 63.5 cm)
Collection Zimmerli Art Museum at
Rutgers University, museum purchase,
Brother International Corporation
Japonisme Art Acquisition Fund,
1997.0199
plate 75

La Maison Moderne, 1900
Color lithograph
sheet: 31⅝ × 45¼ in. (80.3 × 114.9 cm)
The Rennert Collection, New York City
plate 73

Pal (Jean de Paléologue)
(Romanian, 1860–1942, active in
France)

La Loïe Fuller, ca. 1893
Color lithograph
sheet: 48 × 33 in. (121.9 × 83.8 cm)
Los Angeles County Museum of Art,
Kurt J. Wagner, M.D., and C. Kathleen
Wagner Collection (M.87.294.47)
plate 76

Rayon d'Or, 1895
Color lithograph
sheet: 45¼ × 29⅜ in. (115 × 74.5 cm)
Los Angeles County Museum of Art,
Kurt J. Wagner, M.D., and C. Kathleen
Wagner Collection (M.87.294.48)
plate 77

Déesse, ca. 1898
Color lithograph
image: 54 × 40½ in. (137.2 × 102.9 cm)
sheet: 58½ × 42⅜ in. (148.6 × 107.6 cm)
Machinery Row Bicycles, Madison, WI
plate 78

Henri Rivière
(French, 1864–1951)
Paris in Winter, program for the
1889–90 season of Le Théâtre Libre,
1890
Color lithograph
image: 7¹⁵⁄₁₆ × 11¹¹⁄₁₆ in. (20.1 × 29.7 cm)
sheet: 8⁹⁄₁₆ × 12¼ in. (21.7 × 31.1 cm)
National Gallery of Art, Washington,
Gift of The Atlas Foundation
figure 4

Théophile-Alexandre Steinlen
(Swiss, 1859–1923)

Lait pur stérilisé de la Vingeanne,
1894
Color lithograph
sheet: 54¾ × 39⅜ in. (139 × 100 cm)
Collection of Donald and Donna
Baumgartner
plate 80

Yvette Guilbert, 1894
Color lithograph
sheet: 70⅝ × 29⅞ in. (179.4 × 75.9 cm)
Los Angeles County Museum of Art,
Kurt J. Wagner, M.D., and C. Kathleen
Wagner Collection (M.87.294.53)
plate 79

*Compagnie Française des Chocolats
et des Thés*, 1895
Color lithograph
sheet: 32¼ × 24½ in. (81.9 × 62.2 cm)
Los Angeles County Museum of Art,
Kurt J. Wagner, M.D., and C. Kathleen
Wagner Collection (M.87.294.51)
plate 81

La Rue, 1896
Color lithograph on wove paper,
mounted on canvas
sheet : 93¹⁄₁₆ × 119 in. (236.3 × 302.3 cm)
National Gallery of Canada, Ottawa
plate 83

*Tournée du Chat Noir de Rodolphe
Salis*, 1896
Color lithograph
sheet: 53½ × 37¾ in. (135.9 × 95.9 cm)
Los Angeles County Museum of Art,
Kurt J. Wagner, M.D., and C. Kathleen
Wagner Collection (M.86.363.3)
plate 82

Cocorico, 1899
Color lithograph
sheet: 55⅛ × 39⅜ in. (140 × 100 cm)
Collection of Donald and Donna
Baumgartner
plate 85

Motocycles Comiot, 1899
Color lithograph
sheet: 78 × 54 in. (198.1 × 137.2 cm)
From the Collection of Richard H.
Driehaus, Chicago
plate 86

La Traîte des Blanches, 1899
Color lithograph
sheet: 73 × 48⅝ in. (185.4 × 123.5 cm)
Reva and Philip Shovers
plate 84

Henri de Toulouse-Lautrec
(French, 1864–1901)

Moulin Rouge—La Goulue, 1891
Color lithograph
image: 75 × 45¾ in. (190.5 × 116.2 cm)
sheet: 76⁷⁄₁₆ × 48 in. (194.2 × 121.9 cm)
Milwaukee Art Museum, Gift of
Mrs. Harry Lynde Bradley, M1977.47
plate 87

Ambassadeurs: Aristide Bruant, 1892
Color lithograph
image: 54¾ × 37½ in. (139 × 95.2 cm)
sheet: 57¹⁵⁄₁₆ × 39⁵⁄₁₆ in. (147.2 × 99.9 cm)
The Art Institute of Chicago, Mr. and
Mrs. Carter H. Harrison Collection,
1948.450
plate 89

Reine de Joie, 1892
Color lithograph
image: 54¼ × 36¾ in. (137.8 × 93.4 cm)
sheet: 56¼ × 37¼ in. (142.9 × 94.6 cm)
Milwaukee Art Museum, Gift of
Mrs. Harry Lynde Bradley, M1977.46
plate 88

Aristide Bruant dans son cabaret,
1893
Color lithograph
image: 50¹⁄₁₆ × 37¹¹⁄₁₆ in. (127.2 × 95.7 cm)
sheet: 54¾ × 39⁵⁄₁₆ in. (139.1 × 99.9 cm)
Milwaukee Art Museum, Gift of
Mrs. Harry Lynde Bradley, M1977.51
plate 90

Divan Japonais, Study for, 1893
Black chalk on paper
sheet: 31¾ × 24⅝ in. (80.7 × 62.6 cm)
Collection of Jeffrey H. Loria,
New York, in honor of Sue Selig
Milwaukee only
plate 91

Divan Japonais, 1893
Color lithograph
image: 31⁵⁄₁₆ × 23⁹⁄₁₆ in. (79.5 × 59.9 cm)
sheet: 31⁵⁄₁₆ × 23¹⁵⁄₁₆ in. (79.5 × 60.8 cm)
Milwaukee Art Museum, Gift of
Mrs. Harry Lynde Bradley, M1966.160
plate 92

Confetti, 1894
Color lithograph
image: 22³⁄₁₆ × 15½ in. (56.4 × 39.4 cm)
sheet: 22⁹⁄₁₆ × 17⅝ in. (57.3 × 44.8 cm)
Milwaukee Art Museum, Gift of
Mrs. Harry Lynde Bradley, M1977.50
plate 93

Henri de Toulouse-Lautrec *(continued)*

Miss May Belfort, 1895
Peinture à l'essence and gouache on
paper laid down on canvas
sheet: 32 ¾ × 24 ⅜ in. (83.2 × 61.9 cm)
Collection of Jeffrey H. Loria,
New York, in honor of Sue Selig
Milwaukee only
plate 95

May Belfort, 1895
Color lithograph
image and sheet: 31 ¼ × 23 ⅞ in.
(79.4 × 60.6 cm)
Private collection, P. R.
plate 96

May Milton, 1895
Color lithograph
image and sheet: 30 ½ × 23 ¾ in.
(77.5 × 60.3 cm)
Milwaukee Art Museum, Gift of
Mrs. Harry Lynde Bradley, M1966.161
plate 94

La Revue blanche, 1895
Color lithograph
image: 49 ¼ × 35 ⅞ in. (125.1 × 91.1 cm)
sheet: 50 ½ × 36 ⁷⁄₁₆ in. (128.3 × 92.6 cm)
Milwaukee Art Museum, Gift of
Mrs. Harry Lynde Bradley, M1977.58
plate 97

L'Artisan Moderne, 1896
Color lithograph
image: 35 ¹⁄₁₆ × 24 ½ in. (89.1 × 62.2 cm)
sheet: 35 ¹⁵⁄₁₆ × 24 ¹⁵⁄₁₆ in. (91.3 × 63.3 cm)
Milwaukee Art Museum, Gift of
Mrs. Harry Lynde Bradley, M1977.54
plate 99

L'Aube, 1896
Color lithograph
image and sheet: 23 ¾ × 30 ¾ in.
(60.3 × 78.1 cm)
Milwaukee Art Museum, Gift of
Mrs. Harry Lynde Bradley, M1977.64
plate 101

The Ault & Wilborg Co. (Au concert),
1896
Color lithograph
image: 12 ⅝ × 10 in. (32.1 × 25.4 cm)
sheet: 19 × 14 in. (48.3 × 35.6 cm)
Milwaukee Art Museum, Gift of
Mrs. Harry Lynde Bradley, M1977.63
plate 98

*Troupe de Mademoiselle
Églantine*, 1896
Color lithograph
image and sheet:
24 ⅛ × 31 ⁵⁄₁₆ in. (61.3 × 79.5 cm)
Grand Rapids Art Museum, Purchase,
Peter M. Wege, 2005.4
plate 100

La Gitane, 1899
Color lithograph
image: 35 ¾ × 24 ¹⁵⁄₁₆ in. (90.8 × 63.3 cm)
sheet: 39 ⅝ × 25 ½ in. (100.7 × 64.8 cm)
Milwaukee Art Museum, Gift of
Mrs. Harry Lynde Bradley, M1964.50
plate 103

Jane Avril, 1899
Color lithograph
image and sheet: 21 ¾ × 14 ⅞ in.
(55.3 × 37.8 cm)
Private collection, P. R.
plate 102

Unknown (L.W.)
Cycles Gladiator, ca. 1895
Color lithograph
sheet: 38 ½ × 53 in. (97.8 × 134.6 cm)
Private collection, Potomac, MD
plate 104

Félix Vallotton
(Swiss, 1865–1925)

Print Lovers, 1892
Woodcut
image: 8 ¹⁄₁₆ × 10 ¾ in. (20.5 × 27.3 cm)
block: 6 ⅝ × 11 ⁵⁄₁₆ in. (16.8 × 28.7 cm)
sheet: 10 × 12 ¾ in. (25.4 × 32.4 cm)
Milwaukee Art Museum, Gift of the
Hockerman Charitable Trust, M2011.31
figure 8

Book jacket for *Badauderies
parisiennes—Les Rassemblements,
physiologies de la rue*, 1896
Photo-relief
sheet: 13 ⁷⁄₁₆ × 21 ⁵⁄₁₆ in. (34.1 × 54.2 cm)
National Gallery of Art, Washington,
Virginia and Ira Jackson Collection,
Gift in memory of Virginia H. Jackson
figure 6

Jacques Villon
(French, 1875–1963)
Le Grillon, 1899
Color lithograph
sheet: 49 × 34 ⅝ in. (124.5 × 88 cm)
The Museum of Modern Art, New York
plate 105

SELECTED BIBLIOGRAPHY

Abdy, Jane. *The French Poster: Chéret to Cappiello.* New York: Clarkson N. Potter, Inc., 1969.

Adriani, Götz. *Toulouse-Lautrec: The Complete Graphic Works; A Catalogue Raisonné.* New York: Thames and Hudson, 1988.

Alexandre, Arsène. "French Posters and Book-Covers," *Scribner's Magazine* 17 (May 1895), pp. 603–614.

Appelbaum, Stanley. *The Complete "Masters of the Poster": All 256 Color Plates from "Les Maîtres de L'Affiche."* New York: Dover, 1990.

Arwas, Victor, Jana Brabcová-Orlíková, and Anna Dvořák. *Alphonse Mucha: The Spirit of Art Nouveau.* Alexandria, VA: Art Services International, 1998.

D'Avenel, Georges. *Le Mécanisme de la vie moderne.* Paris: Librairie Armand Colin, 1902.

Bargiel, Réjane, and Ségolène Le Men. *L'Affiche de librairie au XIXᵉ siècle.* Paris: Réunion des musées nationaux, 1987.

———, eds. *La Belle Époque de Jules Chéret: De l'affiche au décor.* Paris: Les Arts Décoratifs / Bibliothèque Nationale de France, Paris, 2010.

Bargiel-Harry, Réjane, and Christophe Zagrodzki. *Le Livre de l'affiche: The Book of the Poster.* Paris: Éditions alternatives, 1985.

Bargiel, Réjane, and Christophe Zagrodzki. *Steinlen affichiste: Catalogue raisonné.* Lausanne: Éditions du Grand-Pont, 1986.

Barnicoat, John. *Posters: A Concise History.* London: Thames and Hudson, 1972, reprint 2003.

Bieri, Helen Thomson, with contributions by Patricia Eckert Boyer and Jocelyne van Deputte. *Les Affiches du Salon des Cent: Bonnard, Ensor, Grasset, Ibels, Mucha, Toulouse-Lautrec.* Gingins, Switzerland: Fondation Neumann, 1999.

Bouvet, Francis. *Bonnard: The Complete Graphic Work.* Translated by Jane Brenton. New York: Rizzoli, 1981.

Carter, Karen L. "L'Âge de l'affiche: The Reception, Display and Collection of Posters in Fin-de-Siècle Paris." PhD diss., University of Chicago, 2001.

———. "Unfit for Public Display: Female Sexuality and the Censorship of Fin-de-Siècle Publicity Posters." *Early Popular Visual Culture* 8, no. 2 (May 2010), pp. 107–124.

Cate, Phillip Dennis, "The French Poster, 1868–1900." In David W. Kiehl, Phillip Dennis Cate, and Nancy Finlay. *American Art Posters of the 1890s in the Metropolitan Museum of Art.* New York: The Metropolitan Museum of Art, 1987, pp. 57–72.

Cate, Phillip Dennis. *The Graphic Arts and French Society, 1871–1914.* New Brunswick, NJ: Rutgers University Press, 1988.

Cate, Phillip Dennis, ed. *Toulouse-Lautrec and the French Imprint: Fin-de-Siècle Posters in Paris, Brussels, and Barcelona.* New Brunswick, NJ: Jane Voorhees Zimmerli Art Museum, Rutgers, The State University of New Jersey, 2005.

Cate, Phillip Dennis, and Patricia Eckert Boyer. *The Circle of Toulouse-Lautrec: An Exhibition of the Work of the Artist and His Close Associates.* New Brunswick, NJ: Jane Voorhees Zimmerli Art Museum, Rutgers, The State University of New Jersey, 1985.

Cate, Phillip Dennis, and Susan Gill. *Théophile-Alexandre Steinlen.* Salt Lake City: G. M. Smith, 1982.

Cate, Phillip Dennis, and Sinclair Hitchings. *The Color Revolution: Color Lithography in France, 1890–1900.* Santa Barbara: P. Smith, 1978.

Collins, Bradford R., Jr. "Jules Chéret and the Nineteenth-Century French Poster." PhD diss., Yale University, 1980.

———. "The Poster as Art: Jules Chéret and the Struggle for the Equality of the Arts in Late Nineteenth-Century France." *Design Issues* II, no. 1 (Spring 1985), pp. 41–50.

Deputte, Jocelyne van. *Le Salon des Cent, 1894–1900: Affiches d'artistes.* Paris: Paris-Musées, 1994.

Dhotel-Velliet, Claudine. *Jane Atché: 1872–1937.* Lille: Le Pont du Nord, 2009.

Feinblatt, Ebria, and Bruce Davis. *Toulouse-Lautrec and His Contemporaries: Posters of the Belle Époque from the Wagner Collection.* Los Angeles: Los Angeles County Museum of Art, 1985.

Gallo, Max, and Arturo Carlo Quintavalle. *L'Affiche: Miroir de l'histoire, miroir de la vie.* Paris: Robert Laffont, 1989.

Geyer, Marie-Jeanne, and Thierry Laps, eds. *Le Salon de la rue: L'Affiche illustrée de 1880 à 1910.* Strasbourg: Éditions des Musées de Strasbourg, 2007.

Gold, Laura. *First Ladies of the Poster: The Gold Collection.* New York: Poster Art Library, 1998.

Goldwater, Robert J. "L'Affiche Moderne: A Revival of Poster Art after 1880." *Gazette des Beaux-Arts* 22, no. 910 (December 1942), pp. 173–182.

Hahn, H. Hazel. "Boulevard Culture and Advertising as Spectacle in Nineteenth-Century Paris." In *The City and the Senses: Urban Culture since 1500*, edited by Alexander Cowan and Jill Steward. Burlington, VT: Ashgate, 2007, pp. 156–175.

———. "Du flâneur au consommateur: Spectacle et consommation sur les Grands Boulevards, 1840–1914." *Romantisme* 134, no. 4 (2006), pp. 67–78.

———. *Scenes of Parisian Modernity: Culture and Consumption in the Nineteenth Century.* New York: Palgrave Macmillan, 2009.

Herbert, Robert L. "Seurat and Jules Chéret." *Art Bulletin* 40, no. 2 (June 1958), pp. 156–158.

Hiatt, Charles. *Picture Posters: A Short History of the Illustrated Placard.* London: G. Bell and Sons, 1896.

Hillier, Bevis. *Posters.* New York: Stein and Day, 1969.

Ireson, Nancy, and Anna Gruetzner Robins. *Toulouse-Lautrec and Jane Avril: Beyond the Moulin Rouge.* London: The Courtauld Gallery in association with Paul Holberton Publishing, 2011.

Iskin, Ruth E. "The *Flâneuse* in French Fin-de-Siècle Posters: Advertising Images of Modern Women in Paris." In *The Invisible Flaneuse? Gender, Public Space, and Visual Culture in Nineteenth-Century Paris*, edited by Aruna D'Souza and Tom McDonough. Manchester: Manchester University Press, 2006, pp. 113–128.

———. "Popularising New Women in Belle Époque Advertising Posters." In *"A Belle Époque"? Women and Feminism in French Society and Culture, 1890–1910s*, edited by Diana Holmes and Carrie Tarr. Oxford: Berghahn Books, 2005.

Ives, Colta Feller, Helen Emery Giambruni, and Sasha M. Newman. *Pierre Bonnard: The Graphic Art.* New York: The Metropolitan Museum of Art, 1989.

Koch, Robert. "The Poster Movement and 'Art Nouveau.'" *Gazette des Beaux-Arts* 50 (November 1957), pp. 285–296.

La Plume, no. 110 (November 15, 1893).

Le Men, Ségolène. "L'Art de l'affiche à l'Exposition Universelle de 1889." *Revue de la Bibliothèque Nationale* 40 (June 1991), pp. 64–71.

Le Men, Ségolène. *Seurat & Chéret: Le peintre, le cirque et l'affiche.* Paris: CNRS Éditions, 2003.

Lelieur, Anne-Claude, and Raymond Bachollet. *Célébrités à l'affiche.* Paris: Conti, 1989.

Lepdor, Catherine, ed. *Eugène Grasset, 1845–1917: L'Art et l'ornement.* Milan: 5 Continents Editions, 2011.

Maindron, Ernest. *Les Affiches illustrées (1886–1895).* Paris: G. Boudet, 1896.

Martin, Marc. "L'Affiche de publicité à Paris et en France à la fin du XIXᵉ siècle." In *La Terre et la cité: Mélanges offerts à Philippe Vigier*, edited by Alain Faure, Alain Plessis, and Jean-Claude Farcy. Paris: Créaphis, 1994, pp. 373–386.

Mermet, Emile. *La Publicité en France: Guide pratique.* Paris: Chaix, 1878.

Mucha, Jiří. *Alphonse Mucha: The Master of Art Nouveau.* Prague: Artia, 1966.

Plantin, Yves. *Eugène Grasset: Lausanne 1841–Sceaux 1917.* Paris: Yves Plantin & Françoise Blondel, 1980.

Reaves, Wendy Wick. *Ballyhoo! Posters as Portraiture.* Washington, DC: National Portrait Gallery, Smithsonian, 2008.

Rennert, Jack. *Cappiello: The Posters of Leonetto Cappiello.* New York: Poster Art Library, Posters Please, Inc., 2004.

———. *Posters of the Belle Époque: The Wine Spectator Collection.* New York: Wine Spectator Press, 1990.

Rennert, Jack, and Alain Weill. *Alphonse Mucha: The Complete Posters and Panels.* Boston: G. K. Hall, 1984.

Segal, Aaron J. "Commercial Immanence: The Poster and Urban Territory in Nineteenth-Century France." In *Advertising and the European City: Historical Perspectives*, edited by Clemens Wischermann and Elliott Shore. Aldershot, Hants, England: Ashgate, 2000, pp. 113–138.

Shapiro, Barbara Stern, and Anne E. Havinga. *Pleasures of Paris: Daumier to Picasso.* Boston: Museum of Fine Arts, Boston, 1991.

Talmeyr, Maurice. "L'Âge de l'affiche." *Revue des deux mondes*, September 1, 1896, pp. 201–216.

Thomson, Richard, Phillip Dennis Cate, and Mary Weaver Chapin. *Toulouse-Lautrec and Montmartre.* Washington, DC: National Gallery of Art, 2005.

Verhagen, Marcus. "The Poster in Fin-de-Siècle Paris: 'That Mobile and Degenerate Art.'" In *Cinema and the Invention of Modern Life*, edited by Leo Charney and Vanessa R. Schwartz. Berkeley: University of California Press, 1995, pp. 103–129.

Waller, Bret, and Grace Seiberling. *Artists of La Revue blanche: Bonnard, Toulouse-Lautrec, Vallotton, Vuillard.* Rochester, NY: Memorial Art Gallery, 1984.

Weill, Alain, and Israel Perry. *Jules Alexandre Grün: The Posters—Les Affiches.* New York: Queen Art Publishers, Inc., 2005.

Weill, Alain, and Jack Rennert. *Masters of the Poster, 1896–1900.* New York: Images Graphiques, Inc., 1977.

Wittrock, Wolfgang. *Toulouse-Lautrec: The Complete Prints.* 2 vols. Edited and translated by Catherine E. Kuehn. London: Sotheby's Publications, 1985.

Zmelty, Nicholas-Henri. "L'Affiche illustrée en France (1889–1905): Naissance d'un genre?" PhD diss., Université de Picardie Jules Verne, 2010.

REPRODUCTION CREDITS

Photography

Courtesy of Indianapolis Museum of Art: figure 1

© Photo Les Arts Décoratifs, Paris / Jean Tholance: figure 2

John R. Glembin, Milwaukee Art Museum: figures 3, 8–10, 18, 21, 22; plates 2, 4, 5, 18–20, 22–25, 27, 29–33, 35–44, 50, 52–54, 58, 71, 78, 80, 84, 85, 88, 96, 98, 99, 101–103

© The National Gallery of Art, Washington: figures 4, 6; plates 6, 9

© Musée Carnavalet / Roger-Viollet: figure 5

© Photo Les Arts Décoratifs, Paris / Laurent Sully Jaulmes: figure 7

John Nienhuis, Dedra Walls, Milwaukee Art Museum: figure 11

Courtesy of Collection Oskar Reinhart «Am Römerholz», Winterthur: figure 12

© Kröller-Müller Museum, Otterlo: figure 13

© J. Paul Getty Museum, Los Angeles: figure 14

© Yale University Art Gallery, New Haven, CT: figure 15

© The Metropolitan Museum of Art / Art Resource, NY: figures 16, 19

© Musée Toulouse-Lautrec, Albi: figure 17

Courtesy of Jack Rennert, New York City: figure 20; plates 14, 46, 47, 51, 56, 62, 64, 73, 104

© 2012 Museum Associates/LACMA. Licensed by Art Resource, NY: plates 1, 3, 65–67, 72, 76, 77, 79, 81, 82

© The Art Institute of Chicago: plates 7, 70, 89

Courtesy of Grand Rapids Art Museum: plates 8, 11, 100

Courtesy of Galerie Berès, Paris: plate 10

Peter Jacobs, Zimmerli Art Museum: plate 12, 17, 49, 75

Courtesy of Prints & Photographs Division, Library of Congress, Washington, DC: plates 13, 15, 16, 55, 68

Jack Abraham, Zimmerli Art Museum: plates 26, 57, 60, 61, 63, 74

Victor Pustai, Zimmerli Art Museum: plates 21, 59

Courtesy of Princeton University Art Museum: plate 28

Larry Sanders, Milwaukee Art Museum: plates 34, 45, 87, 90, 92, 93, 94, 97

© The Museum of Modern Art/Licensed by SCALA /Art Resource, NY: plates 48, 69, 105

© National Gallery of Canada: plate 83

Michael Tropea, The Richard H. Driehaus Collection, Chicago: plate 86

Courtesy of Jeffery H. Loria, New York: plates 91, 95

Permissions

© 2012 Artists Rights Society (ARS), New York/ADAGP, Paris: figures 4, 14; plates 6–18, 48, 105

© 2012 Estate of Pablo Picasso/Artists Rights Society (ARS), New York: figure 16

pp. 2–3
Henri de
Toulouse-Lautrec
Confetti (detail),
1894
plate 93

pp. 4–5
Leonetto Cappiello
Maurin Quina
(detail), 1908
plate 18

pp. 10–11
Georges de Feure
Paris-Almanach
(detail), 1895
plate 50

pp. 47–48
Jules Chéret
Loïe Fuller (detail),
1897
plate 42

This catalogue has been published
on the occasion of the exhibition

*Posters of Paris: Toulouse-Lautrec
and His Contemporaries*

Milwaukee Art Museum
June 1 – September 9, 2012

Dallas Museum of Art
October 14, 2012 – January 20, 2013

Curated by
Mary Weaver Chapin, PhD
Associate Curator of Prints and Drawings,
Milwaukee Art Museum

Edited by Christina Dittrich
Designed by Hal Kugeler

Published by the Milwaukee Art Museum
and DelMonico Books, an imprint of Prestel

Milwaukee Art Museum
700 North Art Museum Drive
Milwaukee, WI 53202
Tel: 414-224-3200
mam.org

Prestel, a member of
Verlagsgruppe Random House GmbH

Prestel Verlag
Neumarkter Strasse 28
81673 Munich
Germany
tel 49 89 4136 0
fax 49 89 4136 2335
www.prestel.de

Prestel Publishing Ltd.
4 Bloomsbury Place
London WC1A 2QA
United Kingdom
tel 44 20 7323 5004
fax 44 20 7636 8004

Prestel Publishing
900 Broadway, Suite 603
New York, NY 10003
tel 212 995 2720
fax 212 995 2733
sales@prestel-usa.com
www.prestel.com

ISBN
hardback: 978-3-7913-5204-6
paperback: 978-3-7913-6407-0

Library of Congress Cataloging-in-Publication Data

Chapin, Mary Weaver.
 Posters of Paris : Toulouse-Lautrec and his contemporaries
/ by Mary Weaver Chapin.
 pages cm
 This catalogue has been published on the occasion of
the exhibition Posters of Paris: Toulouse-Lautrec and His
Contemporaries, Milwaukee Art Museum, June 1-September
9, 2012 and Dallas Museum of Art, October 14, 2012-January
20, 2013.
 Includes bibliographical references.
 ISBN 978-3-7913-5204-6 (hardback) —
 ISBN 978-3-7913-6407-0 (paperback)
 1. Posters, French--France--Paris--19th century--
Exhibitions. 2. Posters, French--France--Paris--20th
century--Exhibitions. I. Milwaukee Art Museum.
II. Dallas Museum of Art. III. Title.
 NC1807.F7C49 2012
 741.6'74094436107477595--dc23
 2012002497